MAY 2002

# FRIEDL

## Dicker-Brandeis

### Vienna 1898 – Auschwitz 1944

**THE ARTIST WHO INSPIRED THE CHILDREN'S DRAWINGS OF TEREZIN**

# FRIEDL
## Dicker-Brandeis

Vienna 1898 – Auschwitz 1944

**THE ARTIST WHO INSPIRED THE CHILDREN'S DRAWINGS OF TEREZIN**

**Written by Elena Makarova**
**International Coordinator Regina Seidman Miller**

**Published by**
**Tallfellow/Every Picture Press**
**In association with**
**The Simon Wiesenthal Center/Museum of Tolerance**

SKOKIE PUBLIC LIBRARY

Copyright © 2001 Regina Seidman Miller and Elena Makarova

All rights reserved. This book, or any parts thereof, may not be reproduced in any
fashion whatsoever without the prior written permission of the publisher.

Library of Congress
Cataloging-in-Publication Data

Makarova, Elena
Friedl Dicker-Brandeis
1. Brandeis, Friedl Dicker  1898 – 1944   2. Bauhaus   3. Terezin
4. Children's art – psychological aspects   5. Art Therapy
6. Holocaust Education – Maria  Montessori

Printed in Hong Kong

Published by
Tallfellow/Every Picture Press
1180 South Beverly Drive
Los Angeles, CA  90035

International Coordinator:
Regina Seidman Miller
Book Design and Art Production:
Arnold & Isolde Schwartzman
Special Thanks to Somogy Éditions, d'art, Paris

everypicture.com
ISBN  0-9676061-7-9

First Edition
First Printing

759.36
D549ma

# CONTENTS

## A Message from Regina Seidman Miller and Elena Makarova

WE ARE DEEPLY GRATEFUL to Friedl Dicker-Brandeis. Her honesty and fearlessness have supported us during the most challenging and difficult of times. She has brought us into a world filled with extraordinary people. The contributions of Friedl's friends and pupils—both in our work and in our lives—is impossible to overestimate. We are thankful and indebted to them all.

**The book is always written collectively, even when the authors do not know each other and 50 years lie between them.**

Our fondest dream was to share Friedl's art and life story with the world, in the hope that others would feel as enriched, impassioned and inspired as we have been. Again, we must express our heartfelt thanks to everyone who has been a part of this project.

THE LENDERS TO THE EXHIBITION:
Prague Jewish Museum: Director Leo Pavlat, curators Arno Pařík and Michaela Hajková
University of Applied Arts Vienna:
Archive Director Erika Patka and her researchers
Bauhaus Archive, Berlin:
Director, Dr. Peter Hahn and archivist Frau Elke Eckert
Paul Getty Museum, Los Angeles:
Special Collections Director Wim de Witt
Beit Theresienstadt Memorial, Israel:
Alisa Schiller and Alisah Shek
Netherlands Institute
for War Documentation
Curator René Kok

Dr. Hilde Angelini-Kothny, Dr. Edith Kramer, Judith Adler, Willy Groag, Hanne and John Sonquist, the children of Pavel Brandeis: Peter Brandeis and Jana Krejbichova, daughters of Eva Brandeis: Zdenka, Olga and

Irina, Dani Singer and the Rueff family, Milan Marvan, George Schrom, Rev. Jan Dus and his family, Michal Beer, Hava Selcer, Alice Eisler, Barbara Tzur, Miroslav and Dagmar Litomiska and the Terezin Memorial and The Terezin Institute

To our Friends and Friedl's Friends who will be forever missed:
Florian Adler, Georg Eisler and Anna Sládková

The Simon Wiesenthal Center for their trust and belief in this project, especially Rabbi Abraham Cooper who believed in this exhibition from the very beginning and has been our mentor throughout this journey.

Rabbi Marvin Hier, Rabbi Mayer May, Susan Burden, Liebe Geft, Rhonda Barad, Marlene Hier, Adaire Klein, Fama Mor, Janice Prager, Avra Shapiro, Michele Alkin, Rick Trank, Phyllis Rosenhaft, Matthew Asner, Jamie Hoffer, Lauren Hellman, Talma Hurwitz, Lorraine Sais, Susan Grande, Shimon Samuels, Efraim Zuroff, Janet Garfinkle, Felice Richter, Bob Novak and the entire Simon Wiesenthal Center Staff.

The Honorable Consul General of Austria to Los Angeles, Mr. Werner Brandstetter and his wife Leonie Brandstetter—your commitment has been exceptional.
The Austrian Government:
Federal Ministry of Foreign Affairs,
The Austrian Cultural Institute New York,
Los Angeles Austrian Consulate Office.

The Czech Foreign Ministry.

FOUNDATIONS:
Arthur M. Blank Family Foundation—
Arthur and Stephanie Blank, Elise Eplan,
Deva Hirsch, Dena, Danielle, Kenny and Nancy.
Gruss/Lipper Foundation
National Endowment for the Arts
Eli Broad Art Foundation
The Chas Levy Foundation
Pär Stenberg
Dr. Gail Furman
Wolfensohn Family Foundation
Each private donor whose generous
contributions helped to make our project
a reality.

CORPORATE SPONSORS:
Starwood Hotels & Resorts Worldwide INC.
Clarion Marketing and Communications,
Caren Berlin, Steve Gold, Jill Fallon,
Angela Vecchio, Dawn White and the
entire Clarion staff.

Friedl's pupils—for their stories
and devotion to Friedl:
Erna Furman, Edna Amit (Lilka Bobašová),
Raja Žadniková (Engländerová),
Helga Kinsky (Pollak), Handa Drori
(Hana Pollak), Rita Münzer (Bejkovská),
Eva Adorean (Erlichová), Dita Kraus (Pollach),
Marta Mikulová (Frölichová),
Milan and Irena Marvan (Eisler),
Anna Hanusova-Flachová,
Eva Štichová-Beldová, Hava Selcer
(Eva Reissová), Noemi Makovcová (Blanová),
Esther Birnstein (Schwarzbartová),
Eva Merová-Landová, Ela Weisberger.

Terezin survivors who shared with us the
sacred memory of their relatives and friends:
Marie Vitovcová (Spitzová), Grete Klingsberger
(Hofmeister), Michal Beer (Maud Stecklmacher),
Suzana Podmelová (Dorfler), Lisa Gidron,
Jiři Franek, Margit Silberfeld, Jiři Kotouč,
Helga Hoskova (Weissova) and Zdenek Ornest.

EXHIBITION TEAM:
*Architectural Design Firm:* Brandt & Schrom
*Architects:* George Schrom, Marcin Gregorowicz
*Database Designer:* Alexei Leltchouk
*Publishers:* Tallfellow/Every Picture Press:
  Larry Sloan, Leonard Stern and Lois Sarkisian
*Editorial Assistance:* Lee Cohen
*Book Design and Art Production:*
  Arnold and Isolde Schwartzman
*Translators:* Ron Meyer, Kevin Klabut
Natalia Leltchouk and Sergei Makarov
*Photographer:* Ryta Ostrovskaya

SUPPORTERS OF OUR PROJECT:
Bedřich Nosek, Anita Franková,
Magdalena Plazová, Oscar Moreni,
Renata Štindlová, Alona Abt and Tamir Paul,
Claudia Sugliano, Ingegerd Hanssen,
Gerwald Sonnerberger, Babbie Green, Antoinette
Muto, Brein Lopez, Susan Goldstein, William and
Lisa Gross, Milada Divišová, Elena Keshman,
Malwina Sohr, Nicholas Rodriguez, Erika Fischer
Laura Stern, Claudia Sloan and Kathy Babkow.

Our friends and family for their love, support,
endless patience, guidance and inspiration:
Wayne Miller, Fedor and Mania Makarov, Stan,
Diane and Lillian Seidman, Lee Cohen, Alex
Cohen, Joy Jarret, Hanne and John Sonquist,
Ruth Weil, and Leo and Connie Miller.

Friedl with her father
Simon Dicker.
Photograph, 1903.
Private collection

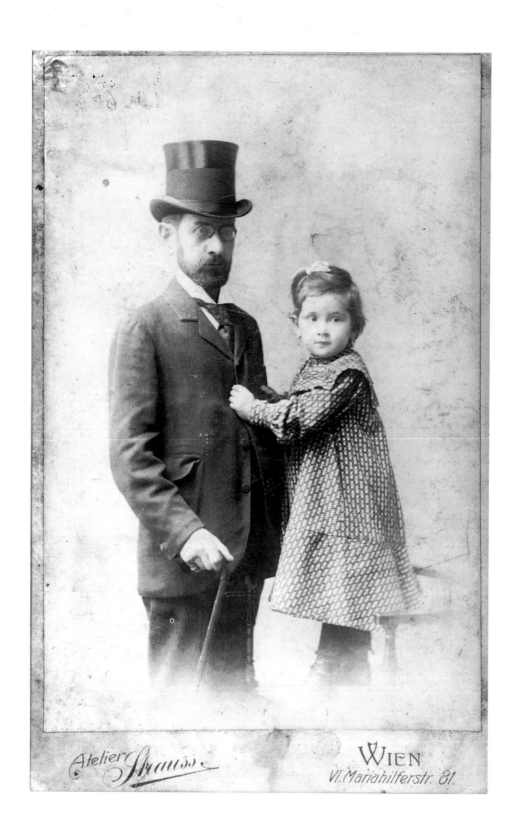

Atelier Strauss

WIEN
VI. Mariahilferstr. 81.

# BEGINNINGS/VIENNA

**My life in art has redeemed me from a thousand deaths. Through my painting, which I have practiced diligently, I have atoned for a guilt I do not know the origin of.**

— FRIEDL DICKER-BRANDEIS, MARCH 1938

CRAYONS, PAINTS, INK, CLAY—even as a little girl, she preferred playing with artist's materials to playing with dolls. She immersed herself in picture books, copying the images of her fantasy world. She yearned to create figures in motion — and as long as she still held them in her hands, they would play along, coming to life by moving, dancing and jumping. The young child constantly set herself new tasks; she was her own teacher and pupil.

She was born Friederike Dicker on July 30, 1898 in Vienna, Austria. Her mother, who gave her the pet name Friedl, died when she was not yet four years old. Friedl was raised by her father, a hard working shop assistant in a stationery store. He could not have been more pleased to see his daughter disappear into her world of paper and paint and ink. Friedl experienced the world in accordance with Götz prescription: she mastered life "with the help of her own artistic strengths in order to create something Good and Beautiful."

Friedl Dicker grew up with a love of art and an insatiable curiosity. For a young girl at the turn of the 20th century, Vienna was a feast for the senses. From her modest apartment in the ninth district, Friedl could explore the heart of Vienna, Europe's cultural center.

There were concerts in the garden cafes and parks, powerfully expressive posters on the walls of houses and exhibition buildings— lithographs by Klimt, drawings by Schiele. Even for a teenager of modest means, there was much to do and see. Friedl would slip into the Art History Museum without a ticket and stare at Bruegel's "Peasant Wedding." She would step quickly into a cafe to admire the elegantly dressed patrons and the play of colors on the lampshades. She would immerse herself in the bookstores—taking expensive art books from the shelves and copying her favorite pictures into a notebook— then carefully placing the volumes back.

In 1914, the world was at war and Friedl Dicker began her first formal training, a student at Vienna's School of Experimental Graphic Design. Her father had supported her wish to study photography— at the time, an unusual choice for a young woman. She trained under master photographer Johannes Beckmann. Within two years, Friedl mastered photography but never indulged in this passive occupation. She wrote, "Photography captures a single moment… the relationship between a person and his

**Friedl Dicker, Photograph, 1916. Private collection**

surrounding and to himself cannot be expressed in a single instant."[1]

After receiving her diploma, Friedl continued her studies at the School of Arts and Crafts, earning her own tuition by working in the school's theater. She worked as a prop-woman, designing costumes and even acting in small roles. Once, she had to play a horse. The curtain rose—but Friedl had yet to put her costume on. Improvising, she placed the horse's head on the stage, pulled the torso out from behind the backdrop and finally dragged on the legs. To the delight of the audience, "the horse" came to life before their eyes.

Friedl left home at the age of sixteen. She was tired of the arguments between her father and stepmother, Charlotte.

In 1915, Friedl Dicker was accepted by the School of Applied Arts and enrolled in a course taught by the painter Franz Čižek. He was the first teacher she would encounter who would prove to have a lasting influence on her thinking.

Čižek was credited with reforming art education by calling for the free development of spontaneous artistic activity. He believed students at every level should work according to their leanings and their inner impulses. Like Sigmund Freud, the founder of psychoanalysis, Čižek focused on the inner world of his students and their unconscious. To him, drawing was a tool to exteriorize their complexes. "Today, show me your soul!" he would exclaim.

Čižek explained his work with his students: "My method is free of any pressures. I do not have a prepared plan of instruction. The children and I move from the simple to the complex. The pupils can do anything they wish, anything that falls within the sphere of

their inner aspirations."[2]

Friedl's independent, creative imagination thrived under Čižek's philosophy. In fact, the rebellious nonconformity of her childhood had not changed.

A school friend, Gisela Jäger, remembers a defiant Friedl cutting her hair short, wearing the same gray dress day after day and skipping evening classes to attend the theater or a concert.

Gisela recalled Friedl's method for sneaking into sold-out performances: she would slip into the front stalls of the theater and hide behind the curtains where she would listen spellbound to the performances of Beethoven.

In 1916, Vienna was flooded by refugees. Food was scarce and even bread and flour were rationed. In this difficult time, the Swiss painter Johannes Itten settled in the "cultural Mecca" that was Vienna and opened his own school. Itten was a mystic and an adherent of Zoroastrianism, the religion of the ancient Persians. Itten believed the world was a stage for the battle between the opposing forces of good and evil.

Friedl Dicker found a new spiritual home in the world around Johannes Itten and quickly moved from Čižek's realm of "spontaneous self-realization" into a world of mystical laws— a world where life and art were inseparably joined and feelings and impulses were only the

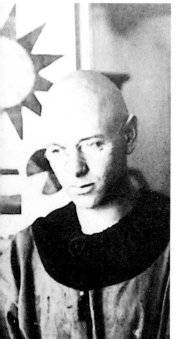

Johannes Itten. Photograph, 1923. Bauhaus-Archiv, Berlin

Viktor Ullmann. Notes for "Wendla in the Garden" with a dedication by the composer. 1944 Private collection

*Right:* Viktor Ullmann. Photograph from the album for Arnold Schönberg's 50th birthday, 1924

first step to comprehension.

Whenever Itten lectured, the classroom would be completely silent. The students were to attune themselves to their emotions and transfer that feeling to their drawing. The means of art was the transference of the inner movement of the soul, but the end of art was much more universal: spiritual progress. According to Itten, concentrated spiritual work required proper breathing. He was convinced that the way a person breathed could determine the entire rhythm of his life.[3]

In his school, Itten, who later became a Bauhaus teacher, created a unique atmosphere of artistic creativity and mutual understanding. The students learned not only from him but from each other. Without restricting any of their individuality, Itten was able to unify them.

From Itten, Friedl learned that art was a connecting link between word, sound, form, color and movement; in this way, art served global harmony. She found that the reality we perceived could not simply be described: it demanded a constructive understanding. Its skeleton consisted of the simplest shapes. These shapes, in which ideas are imprisoned, must be opened up, taken apart, studied. One must do away with the superfluous, but not the functional.

Friedl thrived. Her impulsive nature could express itself perfectly within her large circle of friends and within her artistic work.

Friedl and a fellow student at Itten's school,

Anny Wottitz, rented a small studio together. Anny was studying bookbinding, and she and Friedl would take bookbinding commissions to support themselves.

Friedl Dicker continued to draw, but she drew quickly now, not allowing herself to be hampered by too much reflection. She never attempted to make corrections to a page: an unsuccessful sketch was not the result of mere ineptness but rather the product of a "blind soul."

Friedl could not live without music. As before, she spent her evenings in concert halls. She developed a passion for the modern music of the day: Mahler, Stravinsky, Schönberg. It was as if she could hear herself in the music: the dark passions, the melancholy, the hysteria.

In 1918, Friedl Dicker and Anny Wottitz joined the composition course of Arnold Schönberg where she met a young composer named Viktor Ullmann. Not long after, Ullmann gave Friedl a song he had written for her birthday, a composition called "Song for Wendla" from Wedekind's *Wendla in the Garden*. Another composer, Stefan Wolpe, who dedicated his song "Half of Life" to Friedl, later said that Friedl Dicker was his first great love but that it was unrequited.

Instead, in that same year, Friedl lost her heart to the architecture student Franz Singer who had just returned from the war and who, like herself, was a student of Johannes Itten. Friedl Dicker, full of vitality and inner strength, was a source of living energy to him. The two of them spent day and night together. They would fantasize, planning the cities of the future, designing apartments that looked like theater sets and dreaming of a harmonious world.

**Left:** Johannes Itten. Photograph, circa 1960. Private collection

**Right:** Johannes Itten. Representation of Contrasts. 1919-23. Drawings

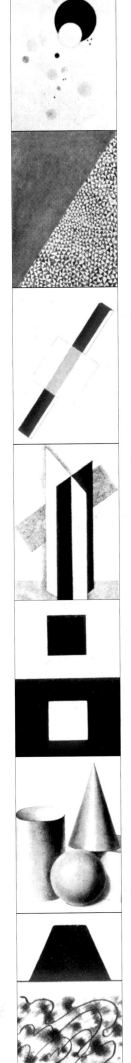

## BAUHAUS

### Man, whose time is so short, cannot grasp the simultaneousness of events, their lightning-quick coincidence.

—FRIEDL DICKER-BRANDEIS, UNDATED

**Stefan Wolpe.**
**Photograph circa 1919-23.**
**Private collection**

**Franz Singer.**
**Photograph, circa 1919-23.**
**Private collection**

IN 1919, WALTER GROPIUS created the Staatliche Bauhaus in the small town of Weimar, Germany. As the school's Director, Gropius established the goal of the Bauhaus in his "Message to Young Architects." He wanted to seek "an expression of the living spirit in its constantly changing form."[4]

Inspired by the medieval idea of cooperative artisan work, Gropius said in his manifesto: "Let us create a new guild of craftsmen without the class distinctions that raise an arrogant barrier between craftsman and artist!" He sought to create "the new structure of the future, which will embrace architecture and sculpture and painting in one unity and which will one day rise toward heaven from the hands of a million workers like the crystal symbol of a new faith."[5]

Shortly thereafter, Friedl and Franz Singer were among the idealistic students who joined Johannes Itten in answering Gropius' call. These "united individualists," as they called themselves, moved from Vienna to Weimar.

In Weimar, teachers and students lived together as a commune, discussing the art of the future and the destiny of Europe. Many years later, Friedl recalled they were "poor but cheerful." She wrote to Anny Wottitz, "The quiet work days completely enthrall me and inspire me."[6]

The teaching program at the Bauhaus was perfect for Friedl, and from the beginning she was one of its best students. The program supported her inner development and her

**Above:** Friedl Dicker.
**Photograph, circa 1922-24.**
**Private collection**

practical relationship to art. With her childlike curiosity and energy, she learned to use the printing presses, the metalworking machines and quickly mastered weaving. She and Anny Wottitz produced book bindings that are represented in the catalogues and the history of the Bauhaus to this day. For the first time, the sketches and half-finished drawings she had always made existed in material form.

The medieval system of master and apprentice that Gropius introduced had only one shortcoming—excessive authoritarianism. It was not easy to maintain your independence and find your own path in art after such masters as Feininger, Klee, Muche, Schlemmer, Kandinsky, Itten and Gropius. For many students, the impact of Itten's system became insurmountable.

Florian Adler recalls, "My mother, Margit Tery-Adler, a close friend of Friedl's, was unable to free herself from the Bauhaus influence. Their entire group was very talented …but Friedl was very emancipated. She is perhaps the only one who went on and found her own individual identity."[7]

In 1921, the painter Paul Klee came to the Bauhaus as a teacher. He was to have a significant, lasting influence on Friedl. Klee would prove to be the source not only of Friedl's artistic motifs, but also of her strength as a teacher.

Friedl studied with Klee almost every day, listening to his lectures on the essence of art and childhood imagination and watching him paint. She was fascinated by the way Klee would let his pen glide over the paper, creating cities and towers and simple, uncomplicated people and animals. She noted that his drawings were not artificially childish; they emerged from memories, emotions and long-forgotten bliss.

Friedl admired Klee's power and his perceptions. He saw things from all sides and from within. Years later, Friedl would write of Klee, "He establishes his own interconnections between individual parts—whether they be the earth, sky, the painting's title or what is depicted. He is a mathematician who works not with numbers, but with the values and connections between them.

"Once one of the students brought his picture to Klee for an opinion. Another student tore the picture to shreds in Klee's presence— poor composition, incorrect proportions of land and sky, poor correlation of colors. 'These young people,' Klee exclaimed, 'want to bring the earth in line with the sky.'"[8]

At the Bauhaus, Itten continued to develop the "scientific–mystical" system that he had already tested in Vienna. According to Itten, the basis for the creation of form was the universal teaching of contrasts. Light and darkness, material and texture, shape and color, rhythm and form of expression, must be represented in their opposing manifestations.

In 1921, the publisher Bruno Adler established the almanac, "Utopia – Documents of Reality", an open forum for Itten's expanding philosophies. Itten chose Friedl to illustrate the chapter on "Analyses of Old Masters" and assigned her the task of finding

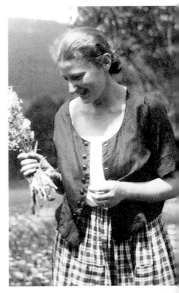

*Above:* **Anny Wottitz (married name Moller). Photograph, circa 1920. Private collection**

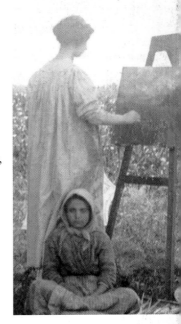

*Above:* **Margit Tery (married name Adler). Photograph, circa 1916. Private collection**

*Left:* **Bauhaus workshops in Weimar. Photograph, 1990. Private collection**

a typeface that would turn the reading of this manifesto into meditation.

The annual market at Weimar marked the beginning of the history of the textile workshops. It was a festive scene and the Bauhaus was well represented, its designs in high demand.

Friedl's booth at the market was surrounded by children, fascinated by the wooden puppets she had created. With a pull of a string, she could make the puppets do anything —but Friedl's puppets were not for sale; the delighted reactions of the children were all she sought.

Friedl studied textile design with Georg Muche, lithography from Lyonel Feininger and sculpture in Oskar Schlemmer's studio—but all the while, she dreamt of the theater.

Friedl and Franz Singer applied to the theater workshop of the innovative director Lothar Schreyer, but they did not stay with him for very long.

In 1921, the producer Berthold Viertel invited Friedl and Franz Singer to take part in his productions of the plays "The Awakening" and "The Pagan Bride." Soon afterwards, they began their work with Bertolt Brecht.

Friedl and Franz quickly became enmeshed in the many and varied theater programs of the Bauhaus. There were dramatic productions, music, masquerades, evenings of dance. Each autumn there was a kite festival. The students would gather in the fields and send their homemade creations up into the sky. On summer evenings, the performances frequently would begin

with a theatrical procession through Weimar.

The "Friends of the Bauhaus," whose members included prominent artists like Schönberg, Stravinsky, Kokoschka and Chagall, supported the Bauhaus spiritually and materially. Famous musicians, dancers and writers attended Bauhaus evenings. Else Lasker-Schüler appeared at the first Bauhaus evening.

One of the posters, designed by Friedl— for a performance of Debússy's music— contained Friedl's passionate tribute to the composer: "Debússy, you play instruments that are not made of ordinary wood and metal, but of nerves, flesh and blood."

A song recital performed by the singer Emmy Heim changed Friedl's life. Her lover, Franz Singer, fell in love with the singer. On the program—like a bad omen—was the song "Come, Sweet Death, and Stay With Me". Another composition performed that evening was Mahler's *Kindertotenlieder* (Songs on the Deaths of Children).[9]

Friedl wrote to her old friend, Anny Wottitz, "The main thing is to calm the anxiety —and then everything is fine. I am seized by the enormous fear of loneliness, utter loneliness …May God see me through this period."[10]

Not long after, Singer and Emmy Heim were married. Friedl busied herself in her work. She was allowed to teach the Basic Course to the beginners—the first student of the Bauhaus to do so. Friedl also found comfort in her art.

She became fascinated with sculpture and created small

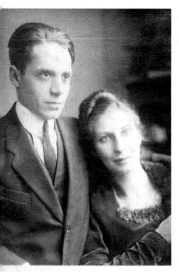

Margit Tery with her future husband Bruno Adler. Photograph, circa 1920. Private collection

*Right:* Diagram of the Bauhaus Course of Instruction by Walter Gropius. 1919

compositions based on her sketches—all on the same theme of the miraculous birth of the Mother of God to the elderly, childless couple Anne and Joachim. The art historian Hans Hildebrandt called Saint Anne, "One of the most original works of modern art by a woman." He wrote, "the source of Friedl's artistic work is an unbelievable imagination. One notices the accomplished graphic technique, her absolute mastery of the chiaroscuro." [11]

Her angel had no wings. The figures of Anne, Mary and Christ were set inside one another. Throughout her life, Friedl would return again and again to the subject matter of "Saint Anne": childlessness, the great trauma of her own life.

Friedl is remembered at the time as being "funny, quick to enthusiasm, and overflowing with spontaneous ideas and improvisations"—[12]

but behind the facade was another Friedl: hypersensitive, worried, lonely. Her "dark" compositions from the Bauhaus period express her premonitions and terrible nightmares about the future. She wrote to Anny Wottitz, "I often have the feeling that I am a swimmer who is being carried away by a horrible flood… For a moment, I raise my head above water… and I manage to cry out to the other swimmers. It is good that I am not making any plans, not for even a minute in advance." [13]

By 1923, the relationship between Walter Gropius and Johannes Itten had exhausted itself. With philosophical and religious differences splitting the Bauhaus, Friedl and Singer made the decision to leave behind the security of the Bauhaus for new opportunities.

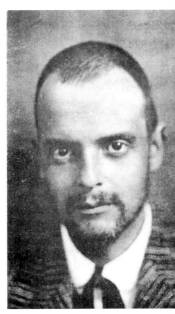

**Paul Klee. Photograph, circa 1920. Private collection**

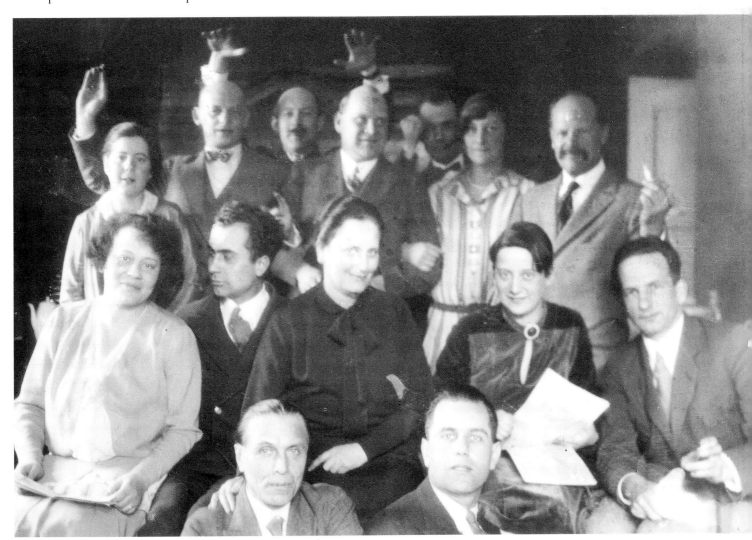

**Friedl Dicker with a group of artists. 1st row (from the left): Hans Hildebrandt, Hans Swarowsky. 2nd row: Mrs. Löwenstein, Bodo Rasch, Lily Hildebrandt, Friedl Dicker, unknown. 3rd row: unknown, Oskar Schlemmer, Mr. Spiegel, Olly von Waldschmidt. 4th row: Richard Herre, Heinz Rasch. Photograph, circa 1919-23. Getty Research Institute, Research Library, Los Angeles**

*Right:* Emmy Heim.
Photograph, circa 1920.
Private collection

*Far right:* Invitation to
Emmy Heim's concert. 1921.
Lithograph. 46 x 29.8 cm.
Bauhaus-Archiv, Berlin

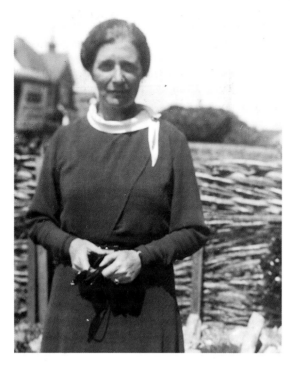 

*Right:* Invitation to
Helge Lindberg's concert. 1919-23.
Lithograph. 32 x 21 cm.
University for Applied Art, Vienna

*Far right:* Composition in
black and white. 1919-23.
Lithograph. 50 x 34 cm.
University for Applied Art, Vienna

# BERLIN/VIENNA

## In order to create something unique, one must not be afraid to repeat the repeatable. —FRIEDL DICKER BRANDEIS, LETTER,1940

Group photo in the Moller house in Vienna, built by Adolf Loos. From the right: Marie and Ludwig Münz, Anny Moller, Judith Moller (married name Adler), the sister of Ludwig Münz and her husband. Photograph, 1932/33. Private collection

LATER THAT SAME YEAR, Friedl Dicker and Franz Singer, with their friends Naum Slutzki and Franz Skala, opened the "Workshops of Visual Art" in Berlin. They designed and manufactured toys, games, jewelry and received numerous commissions for textiles, bookbinding and graphics.

Singer remained married and was now the father of a son, Bibi. To the outside world, Friedl and Singer were business partners, but their problematic love affair continued. The couple would travel back and forth between Berlin, Vienna, Dresden, Cologne and Leipzig creating sets for Berthold Viertel's theater, Die Truppe. In one year, they created sets for three theater productions: Ibsen's *John Gabriel Borkman*, Shakespeare's *Merchant of Venice* and Robert Musil's comedy *Vinzenz, or The Mistress of Important Men*.

Theatrical life in Berlin was flourishing. Bertolt Brecht, Kurt Weill, cabarets, workers' theaters, arguments between the Communists and Social Democrats, these were all part of Friedl's world now.

In 1925, Friedl returned home to Vienna and opened an atelier for textile design and bookbinding. While she designed elegant ladies' handbags, belts and other leather goods, Friedl became passionate about politics and discussed the class struggle.

Franz Singer left Berlin to follow Friedl and together they founded the Atelier Singer-Dicker, an architectural firm. The atelier presented its work at exhibitions in Vienna,

*Below:* Program for the theater tour of Robert Musil's "Vinzenz, or the Mistress of Important Men," under the direction of Berthold Viertel. Set design by Franz Singer and Frieda [sic] Dicker. 1924. Letterpress printing. Private collection

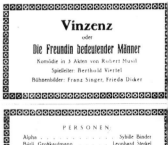

*Left:* Berthold Viertel. Photograph, end of 1950. Private collection

*Far left:* Friedl Dicker and Hans Hildebrandt. Photograph, end of 1920. University for Applied Art, Vienna

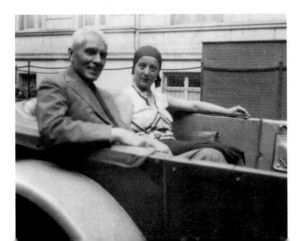

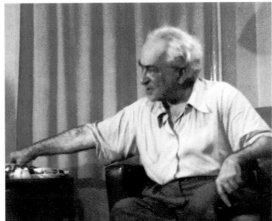

**Friedl Dicker. Photograph, 1930. Private collection**

**Pendant and brooch. Circa 1924. Opal/cornelian, horn, mother of pearl, amber, silver. The band fits into the outer silver ring. Bauhaus-Archiv, Berlin**

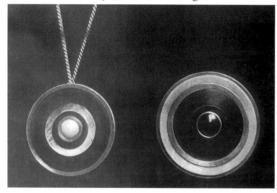

Prague, Brno, Budapest and Berlin. Their works received recognition in 1927 at Berlin's "*Kunstschau*" and at Vienna's "Exhibition of Viennese Designers" in 1929.

Professionally, Friedl and Singer were a perfect match: Singer was an artist who had turned to architecture and Friedl "gave life to" Franz Singer's constructions. They experimented with texture, color and materials. They discovered how they could combine frames and covers for furniture; they created chairs that could easily be stacked together, folding sleeper sofas, tables with bent nickel feet and flexible

lamps that could stand, hang or lie.

The Atelier Singer-Dicker became successful in Vienna. Even if people could not afford to furnish their whole apartments, they wanted to have at least one piece of furniture—a chair or a table—from the studio. Franz Singer and Friedl Dicker had achieved the improbable: they became both progressive and fashionable. It was not clear what attracted their clients more, the originality—Bauhaus geometry with a Viennese flavor—or the practicality. Though Singer traveled all over Europe with sketches and samples, none of the studio's designs ever went into mass production.

In 1930, Atelier Singer-Dicker received a commission to provide furnishings for a kindergarten run according to the innovative methods of the Italian doctor and educator Maria Montessori. She believed adults needed to allow children enough freedom to become their own teacher. The innovative space they designed

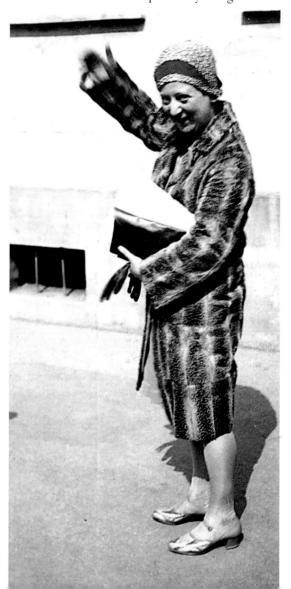

**Friedl Dicker. Photograph, 1920's. Private collection**

came to be known as "the model kindergarten of proletarian Red Vienna." The toys they created were made of the simplest geometric shapes in order to stimulate the children's intellectual abilities. The "Montessori children" came from the families of left-wing socialists—radicals in their views on politics and in their views on art.

After the February, 1934, right-wing revolt in Vienna, many of the buildings and commissions designed by Atelier Singer-Dicker were destroyed. Among these was the Montessori school. The National Socialists would not tolerate the teachings and designs that encouraged individual thought and freedom. Other buildings designed by the Atelier Singer-Dicker have since been destroyed, including the Vienna Tennis Club which was built in 1928 and a guesthouse for the Countess Heriot built in 1934.

Friedl had already found a new audience for her visions. In 1931, the city of Vienna invited her to teach an art course for kindergarten teachers. To secure the position, she had submitted two letters of recommendation. The letter from Itten read simply, "Miss Dicker… is an extraordinarily gifted artist and person, whom I value highly. She is an original personality. I recommend her to you most warmly."

Walter Gropius wrote, "Miss Dicker studied at the State Bauhaus from June 1919 to September 1923. She was distinguished by her rare, unusual artistic gifts; her work constantly attracted attention. The multifaceted nature of her gifts and her unbelievable energy made her one of the best students so that already in her first year she began to teach the beginners. As the former director and founder of the

Bauhaus, I follow with great interest the successful progress of Miss Dicker."[15]

As an art teacher, and particularly in her work with children, Friedl finally had a chance to apply the system she had learned from Itten. In her work with educators, she learned not only new ways to teach children but how to make adults aware of a child's artistic abilities. According to her former students, her mere presence was enough to create a positive atmosphere.

Edith Kramer was one of Friedl's students. Writing about Friedl's classes, she stated, "It was impossible to guess what would come next; she had an unbelievable imagination."

The dictation, or rhythm exercises, Friedl used were inspiring. "She began quietly, with a quick tempo. She would get faster, raising her voice." According to Kramer, Friedl would have you imagine a rising staircase or "how bamboo grows in bursts—up, up, and finally its leaves come out. That was a wonderful way to understand how art is made.

**Bibi, the son of Franz Singer and Emmy Heim. Photograph, circa 1930. Private collection**

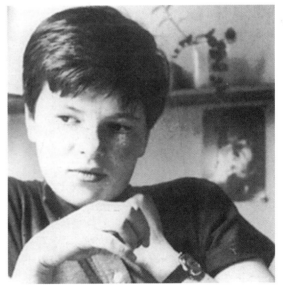

**Edith Kramer. Photograph, 1933. Private collection**

## This is how it looks, my child, the world you were born into... if you do not like this world, then you will have to change it.

"Itten was an amazing teacher but not a brilliant artist. Friedl was the most brilliant artist. All the teaching methods she used had come through her art—they were alive. With Itten, it was more a matter of method.

"Nobody on earth could have given me what she did—an understanding of a thing's essence and the rejection of lies and artificiality."[16]

Friedl's goal was to help the children recognize and express their own feelings and experiences. Her exercises, inspired by Itten,

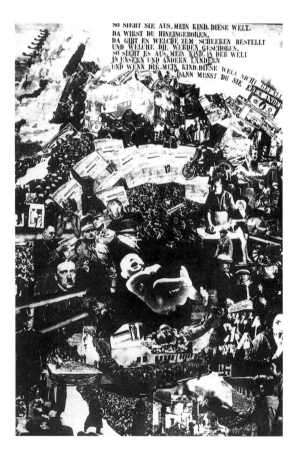

Anti-capitalist poster with a poem by Bertolt Brecht. Circa 1930-34. Photo collage. Private collection

did not serve any immediate purpose. They called upon the children to become engaged in an active and concentrated process of creation. However, Itten's system was not the only point of reference in Friedl's new work. Through discovery and application, she was finding her own insight into the psychology of artists and children as artists.

Eventually, her classes were filled—not only with kindergarten teachers, but with children and other adults.

Meanwhile, the relationship between Friedl and Franz Singer had become unbearably complicated. Friedl had longed to have a child. "If I had a child," she wrote to Anny Wottitz, "I would be better suited for battle and I would also hope that, where I failed, the child would make a success."[17] She became pregnant several times—but Singer did not want to have children with her. Each time, Singer pressured her to have an abortion. Each time, she complied.

Friedl was forced to watch how much Singer adored his young son and how proud and happy he was. Despite her pain and humiliation, Friedl treated the boy with great affection. When Singer's son fell ill and died suddenly, the relationship between Friedl and Franz became even more strained. Friedl Dicker rented a new studio in the 19th district, away from the old atelier and its painful memories.

The political discussions in Friedl's parlor had evolved. When asked why she became a member of the Communist Party, Friedl would quote two lines from a poem by Matthias Claudius (1740-1815): "Sadly there is war, and

I desire not to be guilty of it."

It was a time of budding fascism and Edith Kramer believes that Friedl was "torn between the urgent necessity to flee and the wish to stay and fight fascism in order to save its victims."

As a passionate new convert, Friedl plunged into Communism, believing it was the only alternative to Fascism. Friedl wanted to embody the Communist ideal in her art. In one of her adult classes she read part of the "Communist Manifesto" to her students and required that they paint an abstract composition on this theme.

She entered into battle with Hitler himself —creating propaganda posters that attacked the tyrant. In addition, Friedl made many photo collages for agitprop posters. She manifested a world of pictures that were bound to each other in a whirling rhythm. She wrote on one of her posters, "This is how it looks, my child, the world you were born into… If you do not like this world, then you will have to change it."

In 1933, Hitler came to power in Germany. The Bauhaus, labeled a "breeding ground for Jews and Bolsheviks," was closed immediately thereafter. The Communist Party was forced to go underground. Arrests took place throughout the country. In 1934, there was a right-wing putsch in Vienna, and the Chancellor Dollfuss was assassinated.

In Friedl's circle, everything revolved around whether to do battle with Fascism here or to flee, to escape. Flight was repugnant and shameful to Friedl.

Friedl Dicker helped friends by hiding their personal documents in her atelier. The studio was searched by government agents a short time later, and forged passports were found. Friedl was arrested.

Prison did not frighten Friedl. During the humiliating interrogations each night, she did not break down. She maintained silence under the blinding light they shone in her face. Later, she told friends that during her interrogations her "ears burned."

Confined to the prison, Friedl felt surprisingly unconstrained. She viewed the work they gave her—patching up the prison clothing—as a free course in embroidery.

Singer was summoned to testify against her. To the question about forging documents, he replied: "That is impossible; Friedl does not know how to draw a straight line."

Friedl was immediately released from jail. She fled to Prague as soon as she could.[18]

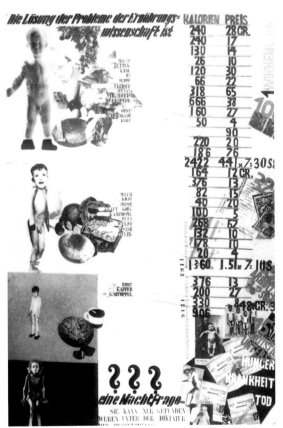

Anti-capitalist poster.
Circa 1930-34.
Photocollage.
Private collection

## PRAGUE

# When you run away, you take your fear with you.

—RENÉ DESCARTES

I N 1934, CZECHOSLOVAKIA was a free country under democratic rule—open to political refugees. In the early thirties, Jews had seats in parliament, students interested in Zionism attended seminars and refugees opened their own schools. German and Austrian intellectuals established journals and newspapers that had long been banned in their home countries.

In Prague, Friedl fundamentally changed her relationship to the world, as well as the tempo and direction of her life.

In her first Prague pictures, Friedl tried to come to terms with her impressions from jail. Although the first sketch still bears the traces of her former existence, the next two works can be seen as a turning point in her art. She moved away from the constructivism of the Bauhaus and stopped creating her pictures "from simple shapes and colors." Now she dedicated herself to painting: she created portraits, landscapes, still lives and allegories, often in a figurative style.

A fellow refugee, the psychoanalyst Annie Reich, became Friedl's analyst, leading Friedl back through her difficult childhood. With carefully directed questions, Annie helped Friedl change her relationship to herself. Annie Reich told her it was not a sin to long

for happiness at all times.

She also convinced Friedl to finish a series of paintings that had remained incomplete for years and on which she had been making constant corrections and changes. Among these works were "The Resurrection of Lazarus" and "The Large Griffin and the Small Griffin." The completion of these paintings freed Friedl from sterile experiments and allowed her to find a personal style independent of the Bauhaus tradition.

Friedl would sit by her window or on the balcony, arrange her paints in front of her, and from her comfortable, protected hiding place, admire the world: the flowers on the window-sill, the view of the balcony or a passing train through a net curtain. She examined the world carefully and penetrated into its depth, not its breadth.

Friedl began to work with the children of the refugees, and soon she was joined by her student from Vienna, Edith Kramer. According to Kramer, "Friedl worked with the children freely and generously...(teaching them) tone and texture, rhythmic exercises, collages, copies. For traumatized children, it was astonishingly effective therapy. Friedl became a 'center of inspiration' to them and the

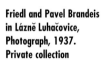

**Pavel Brandeis,
Photograph, circa 1934-36.
Private collection**

**Friedl and Pavel Brandeis
in Lázně Luhačovice,
Photograph, 1937.
Private collection**

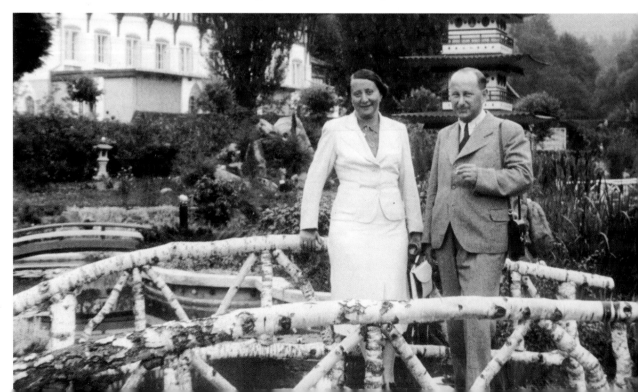

children blossomed before our eyes."

Friedl Dicker's friend, Hilde Angelini-Kothny, also has vivid memories of this time: "I loved hearing her stories about the children. A girl asked Friedl what a church was. Friedl answered that it was God's house. But the girl said she was wrong, that God lived in Heaven and that the church was the place where he worked.

"Another time, a little girl appeared at Friedl's doorway and said she needed to talk about something. Friedl waved her in and offered her a place at the table—very seriously, as though between adults. The girl sat down and did not say anything. 'Now, what was it you wanted to talk about?' 'Can I just sit here like this?' the girl asked shyly. Children felt at ease around Friedl."

Friedl organized an exhibition of work by her students. She showed not only the beautiful pictures but also afforded a view into the children's psychological state. Friedl's work would greatly influence art therapy. Edith Kramer stated, "These were the first steps toward… interpreting children's works from the perspective of the inner life of the children."

Friedl began to paint "Interrogation," a reflection of her arrest in Vienna. Painting from life, Friedl introduced her inquisitor, gnashing his teeth, crushing the dirty page with his elbow. She portrayed herself, hair cut short and a red ear. The typist's hand, carved from

**Friedl Dicker's passport, 1936. Private collection**

wood and pasted on, had fingers like tentacles.

Friedl reestablished her collaboration with the atelier in Vienna, both personally and professionally, and cooperated on many projects from Prague. With Greta Bauer, she worked on the renovation of apartments. With Frieda Stoerk—Franz Singer's sister—she developed new textile patterns. She worked in the atelier for the last time in 1937.

In Prague, Friedl made contact with some of her relatives. At the Jewish Community Center, Friedl searched the archives for her mother's sister —who according to her father had lived in Prague. She found the name Adéla Fanta Brandeis. Adéla had three sons—and the youngest, Pavel, lived with his mother.

A close relationship soon developed between Pavel and Friedl. For the first time in her life she seemed genuinely happy.

On April 29, 1936, Friedl married Pavel Brandeis. She began to sign her pictures with "FB" instead of "FD."

Friedl was embraced by Pavel's family. In the morning, Pavel would go to the office and she would stay with her mother-in-law, her Aunt Adéla.

Soon, Friedl and Pavel were expecting their first child. Adéla took care of Friedl and gave her vitamins. In the warmth of the Brandeis home, Friedl slept and dreamt of the child. It was not to be; Friedl suffered a miscarriage.

Elisabeta ("Lizi") Deutsch in her bookstore "The Black Rose." Photograph, 1941. Private collection

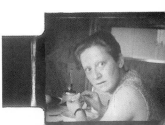

Friedl Dicker's apartment building during the years 1934-36, Praha-Nusle, Jaromirovástrasse 46. Photograph by Alex Leitchouk, 1998. Private collection

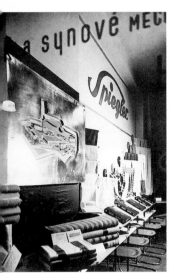

Spiegler's stand at the textile trade fair "Nachód-38." Photograph, 1938. Bauhaus-Archiv, Berlin

Friedl had begun to frequent the Black Rose, a Prague bookstore owned by Lizi Deutsch that served as a meeting ground for underground political groups. Here, Friedl made a new friend, an activist named Hilde Kothny.

Friedl had been able to smuggle out of Vienna lists of all the underground Communist members. Hilde called Friedl's effort "a desperate act of courage."

One of the paintings Friedl created during this period was of her friend, the philosopher Albert Fuchs. In "Fuchs Studies Spanish," she portrayed him preparing to go to Spain to fight the Fascists.

Friedl believed that the times demanded sacrifice and that she should answer the call. She wanted to fight the Fascists in the Spanish Civil War, but her commitment to Pavel held her back.

In July 1937, two art exhibits opened in Munich. "The Great Exhibit of German Art" was installed in the main galleries of the Munich House of German Art. The works had been selected by the Fuhrer himself. The second exhibit, entitled "Exhibit of Degenerate Art" was housed in a building that normally served as a warehouse. Hitler had assembled examples of "degenerate art" to help the masses identify artworks that would no longer be tolerated in his society. At the opening of the Degenerate Art Exhibit, Hitler announced, "Amateurs in art, today they are contemporary; tomorrow they will be forgotten…dilettantes who ought to be sent back to the caves of their ancestors along with their scrawls."[19]

The names of the artists in the first exhibit have been forgotten. The Degenerate Art Exhibit included the work of Otto Dix, Ernst Ludwig Kirchner, Oskar Schlemmer, George Grosz, Ernst Barlach, the German expressionists and every single German-Jewish artist of renown.

With the Munich Agreement, Nazi Germany had legalized the annexation of the Sudetenland. On November 9, 1938, widespread attacks on Jews, Jewish-owned property and synagogues were made throughout Germany, Austria and the Sudetenland. This anti-Jewish pogrom has gone down in the annals of history as *Kristallnacht*.

News of the devastation of her old studio in Vienna by Nazi storm troopers and the destruction of almost everything they had designed and built there seemed to have little effect on Friedl. She was busy with her art, her children and her politics in Prague.

Friedl's friends tried to convince her to leave Europe as quickly as possible. From London, Franz Singer called upon Friedl to join him. Anny Wottitz Moller and her husband Hans sent Friedl an immigration certificate to Palestine. Friedl did not want to hear any of it.

More and more of Friedl's friends and acquaintances were fleeing Prague—including Georg Eisler, one of Friedl's early students. "We were all in the same boat," says Eisler, who was able to escape to England with his mother. "Everyone tried to convince Friedl to leave too, but she refused because of Pavel."

It was no longer possible for Pavel to get a visa. Friedl herself could have gone to a safe foreign country and then attempted to bring Pavel out. She refused to take such a risk.

Friedl Dicker-Brandeis. Photograph, 1940. Jewish Museum, Prague

# HRONOV

## ...I belong, like mortar or stone, to the small building of life...

—FRIEDL DICKER-BRANDEIS, 1939

IN THE SUMMER of 1938, Friedl and Pavel moved to the Czech countryside, where Pavel grew up. Friedl wrote, "It is peaceful here…I would not believe even in my final hour that something evil was taking place…"

Hronov was a small town northeast of Prague, near the Polish border. Pavel had become the head bookkeeper at B. Spiegler and Sons textile factory. Friedl was also offered work at the factory — and at the textile trade show "Nachod 38" she was awarded a diploma and a gold medal for textile design as a representative of the firm.

After a while, Friedl was able to revive her personal contacts. Laura and Elsa Schimková, two friends from the Prague underground, also moved to Hronov. In 1939, her close friend Hilde Kothny left for Germany where she continued to support Friedl from a distance by sending books, food and medicine. As often as she could, Hilde would come to visit.

In 1939, both Friedl and Pavel lost their jobs at the textile firm.

Life in Hronov was only rarely interrupted by guests. For this reason, Friedl awaited letters from friends with great impatience; they were her bridge to the world. Her return letters contained the phrases, "Today I went to the post office to ask" and "Yesterday the letters I longed for finally came." Friedl wrote to Hilde. "I wish I could put up a monument to you: behold, a person who lives!"

She would answer letters as soon as she received them. "After I send this letter, I will start a new one to you right away, full of all the odds and ends and little details that one can

collect here in the desert, in this beautiful desert," she wrote to Hilde.[21]

Hilde remembers those times. "Once I visited Friedl, and we were so happy we sang all night…We were so happy whenever we could be together. There was always something to celebrate. Friedl turned everything into theater.

"I remember Christmas in Hronov. That night, Friedl was in good form. She tried to dress everybody in costumes. Then she grabbed a spool of black thread, stuck it under her nose and gave a congratulatory speech as Hitler. We were all doubled over with laughter.

**Once I visited Friedl and we were so happy we sang all night. There was always something to celebrate. Friedl turned everything into theater.**

"Then she had us all draw with charcoal to the sound of her voice, and she would deliberately change the pitch and rhythm very quickly. It was probably amusing for her to watch us smearing the charcoal with our hands on the wallpaper—it was some sort of insane discharge of energy.

"Friedl always tried to liberate us. To her, we all seemed constrained. No one could lead a full life, and she felt herself to be a liberator."

In her letters, Friedl tried to make sense of what was happening. Her painful search would sometimes lead her to surprisingly simple truths: "Even if it were never possible to appreciate life, love is so wonderful that you should never grieve."[22]

Although isolated, Friedl remained the

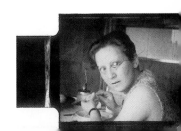

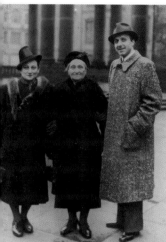

**Adéla Brandeisová, Josefa and Bedřich Brandeis in Berlin. Photograph, 1941. Private collection**

*Right:* **Friedl Dicker-Brandeis with her dog Julenka in Zdárky. Photograph, circa 1940. Bauhaus-Archiv, Berlin**

GERALD DAVIS
(American)

F. BRANDEISOVA
(Czechoslovakian)

Flowers
Still-Life
Landscapes

ARCADE GALLERY
28 Old Bond Street
The Royal Arcade

August 9th . . . . . . August 20th 1940

**Title page of the catalogue for the exhibition in the Arcade Gallery, London. 1940. Letterpress printing. Bauhaus-Archiv, Berlin**

teacher. Her letters to Hilde became entire lectures about art history and philosophy—complete with little pictures and copies she had made and quotes from Kierkegaard.

In Hronov, Friedl stopped drawing the view from her apartment window. She wandered through the forests and over the mountains and began to observe the world and to reshape it from simple forms and colors. She saw the open fields, stretching out into the distance, through a fence of trees, through a corner of the town with a chimney. At the Bauhaus and in Vienna she wanted to build and reconstruct the world, to improve it and make it more beautiful. In Hronov, Friedl began to listen to what the world had to say to her.

Her portraits were of those around her. A neighbor came by to teach her how to cook and clean, and she was absorbed into Friedl's canvas. The local music teacher determined to teach Friedl to speak Czech, so Friedl painted her with a textbook in one hand. Otto Brandeis' wife Maria came to visit, sat down with her knitting, and became one of Friedl's subjects.

In a letter to Hilde, Friedl explained her artistic development: "I no longer want to work allegorically, but instead want to express the world as it is, neither modern nor outdated. Although I love Picasso and Klee as passionately as before, I cannot use their means of expression."[23]

In 1940, the art dealer Paul Wengraf, who was living in London, wanted to exhibit Friedl's work and to bring her to London. In August of 1940, the London exhibition opened at the Arcade Gallery. Wengraf showed Friedl's still lifes, landscapes, paintings of flowers, as well as "The Resurrection of Lazarus" and a work from her series of illustrations for Flaubert's "Bouvard et Pécuchet." Friedl was not present.

Friedl found it easy to part with her paintings. Whenever she moved, she would leave incomplete works with acquaintances, neighbors and friends, never coming back to retrieve them. That which had been "done" did not satisfy her; for Friedl, a completed picture belonged to the past. She fought against the rigidity of the past and, unable to overcome it, would start another picture.

In the summer months of 1940 and 1941, Pavel and Friedl Brandeis rented a room not far from Hronov in the village of Žďarky. There, Friedl encouraged Pavel to learn some carpentry. At the beginning, he was not used to the work and cut himself. Another time, he fell

**View from Hronov. 1942. Postcard. Private collection**

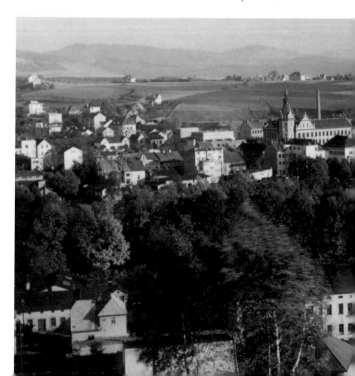

from some scaffolding. Still, he persisted.

Josef Knytl, who rented Friedl and Pavel a room, remembers that Friedl would go into the mountains with a portfolio and her little dog. "Then," says Knytl, "there was an order that Jews weren't allowed to have dogs." Knytl offered to keep the dog, but Friedl refused. "The next time they came," says Knytl, "they didn't have the dog. They were forced to give it up after all."

The anti-Jewish laws became more and more degrading. In February 1941, Friedl and Pavel were forced to move again and in September of 1942, they had to move into even smaller quarters. "Despite the discomforts," Pavel wrote to Hilde, "we still have courage and hope…"[24]

Jews were no longer allowed on the street without a yellow star sewn onto their clothes. They were no longer allowed to ride in the same tramcars as everyone else. Groceries were rationed for Jews, who could only buy them at specific times and with coupons.

During these times, Friedl and Pavel were "saved" by the courage and generosity of many of the local citizens. Zdenka Valašcová helped with the house cleaning, and Josef Vavrička, a shopkeeper, gave goods to Friedl without charge. Anna Sládková and her husband gave Friedl books to take home. Josef Dufek, the choirmaster at a nearby church, often came to visit and Friedl would give Dufek art lessons.

Once, she scolded him for painting closed window shutters. Friedl told him, "A window should look out onto the world."[25]

Hilde continued to answer Friedl's requests for reading materials. "I'm interested in everything," Friedl wrote. "We read voraciously, as we keep in mind that too little time remains before we are sent further on."[26]

Not long after, Friedl was diagnosed with avitaminosis of the retina. Hilde sent along the necessary medicines, but at times Friedl could neither read nor write.

In the spring of 1942, in Prague, Pavel's mother, Adéla Brandeis, prepared her eldest son Bedřich and his wife Josefa for deportation. Bedřich and Josefa passed quickly through Theresienstadt on their way to Izbica—where Josefa died. Bedřich died three months later in Majdanek. Adéla was transported to Theresienstadt—and then to Treblinka, where she was sent immediately to the gas chambers.

Otto Brandeis, Pavel's surviving brother, worked at the Synagogue of the Jewish Community Center in Prague. He smuggled letters, food and essentials into the concentration camps through the channels his work provided.

Friedl did not paint during her last months in Hronov. More and more people were being deported, and she could not bring herself to pick up a brush. Pavel was devastated by the news of what had happened to Bedřich and Josefa. The final blow was the news of his mother's death.

In the late autumn of 1942, Friedl received her own call to deportation. She was surprisingly calm and possessed of a certain gallows humor. Josef Vavrička, a shopkeeper, remembers Friedl entering his shop and saying, "'Hitler has invited me to a rendezvous. Do you have something

**Otto Brandeis draws up a list of expropriated pictures for the Jewish Community Center, Prague. Photograph, circa 1940-43. Private collection**

warm?' I gave her a gray coat, warm and sturdy. I told her she did not have to pay me for it, but she brought me a picture: 'The View of Franzensbad from the Window.' A painting like that for a coat! And she said: 'I painted this picture in an hour. It takes much longer to make a coat.'"

Hilde Kothny traveled to Hronov from Hamburg to support her friend. She recalled, "We packed and repacked without stopping. It looked like a rehearsal for a play that would never be staged. We wrote lists, sometimes me, sometimes Pavel: scarf – 1, aprons – 2, a spoon, a fork, a bandage, ethyl alcohol – 50 kilograms for each of them. Pavel also had to look good in the camp and at work. He had to have a suit and three white shirts. Friedl dyed the underwear and the bed linen a darker color so that it would be harder to see the dirt.

"Friedl decided right away that the sheets would be used in plays that they would stage with the children. For example, a sheet dyed green, thrown over the children, would represent a forest.

"Friedl was completely fixated on her work with children. Did she have enough paper and pencils? One had to consider so many details, we simply did not have time to be afraid.

"We said good-bye at the school which was the assembly point. I set off for the station and along the way I said to myself: 'I will never see her again.'…I was standing at the station, not knowing where I should go now…My state was like that of one under anesthesia. It is impossible to describe a farewell like that…

"And that is how I picture her to this day— standing at the school, on the first floor,

wearing a gray coat and looking at me. That is the way people look [at you] when they are trying to memorize…"

It was not a long way from the train station in Hradec Králové to the assembly point, but the luggage was heavy. The allowance was 50 kg per person, and people took whatever they could carry. Pavel tried to convince Friedl to stop and rest but she continued silently, a suitcase in her hand and a backpack on her shoulders.

The local police provided an escort to the march. On December 16, 1942, Pavel and Friedl wrote to Otto and Maria Brandeis: "So far everything has gone smoothly. We have already lost some of our baggage. The fate of the others is unknown. It affected us deeply. The food is wonderful. We are thinking of all of you. We also traveled in a decent railway car. Everyone is bearing up very well. Do not worry about us. Today we will hand over some of our extra money and belongings."

Immediately afterward, Friedl and Pavel's money, gold and valuables were taken from them. They ended their postcard that day with: "The last farewell! Pavel + Friedl"

On the same day, Friedl also wrote to Hilde. "My dearest! Contrary to all expectations, everything is fine. If it continues this way, it will be bearable. I am stronger than I thought…"[27]

On December 17, 1942, Transport Ch from Hradec Králové arrived in Theresienstadt with 650 people. Friedl Dicker-Brandeis was given the number 548, Pavel Brandeis, the number 549. Fifty-two people from this transport survived the war.

**Friedl and Pavel Brandeis. Letter to Otto and Maria Brandeis from Königgrätz (Hradec Králové). 1942. Private collection**

# THERESIENSTADT

## There are many forms of survival.

—EDITH KRAMER

THERESIENSTADT (Terezin) is a fortress from the 18th Century, 60 kilometers north-west of Prague. Nazi propaganda called it "a pleasant Jewish settlement," a "gift from the *Führer* to the Jews." In fact, it was an attempt to disguise "the final solution to the Jewish question."

Jews were ordered to govern themselves. Lodging, division of labor, food, health and even the preparation of the lists for the transports to the east—to the death camps—were the responsibility of the camp inmates themselves. The Nazis had a reason for this: the prisoners were to be dependent on each other, be on guard against each other and mistrust each other. In Nazi jargon, Theresienstadt was an *Übergangsghetto*— a transition ghetto.

In peacetime, about 6,000 people had lived in Theresienstadt. In 1942, they were moved out and resettled—in order to make room for 65,000 Jews. 140,000 Jews passed through Theresienstadt; 88,000 were sent to extermination camps. Most of these prisoners were sent to Auschwitz (Birkenau). 33,340 inmates died in Theresienstadt of hunger, disease and the catastrophic living conditions.

The prisoners came from Czechoslovakia, Germany, Austria, Holland and Denmark. Many of them were highly educated, well organized and experienced in Zionist work. Grouped according to their respective interests, the inhabitants led a cultural life that was made presentable for Nazi propaganda.

Among the deportees to Theresienstadt were artists, musicians, theater people, intellectuals, authors and scientists. Their talents were exploited in what the Nazis designated "the ideal city of the Jews." There were lectures, theater productions for adults and children, music performances, poetry readings and hand-written newspapers and magazines. There was also a community of artists— forced to paint idealized propaganda pictures. As Friedl later wrote to Hilde, "One could live well here, among educated, intellectual people, were it not for the fear of being sent further on."[28]

The Nazi Propaganda Minister Joseph Goebbels stated, "While the Jews in Theresienstadt sit in cafes drinking coffee, eating cake and dancing, our soldiers bear all the weight of a horrible war."

The arrival point for the new prisoners at Theresienstadt was called the "sluice." There, all of their money and most of their other property was taken from them. They were then assigned to work duty. Pavel Brandeis, who was now considered a skilled carpenter, was immediately sent to the workshops; Friedl was sent to the technical department with her artist colleagues. Friedl protested and after

Joseph Spier. Star of David— Emblem of the Ghetto. 1943. Ink and watercolors on paper. 22.8 cm x 15.6 cm. Beit Theresienstadt, Kibbutz Givat Chaim, Israel

*Right:* Arrival of a transport in Theresienstadt. Photograph, 1942. Jewish Museum, Prague

*Far right:* Kitty Brunnerová (12/26/1931–10/18/1944). Pencil on paper. Jewish Museum, Prague

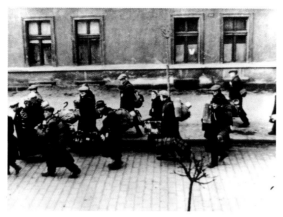

considerable effort was reassigned to L 410, the children's home for girls, on the town's main square. Even though there was not a single opening for a teacher, it was suggested that she would lead art groups for the children in all the different homes.

The children's homes had been organized in the summer of 1942. In home L 410, girls between the ages of ten and sixteen lived in the large three-story building. Each room had 24 places for sleeping, with triple bunk beds and a table. The teachers lived in the same building.

"In general, conditions in this home are satisfactory," Fritz Stecklmacher wrote in his confidential report on the girls' home L 410. "Mr. Freud takes his job very seriously. The teachers looking after the children are highly educated, although their knowledge of Judaism is poor. The teachers work around the clock; every third week they have night duty. Those with whom I discussed this explained it as love for the children, that is, pure idealism."

Walter Freud, an educator, was the director of home L 410 until the end of 1943. His post was taken over by the Zionist Willy Groag, a nephew of Jacques Groag, an architect who had been involved in construction with Atelier Singer-Dicker.

The oldest teacher was 44 year old Rosa Engländerová, with whom Friedl immediately became friends. Friedl's friend from Prague and Hronov, Laura Schimková, was one of the other teachers who spent their days and nights with the children.

In the ghetto, children older than fourteen had to work. Education was officially forbidden. Therefore, the regular appearances by the teachers, lecturers, painters and theater people went under the name "cultural leisure activity." Many survivors report that when they later returned to school they were as advanced in their education as their other classmates.

Unlike the "official" teachers, Friedl was not responsible for order in the rooms or the daily schedule. Though she was technically restricted to the painting lessons, she was able to connect with each child individually. Over all, her impact on the children was enormous.

Friedl was now surrounded by children every day, and they became the source of her strength. Her personal concerns receded; she wanted only to work with the children.

One of her students in Theresienstadt, Helga Kinsky, remembered, "Friedl would talk about how to begin a drawing, how to look at things, how to think spatially. How to dream

Pavel and Friedl Brandeis. Postcard to Otto Brandeis, Theresienstadt. 1943. Private collection

16.7.1943

Meine Lieben!

Ich kann Euch berichten, dass wir gesund sind und es uns gut geht. Beide arbeiten wir fleissig, Friedl in der Jugendfürsorge, ich als Zimmermann auf Bauten. Euere Pakete u. Grüsse sind tadellos angekommen

*Far left:* The first deportees in Theresienstadt. Photograph, 1942. Jewish Museum, Prague

*Left:* Ruth Klaubaufová (9/21/1931–10/19/1944). Pencil on paper. Nederlands Instituut voor Oorlogsdocumentatie, Amsterdam

about something, how to do something, how to realize our fantasies. We lived on the top floor of the children's home and we would draw from the window—the sky, mountains, nature."

Friedl created her teaching materials herself. Though Pavel's brother, Otto Brandeis, was able to send her packages of supplies from Prague, Friedl used everything around her: forms from the camp, technical drawings left behind in a former school building, piles of scrap paper. The reverse side of used drawing paper was worth its weight in gold. Still, there were too few brushes, pots of paint and paper to go around. Friedl organized the children and found other places for their diverse talents.

Friedl described how the children worked around these shortages. "One of them organizes a list and divides the children into groups, administers the materials and wants to be responsible for them; another wants to keep a painter's diary; others want to help with the painting or make sketches on paper. There is even someone who is ready to track down materials and bring them to us. None of these occupations should be forfeited…all have their turns."[29]

Friedl wrote, "The drawing classes are not meant to make artists out of all the children.

They are to free and broaden such sources of energy as creativity and independence, to awaken the imagination, to strengthen the children's powers of observation and appreciation of reality."

In addition to the classes, Friedl worked with the traumatized and the infirm. A group of children from Germany arrived whose fathers had been shot before their very eyes. They were in a state of severe shock. They sat on a cot, clinging to each other, their hands hidden between their knees.

At first, Friedl turned away so she would not break down in tears in front of them. The boys saw the tears in her eyes and also began to weep. After having a good cry, they followed Friedl to wash up. Sternly, she informed the children they needed clean hands to draw. To the great delight of the children, she brought them paints and paper and soon they were caught up in Friedl's lesson.

The cold, cramped conditions in Theresienstadt and the meager food supplies brought illness and disease to the "ideal city." Unafraid of becoming infected, Friedl worked in the children's isolation ward in the Hamburg barracks. She brought her paper, pencils and lessons to the sick children, changed their

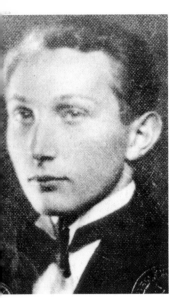

**Egon Redlich. Photograph, 1938.
Pamatnik Terezin, Theresienstadt**

sheets and wiped their brows.

In Theresienstadt, Friedl painted landscapes, flowers, people, street scenes, nudes, abstract compositions and made sketches for theater productions. She chose not to portray the actual world she was living in. There were no transports, no crowds, no soup lines, no dead bodies—no darkness in her paintings. In this regard, Friedl distinguished herself from all the other artists in the camp who saw it as their mission to document the hell where they were imprisoned. For those artists, painting was their attempt to survive. Friedl, however, had her children.

She never signed her works from the camp, but thousands of the children's drawings are signed and include the date and the number of the painting class. Friedl graded each work on a scale of one to six, according to the following categories: "Strength, Intensity, Dimensions, Form, Character, Composition, Color."[30] After each class, Friedl collected the children's drawings and brought them to her own room.

In July of 1943, Friedl organized an exhibition of children's drawings in the basement of children's home L 410. Egon Redlich, the director of child welfare in the camp, wrote of the exhibit: "The problems of Theresienstadt have found expression in the children's drawings."[31]

Friedl began to assess her experiences from her work with children. She hoped the war would end soon so that she could sort through everything her students had done and, on the basis of her experience, write her own study of, "Art as Therapy for Children." That summer, at a teachers' seminar in the camp, she delivered a lecture on "Children's Drawings."

Friedl spoke about the meaning and the purpose of artistic work by children, which she saw as the "greatest possible freedom for the child." She discussed her classes and the distinctive characteristics of children with regard to age and psychological development. She expressed her view on how adults should act toward children and their art.

"Why do adults want to make children be like themselves as quickly as possible?" Friedl asked. "Are we so happy and satisfied with ourselves? Childhood is not a preliminary, immature stage on the way to adulthood. By prescribing the path to children, we are leading them away from their own creative abilities and we prevent ourselves from understanding the nature of these abilities."

The summer exhibition had made such an impression on Egon Redlich that he allowed Pavel to move in with Friedl. Living together as a family was a privilege enjoyed only by members of the council of elders and "prominent figures"—prisoners who had served in the First World War or who had held important government positions in the past.

Friedl and Pavel were given their own "quarters" under the stairway, with a separate entrance from the yard. Using a blueprint drawn by Friedl, Pavel produced a second bed. In time, this storeroom with the slanting roof became a cozy dwelling. One of Friedl's students, Marta Mikulová, recalled, "When you came to her from the courtyard of L 410, you would bump into a day-bed, a shelf, a chair that resembled a bench, no two things matched. On the wall there was a small patchwork rug, very beautiful…"

The Brandeises also helped other prisoners to create at least a minimum of comfort in their accommodations. At Friedl's urging, Pavel made

Poster for the performance of
Jan Karafiát's "The Little Fireflies." 1943.
Pamatnik Terzin, Theresienstadt

Karel Svenk. Photograph by
Olga Hošková, circa 1940.
Private collection

Kamila Rosenbaumová.
Photograph, circa 1960.
Private collection

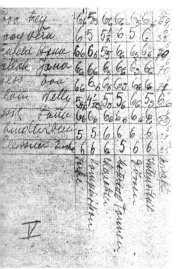

List of grades for the female students in 1943. Strength, Intensity, Dimensions, Forms, Character, Composition, Color

**Below:** Charlotte Schön, Friedl Dicker's stepmother. Photograph, 1904. Private collection

tables and benches during his non-working hours. He had been working as a carpenter and had access to building materials. He would build, and Friedl and the children would decorate.

In L 414, there were thirty girls, cramped and uncomfortable, in a very small room with three levels of bunk beds. Friedl and Pavel drew up a plan. They had the bed sheets dyed Bordeaux red, joined some of the bunks together and hung an individual motto or ornament over each girl's bed. In the end, thirty children had a more personalized and comfortable environment.

In 1943, Friedl received notice of the death of Charlotte Dicker, her stepmother. She had not even known that Charlotte was in the ghetto. Seeking to find her father, Friedl was told that he had died in the camp a long time ago.

In Theresienstadt, Friedl participated in a number of theatrical productions for children. Friedl designed the costumes and sets for one such play, "The Little Fireflies." In the fairy tale, the beetles and the fireflies flew over the spring meadow and, in the winter, they slept obediently. The message was clear: Everything has its proper time and life continues. The young actress Nava Shean had rehearsed the play with the girls from home L 410. It was performed 32 times, featuring the choreography of Kamila Rosenbaum and the music of Karel Svenk.

Another time, the theater piece "The Adventures of a Girl in the Promised Land" was acted out by the girls from room L 414.

The theater was transformed into a ray of hope for the children as they painted stage sets and put on costumes. The play also allowed the

adults to escape into their imaginations for a few moments and forget the dreariness of everyday life.

Any person who wanted to send a package to Theresienstadt had to apply for a certificate of permission. All prisoners were allotted one of these certificates every three months. Additionally, once a year each prisoner was allowed to receive a 25 kg package. "One had to send her so many things," Hilde Kothny remembers. "She didn't want a photograph; she wanted a sculpture. She was absolutely insatiable."

In May of 1944, Eva Brandeis, the daughter of Pavel's brother Otto and his wife Maria, arrived in Theresienstadt. Friedl thought of her as her own. She wrote to Maria, "We are happy. We are finally a small family. If things remain as they are, they will really gain something from their time here."[32]

In her first draft of that letter, Friedl confessed, "I am concentrating on painting with all imaginable intensity."[33]

In the summer of 1944, an inspection committee from the International Red Cross came to Theresienstadt, followed a month later by a film crew from Berlin, who made a propaganda film about the "beautiful life" of the Jews in the camp. During this time, the transports were suspended and the entire camp was cleaned and made to look as nice as possible.

Rumors of the war's end awakened the hope among inmates that they would be set free. Friedl painted with an unexpected strength. She created landscapes, portraits, abstract compositions, costume designs. Despite the modest format and the bad paper, they are among her greatest works.

**Postcard to Otto and Maria Brandeis. 1944. Private collection**

*Above:* Door to the room of Friedl and Pavel Brandeis in Girls' Home L 410. Photograph by Elena Makarova, 1996. Private collection

*Left:* View of the courtyard of Girls' Home L 410. 1943-44. Pastel on paper. 29.5 x 44 cm. Simon Wiesenthal Center, Los Angeles

One of Friedl's last compositions from that year is bright, sky-blue and multi-layered. It is dedicated to Paul Klee, her spiritual friend and teacher who long ago had opened the door for Friedl to the world of children.

On Friedl's birthday, July 30, her students gave her a gift of flowers. She held onto them by painting: the sprouting leaves with tempera, the flowers in a vase and in a bowl with water-colors; every work twice, from different perspectives and with a new palette. With a premonition of the unavoidable end, she savored the beauty of each leaf.

Friedl had been reunited in Theresienstadt with an old friend from her schooldays in Vienna. On her birthday, the composer Viktor Ullmann dedicated a musical composition to her as he had many years before. Ullmann wrote to Friedl, "Are we different than we were, dear Friedl, when I dedicated the same song to you? No, we two have remained 'old friends' to each other and will continue like this in the future."[34]

On September 22, 1944, Friedl wrote to Maria Brandeis, "Received birthday wishes in August. Thanks to Otto, can paint. You are unimaginably present to me. Hugs. Kisses."[35]

Pavel received a summons for the transport that was to embark on September 28. Five thousand men were being sent "to the construction site of a new camp." Friedl appealed to Egon Redlich to allow her to go with Pavel. She was refused. Pavel Brandeis boarded the train car that arrived on the rails

Otto Brandeis. Certificate of permission to send a package to Theresienstadt. 1944. Private collection

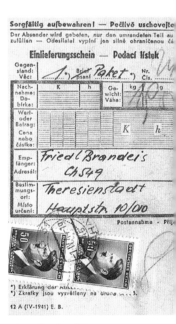

*Above:* Otto Brandeis. Notification of a package. 1944. Private collection

**Plan for children's room OXIV.**
**1943/44.**
**Pencil on paper. 22 x 28 cm.**
**Simon Wiesenthal Center, Los Angeles**

that he and the others had laid.

Friedl insisted she be on the list of volunteers for the next transport. Four years before, she had refused to leave Hronov without Pavel. Now, she refused to remain in Theresienstadt alone.

Her friends tried to persuade her not to rush after Pavel, but without her husband, she did not want to stay. She prepared by distributing her books and reproductions among her students. In empty suitcases, Friedl packed the children's drawings and, with the help of Willy Groag, the director of home L 410, carried them up to the attic hiding place.

*Above:* Wildflowers. 1944.
Tempera on cardboard. 32 x 17 cm.
Jewish Museum, Prague

*Above top::* Girls' Home L 410.
Photograph by Rita Ostrovskaya, 1998.
Private collection

*Above:* Karel Fleischmann
(2/22/1897–10/23/1944).
Street and park by Girls' Home L 414.
1943/44. Pencil on paper. 29 x 42 cm.
Private collection

## AUSCHWITZ...AND AFTER

### This endless, terrible, incomprehensible thing, which stands outside of good and evil...the uncertainty of the direction.

—FRIEDL DICKER-BRANDEIS, 1942

EARLY ON THE MORNING of October 6, 1944, the next transport left Theresienstadt. There were 1,550 people on board the train, most of them women and children. One of them was Friedl Dicker-Brandeis.

Marie Vitivcová and her sister Sonja, one of Friedl's best students, were on the same transport as Friedl. Maria described this day in a letter dated September of 1997:

"1550 people...were leaving to find their husbands and fathers in a new labor camp near Dresden—or so they were informed by the Nazis. In the transport were mothers and nursing infants. This was a good sign. They would not start killing infants! Before the

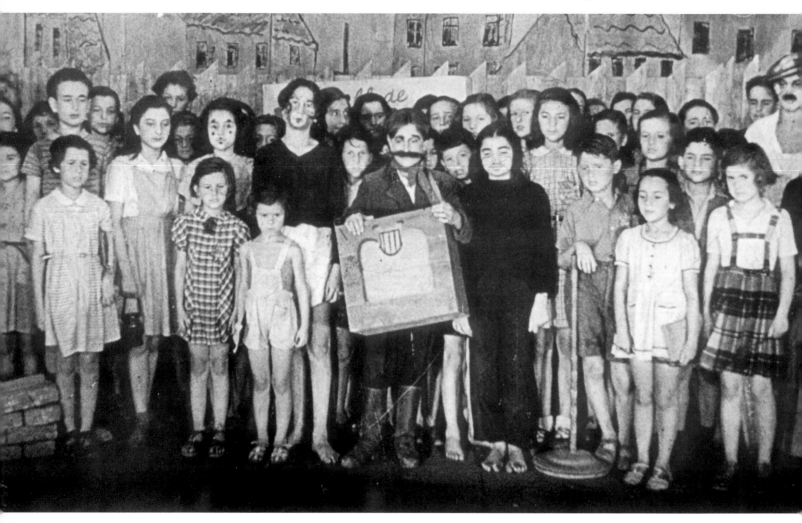

Final scene from "Brundibar." 1944. Still from a National Socialist propaganda film. Yad Vashem Archive, Jerusalem, Israel

I will never forget all that we have experienced here together: how we sang together in "Brundibar," the concerts...I will never forget anything that was wonderful here.

—MARIA MÜHLSTEIN IN ANNA FLACHOVÁ'S NOTEBOOK, OCTOBER 15, 1944

dispatch, on the platform, they removed the numbers. And this was also a good sign."

Thirty-six of Friedl's young students were on this train.

"Everybody was given a loaf of bread and something like sausage for the journey. We thought that we would arrive by evening. During the journey, everybody was talking about where we were going. Sometimes we would fall asleep for a short time and then we'd wake up in a sweat—we had put on as many clothes as we could in order to take with us as much as possible. …When the train would stop, we could fill up bottles and mugs with water. The real torture was making your way through all the bundles and suitcases to get to the toilet."

Friedl was on this train. Through the small hole in the roof of her cattle car were glimpses of black trees, black roofs on black houses, momentarily illuminated by flashes of fire. There was the terrifying sound of nearby bombing

Maria wrote, "Finally my sister Sonja and I fell asleep, and when we woke up the train was moving again—Poland. Where were we going?

Clearly not where the men were sent…

"It was Sunday, October 8th. The transport arrived in Auschwitz at noon, when the gas chambers had already processed their daily quota. We had to wait until morning.

"There were armed SS with dogs on the platform. We did not have a chance to draw a breath before prisoners in striped clothes trotted over, threw open the doors of the train and shouted: 'Leave your things here. They are numbered. You will get them later!'

"Not even ten minutes had passed before we were standing in front of a group of SS. One of them indicated to me and another girl with a nod of his head to go to the right. There was a road there fenced in with barbed wire. Mama and Sonja ended up going the other way…

"From the entire transport, Mengele [Dr. Josef Mengele] selected 190 girls aged 20 from the first and second cars of the train and no one from the following cars."

The next day, October 9, 1944, the remaining women and children from that transport were murdered at Birkenau. Among them was Friedl Dicker-Brandeis.

Our future, if you take it seriously, is after all nothing more than our genuine expansion. But what of God's mercy? Everyone, even the most unworthy, suddenly receives Ariadne's thread and becomes enlightened. Man, whose time is so short, cannot comprehend the simultaneousness of events, their lightning coincidence.

—FRIEDL DICKER-BRANDEIS, 1942

## EPILOGUE

# When people are dead and their testimony is mute, art remains.

—ARNOST LUSTIG

**P**AVEL BRANDEIS survived the camps. His skill as a carpenter and builder made him a valuable commodity to his Nazi captors. He owed his survival to Friedl's encouragement to learn the craft.

Pavel remarried and after his death in 1971, Friedl's works, including those from before the war, were left to his children, Jana, Peter and Libor. A portion of the Theresienstadt works became a part of the Simon Wiesenthal Center collection in Los Angeles.

## The best allies against 'ready-made production,' against cliched aesthetic conceptions, against becoming paralyzed in the stagnating adult world are artists and children.

—FRIEDL DICKER-BRANDEIS, 1943

At the end of August 1945, Willy Groag brought the suitcase full of children's drawings to the Jewish Community Center in Prague. At first, no one there was interested in his donation. "With time," says Willy, "they understood. "The first exhibition of children's drawings from Theresienstadt immediately became a sensation. The works of the children were called "diamonds in the crown of world culture."

Friedl Dicker-Brandeis survives today in the drawings of the children of Theresienstadt, in her own work, and in the influence she had on so many. Friedl's student, Edith Kramer, believes, "Friedl will speak to people for as

long as there is paper and pastel chalk. That is all any of us can hope for after we die: that what one has made, what one has been, remains alive with one's fellow man. One cannot ask for more."

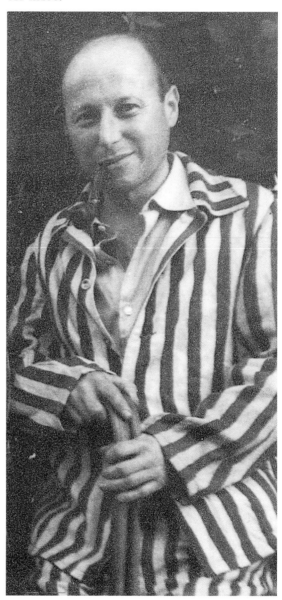

**Pavel Brandeis in Prague after the war. Private collection**

*Opposite:* **Flowers. 1944.**
**Tempera on cardboard.**
**34 x 21.5 cm.**
**Private collection**

**Draft of a letter by Friedl Dicker-Brandeis. 21 x 34 cm. Pencil on paper. Simon Wiesenthal Center, Los Angeles**

## FOOTNOTES

1. Friedl Dicker-Brandeis to Hilde Kothny, Hronov 1940
2. Quote from Zwiauer, Charlotte: Edith Kramer. Painter and Art Therapist between the Worlds. Vienna 1997, pg. 43
3. Itten, Johannes: Mein Vorkurs am Bauhaus. Gestaltungs- und Formlehre. Ravensburg 1963.
4. Gropius, Walter: Message to Young Architects. In "Dekorativnoje Iskusstvo" ("Decorative Art"), No. 3, Moscow 1986, pg. 35.
5. ibid
6. Friedl Dicker to Anny Wottitz Moller, Weimar, undated, circa 1920/21
7. Quotation from a conversation between the author and Florian Adler, Switzerland 1996
8. Friedl Dicker-Brandeis to Hilde Kothny, Hronov 1941
9. "*Kindertotenlieder*"—from the cycle by Friedrich Rückert, in which he laments the death of his two children
10. Friedl Dicker to Anny Wottitz Moller, Weimar, undated, circa 1921
11. Hildebrandt, Hans: "Die Frau als Künstlerin." Berlin 1928
12. ibid
13. Friedl Dicker to Anny Wottitz, Weimar 1922
14. Johannes Itten, April 28, 1931, Bauhaus-Archiv, Darmstadt
15. Letter from Walter Gropius, April 19, 1931, Bauhaus-Archiv, Darmstadt
16. The source of all information attributed to Edith Kramer originates in letters to the author and previous conversations with the author
17. Friedl Dicker-Brandeis to Anny Wottitz Moller, Hronov, March 2, 1938

18. Friedl Dicker had left Vienna several times before, probably working for the communist underground. According to the Vienna city archives, Friedl Dicker reported that she was leaving her apartment on Latschkergasse on June 24, 1933
19. Quote from Igor Golomshtok: "Totalitarian Art," Moscow 1994, pg. 104
20. Exhibition "Vystava 38 Nachód," June 19 – August 21, 1938
21. Friedl Dicker-Brandeis to Hilde Kothny, Hronov, January 19, 1940
22. ibid, Hronov, undated
23. ibid, Hronov, undated
24. Pavel Brandeis to Hilde Kothny, February 13, 1941
25. From the interview, 1989, Nachód, archive of Elena Makarova
26. Friedl Dicker-Brandeis to Hilde Kothny, Hronov, August 19, 1942
27. Postcard from Hradec Králové, December 16, 1942, archive of Hilde Kothny
28. Friedl Dicker-Brandeis to Hilde Kothny, undated
29. "Children's Drawings," Theresienstadt, 1943
30. Note, 1943-44, Archive of the Simon Wiesenthal Center
31. Diary of Egon Redlich, pg. 198
32. Postcard, archive of Elena Makarova
33. Draft from the archive of the Simon Wiesenthal Center
34. Archive of Elena Makarova
35. Postcard, archive of Elena Makarova

Some attributions have been purposely omitted out of respect for the privacy of our contributors who wished to remain anonymous.

# THE WORK

**Aesthetics are the ultimate authority, the moving force, the motor capable of creating production, while defending man from forces over which he has no control.**

—FRIEDL DICKER-BRANDEIS TO HILDE KOTHNY, HRONOV, DECEMBER 9, 1940

DURING HER LIFETIME, Friedl Dicker-Brandeis had only one exhibition of her paintings and drawings. It was held in 1940 in London—together with the American artist Gerald Davis—but she herself never saw this exhibition. Many of her creations—sculptures, carpets, costume and set designs—were published in journals and books. Her designs of textiles, lace, jewelry, books, beds, chairs and tables were often exhibited. That Friedl Dicker-Brandeis remained unknown despite her great talent was mostly her own choice: she was content with the recognition she received within her circles of friends and colleagues. What was important to her was not the finished product, but the process. She wrote in 1942, "I am just a worker."

More than half a century after her death, researchers from countries all over the world and from diverse disciplines began to express a new and far-reaching interest in Friedl Dicker-Brandeis. To one, she was a painter; to another, a designer of furniture and stage sets; to a third, a teacher in the concentration camp, Theresienstadt. Now one can finally begin to draw these threads together to present the diverse and complex art and creative thought of Friedl Dicker-Brandeis.

Friedl Dicker-Brandeis's artistic life can be divided into three main periods: from the Bauhaus to Prague (1919–1934), from Prague to Theresienstadt (1934–1942) and Theresienstadt (1942–1944).

The expressive language of the theater had a lasting influence on her artistic work as did her often-painful relationship with her lover Franz Singer. Friedl's early charcoal drawings were characterized by sharp, often exaggerated forms and dramatic faces. The relationship between dark and light—light being one of the most important elements of set design—lends a three dimensional quality to her compositions of color and form and awakens associations with multi-layered stage sets. Her textiles remind one of pieces of scenery, opulent theater curtains and interiors as well as stage props.

One could call her first period "formative." Friedl Dicker-Brandeis created images on canvas, worked often with scissors and glue, drew plans for houses and sketched intensely—with charcoal, colored pencils and gouache. She worked spontaneously and quickly. The strength of her drawings lies in omission, in lightness: she had masterful control of the form. Instead of bringing individual elements together, she created according to her imagination. The material itself does the work, but without pressure. It does not make itself independent; it does not play the coquette. It merely serves. These works, which at first seemed so open, concealed secrets: something was happening "behind the scenes," which one could only guess at.

Friedl Dicker-Brandeis's painting also had constructivist traits: she seldom mixes colors, and her greatest talent, that of becoming

Untitled. 1918. Pastel, ink, and
charcoal on paper. 30 x 40 cm.
University for Applied Art, Vienna

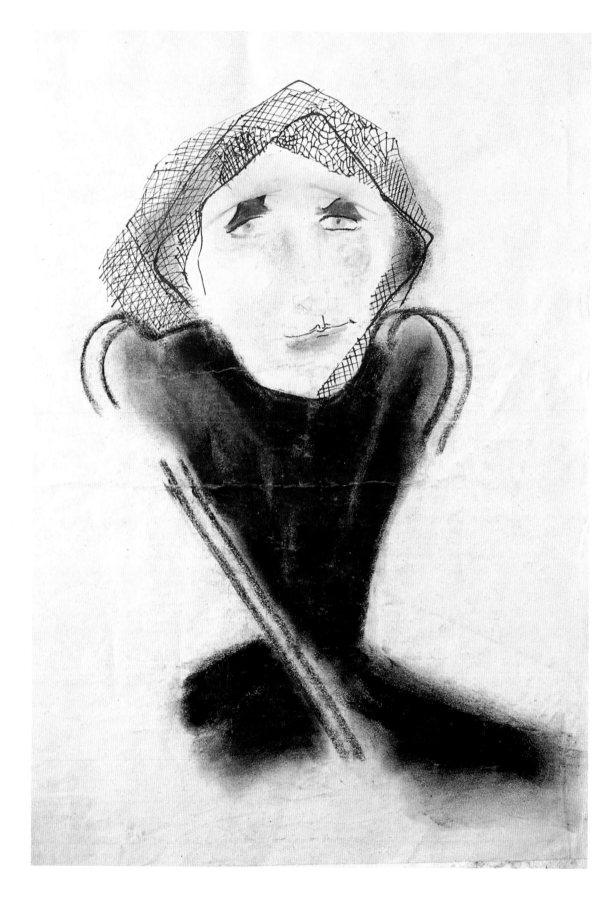

# I know that you are talented, but what you will do with this talent—that is what is important!

—FRIEDL DICKER-BRANDEIS TO EDITH KRAMER

absorbed in the image, is most obvious in her charcoal drawings and lithographs, which show a great feeling for color.

Her second creative period is characterized by a decisive shift toward painting. "The Interrogation" is the transitional work, in which she underscores the paint aspect of the picture with graphic elements: typewriter letters on wood, a unique mixture of relief and oil on wood.

During this period, the artist painted landscapes, still lifes, portraits and figurative allegories. In all of her works, even in the landscapes with their impression of openness, there is a focal point. The eye is drawn into the three-dimensional depth of the picture and held by a central image: an intense sky, a wall, a hill, a tree. Again one has the impression that the picture is a stage, with scenery and a back wall. This depth develops from a precise, balanced and rhythmic composition which is like music or mathematics. Friedl Dicker-Brandeis puts her trust in contrasts. In one work she becomes immersed in black depths; in another she confronts the observer with pale white walls.

Dicker does not want to chronicle history; she does not describe events as they are. She uses the allegorical form to tell her stories ("The Interrogation, "Fuchs Studies Spanish," "Don Quixote and Lenin"). Her agitprop posters are completely different. This genre must be immediately accessible. Interestingly, she chooses to use photo collage to create the posters instead of painting.

Friedl Dicker-Brandeis's works from

the concentration camp cannot be classified in terms of a single style. Formally they are different from her earlier works in their style and technique: not just by choice, but because paper and paints were in short supply in the camp. Many works were never completed; many drawings were probably meant as sketches for later pictures that she was never able to paint. Many works were simply variations of the same composition.

Her themes were no different than before: landscapes, flowers, people, street scenes, nudes, abstract compositions, sketches for theater productions. What she left out of her work was the actual world where she lived, the concentration camp. There are no transports, no crowds, no soup lines, no dead bodies— no darkness.

Friedl Dicker-Brandeis gave practically all of her time and energy to the children of Theresienstadt. It was only in the summer of 1944, when the transports were temporarily suspended, that she was able to completely dedicate herself to painting for a very short and intensive time.

Why is talent granted to someone? What is its purpose? Friedl Dicker-Brandeis would constantly ask these questions of herself and her students. As a farewell, she left a bright, luxuriant sea of flowers, painted on concentration camp cardboard, as though she wanted to remind herself and others that life force is eternal.

**Friedl Dicker. Stills from an amateur film by Anny Wottitz (married name Moller). Circa 1930. Private collection**

# VIENNA/BLUEBEARD PUPPET PLAY

This brief prologue to the puppet play "Bluebeard" gathered together the strands of life which Friedl questioned always: who was the master of life, where did she fit in the circle of life and who would overcome in the struggle between good and evil.

## PRELUDE

**FOOL:** Who is that pulling the wires?

**CHORUS OF OLD MEN:** We are pulling the wires—after all, we were young before you were.

**CHORUS OF KINGS:** No, it is we who are pulling the wires. We control you. And you, young and old, dance at our bidding.

**CHORUS OF GODS:** You impertinent and helpless people. Your domination is merely a vainglorious mask.

**THE SUPREME GOD** (in a deep voice): It is I who direct everyone—you are merely my creatures.

**YOUNG PUPPETEERS** (in deafening chorus): It is we who control you. We pull the wires.

**FIRST ASCETIC** (absolutely motionless): I have found myself. I have been transformed into the round wheel in Everything. The Wheel has carried me away, and I am no longer dead. I am incarnate. I have been set turning. I am the tiniest part of the Absolute, and it whirls and turns me. I want nothing. Everything that is—I am! And I sorely serve myself.

**FOOL** (running about the stage and laughing): Master? What kind of a master are you? You do not even have any servants!

**SECOND ASCETIC:** My realm is not of this world. I am ephemeral…I do not send down thunder and lightning. My thought is buried in stone. Hand, shadow and air are my servants, my spirits. I am unmovable. I move nothing. I dream. My hand neither shrinks from my soul, nor reaches for it—my hand dreams only of being able to do everything, create everything. I am the greatest force in Nature. I am that

which has not come to pass.

**FOOL** (speaking in a high-pitched, sing-song voice): His soul is dark blue. It scatters iridescent bubbles. It wriggles like a worm and at its core is a luminous point.

**FIRST ASCETIC:** I want Life.

**THIRD ASCETIC:** I dream of Life.

(All are plunged into darkness.)

**A LOUD VOICE SPEAKS:** Who pulls the wires?

(The ascetics have disappeared. In their place there is a tree, seashore and a flower.)

**FOOL:** All that has been presented here, to my taste, is very motley. It would be better if I told you some story. But can you link sense and senselessness? Is there sense in this or is there not? Yes, there is sense in this—and it is senseless.

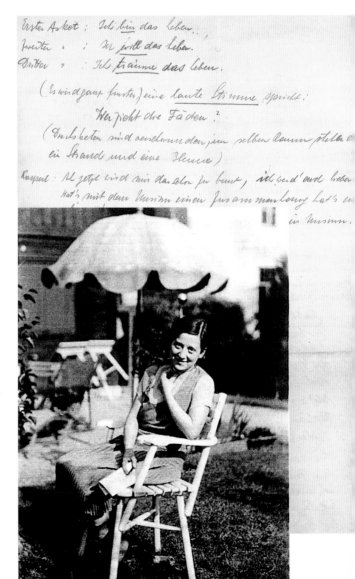

**Friedl Dicker.
Photograph, circa 1922-24.
Private collection**

Blaubartpuppenspiel.                                    53.

Vorspel.

Narr:
Chor der Alten:
" " Könige:
" " Götter:
Großer Gott (tief):
Ein riesiger überstimmender Chor der Jungen:
Erster Asket (ganz starr): Ich fand mich selbst und bin ein kreisend Rad im All geworden

Kasperl (läuft über die Bühne und lacht):
Zweiter Asket (lebhafter): Ich fand die Welt und bin ihre Kraft geworden, die alles treibt. Ich bin das Leben. Ich bin bewegt und ich bewege.

Kasperl = Narr
Dritter Asket.

Kasperl (ganz lod zu sprechen):

*Left and opposite:* Prelude for the "Bluebeard Puppet Play." 1916. Private collection

Dark-light study. 1919.
India ink and paint on paper.
26 x 18 cm.
Bauhaus-Archiv, Berlin

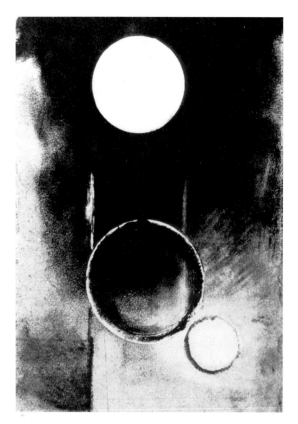

*"Dearest Anny,*

*"I have just made a woodcut and am so happy. Not everything is finished yet, but my joy knows no bounds… The rare pleasure–the quiet work days completely enthrall me and inspire me…and for a time one can stop looking into the distant and dark future, which becomes darker the more one insists on the light…*

*For an egoist, it is better not to cause more sorrow—he does not wish"sorrow" for himself. A dangerous temptation: the magic of narcissism lies in the striving to make others happy, to help everyone. If I am cured of this some day, I will rid myself of desires and will obtain complete happiness and peace. In the 23 years that I have lived, those feelings would be the most unexpected and unusual.*

**FRIEDL DICKER TO ANNY WOTTITZ MOLLER, WEIMAR, UNDATED, CIRCA 1920/1921**

Book binding, Die kleine Stadt
(The Small City) by Charles
Louis Philippe. Circa 1920.
Textile appliqué. 28 x 35 cm.
Private collection

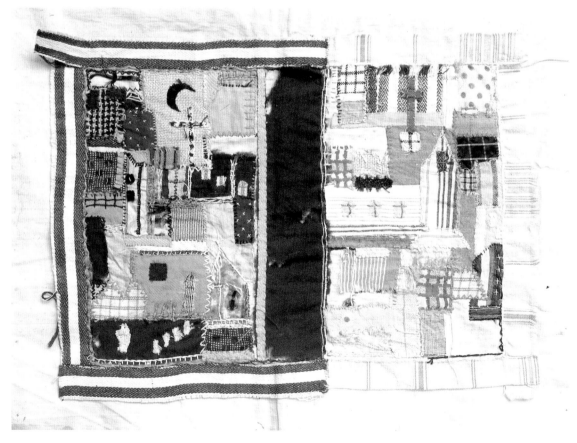

# WEIMAR/BAUHAUS

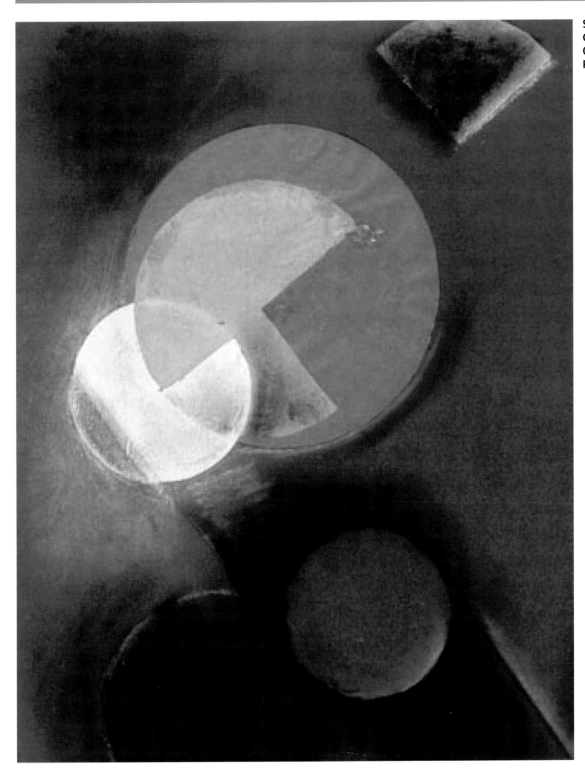

Studies of form and tone. 1919-23.
Chalk on black paper. 32 x 22.5 cm.
Getty Research Institute,
Research Library, Los Angeles

Untitled. Circa 1919-23.
Ink and watercolors on paper.
39.2 x 13.6 cm.
Getty Research Institute,
Research Library, Los Angeles

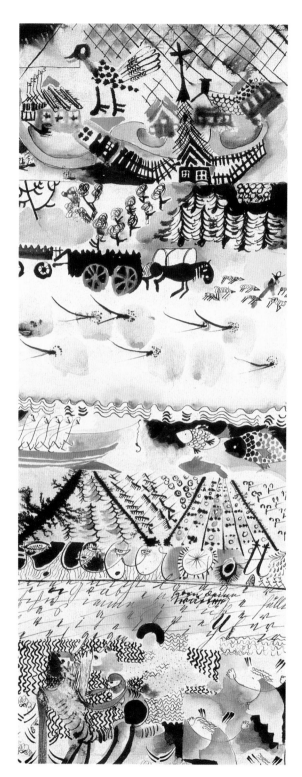

*Above:* Friedl Dicker.
Page from "Utopia." 1921.
Lithograph. 32.4 cm x 24 cm.
Private collection

*Opposite:* Friedl Dicker/Johannes Itten.
Draft for Johannes Itten's Almanac
"Utopia." 1921.
Lithograph. 32.4 cm x 24 cm.
Bauhaus-Archiv, Berlin

Ich habe nun versucht, an fünf Meisterwerken die Bewegungs- also Formcharaktere sowohl graphisch, wie durch die SCHRIFT- und WORTFORM zu zeigen.

Leider war es nicht möglich, die Bewegung der FARBEN wiederzugeben, dieses feine, geistvollste Darstellungsmittel des bildenden Künstlers.

UMSETZEN IN

Der geduldige Leser, der mir bisher gefolgt ist, muss nun, um von den nachfolgenden ANALYSEN einigen Gewinn zu haben, diese NACHZEICHNEND, NACHSCHREIBEND, NACHSPRECHEND DURCHARBEITEN.

Er muß die FORM BEWEGUNG

MAN ZEICHNE OHNE DIE BEWEGUNG zu UNTERBRECHEN, ich möchte sagen, IN EINEM ATEMZUG EIN GANZES BILD NACH.

VERSUCHE, IN ALLEN DREI GRADEN DER BEWEGTHEIT DAS BILD ZU ERLEBEN.

Zeichne DAS Bild auswendig

Er ZEICHNE, SCHREIBE, SPRECHE keine Form, die nicht aus lebendiger herzkräftiger Bewegung fließt.

Vollkomme

HinGABe ist notwendig.

Lasse dich nicht entmutigen, wenn deine NACHZEICHNUNG dem ORIGINAL NICHT GANZ entspricht.

DAS Bild Je vollkommener IN DIR lebendig wird, umso vollkommener WIRD AUCH DEINE Wiedergabe, die ein EXAKTES Mass FÜR DIE Kraft deines Erlebens ist.

Du erlebst

Kunstwerk DAS

es wird in Dir wiedergeboren.

*Right:* Untitled. 1919-23. Paper and foil on cellophane. 31 x 22 cm. University of Applied Art, Vienna

*Far right:* Friedl Dicker/Anny Wottitz (married name Moller). Design for a book binding. *"Chorus Mysticus: Alchemistische Transmutationsgeschichten"* (Chorus Mysticus: Stories of Alchemical Transformation) from Christoph Schmieder's *Geschichte der Alchemie* (History of Alchemy), 1823. Published by Hans Kayser. Insel Verlag, Leipzig 1923. Leather, linen, wood. 23.4 x 16 cm. Bauhaus-Archiv, Berlin

Book binding. Circa 1920. Leather. 23 x 20 cm. Private collection

*Dear Anny,*

*Tomorrow there is a big masked ball at the Bauhaus. All of Weimar is penniless…We certainly will not get rich, and that is fine; we do not need that, and we do not even think about that.*

*When our patience breaks, we often ascribe it to lack of money. In reality, the cause is inside us. Anxiety is extinguished by work—it is a sort of flight from inner turmoil.*

*I often have the feeling (and have it right now in fact) that I am a swimmer who is being carried away by a horrible flood. I realize that I know how to swim, and, for a moment, I raise my head above water. I try to grab hold of a branch, to catch hold of a rock in some sort of backwater, and I manage to cry out to the other swimmers…Once I would have drowned like a wild, foolish animal, and my voice simply would not reach those on the other shore. It is good that I am not making any plans, not for even a minute in advance.*

*The main thing is to calm the anxiety—and then everything is fine.*

*It is dark now. The window frames are light, and it is dark outside. Not long ago everything was the reverse. My dear Anny, I am seized by the enormous fear of loneliness, utter loneliness. It is a useful, instructive time…May God see me through this period…*

*That is all, my dear. I've finished crying…*

FRIEDL DICKER TO ANNY WOTTITZ MOLLER, WEIMAR, UNDATED, CIRCA 1921

*Opposite:* Title page for the first Bauhaus evening: reading by Else Lasker-Schüler. 1920. Lithograph. 32 x 25 cm. Private collection

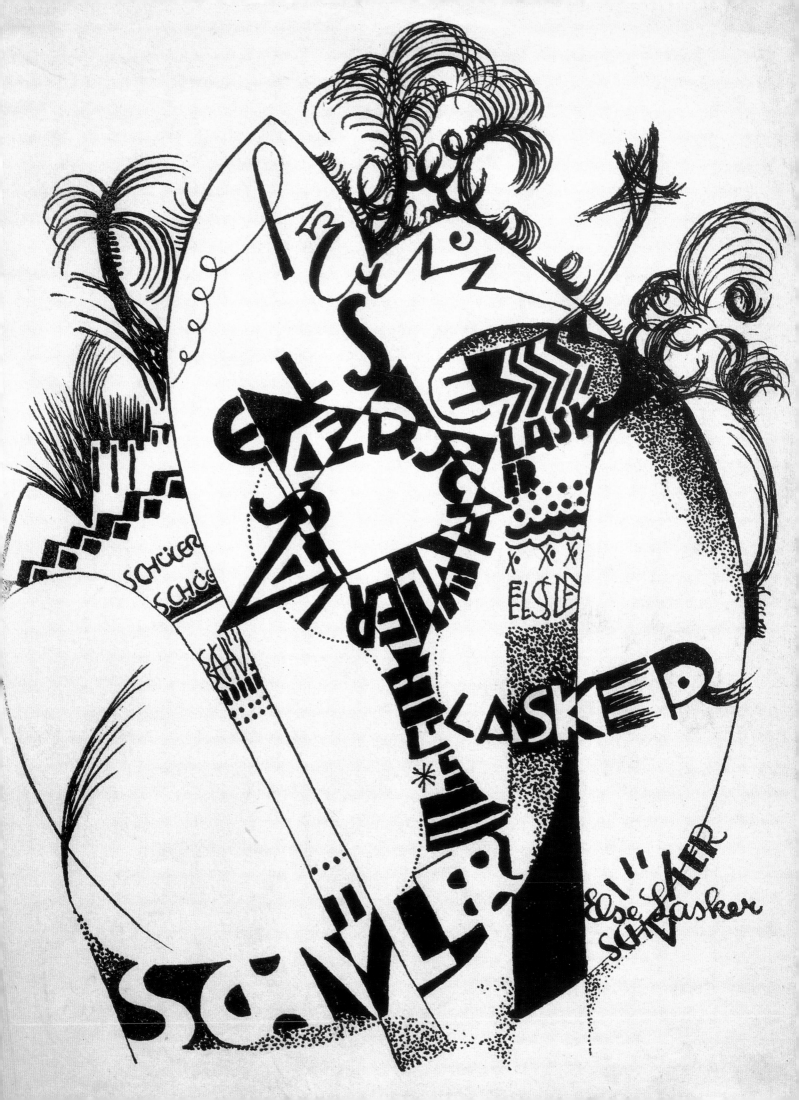

Study for "Anna Selbdritt." 1921.
Gouache, pencil and foil on paper.
149 x 34 cm.
University of Applied Art, Vienna

*The sculptural composition "St. Anne," the work of Friedl Dicker, is in a completely different vein. Friedl Dicker belongs to the more multifaceted and original women talents of today. Thanks to the very contemporary coloring and construction, the work appears to be an architectural detail. The combination of materials, such as nickel, black steel, bronze, glass, white and red lacquer, is so unexpected, as are the shapes of the human bodies themselves, which are constructed from pipes, spheres and cones. The spontaneity of feminine nature, having suddenly become radical, is liberated from everything that restrains its energy and boldly comes forward in this work, which is more than simply an interesting experiment.*

FROM: HANS HILDEBRANDT:
"DIE FRAU ALS KÜNSTLERIN"
(THE WOMAN AS ARTIST). BERLIN 1928

*Opposite:* Anna Selbdritt. 1921.
Sculpture (not preserved).
Bauhaus-Archiv, Berlin

*Opposite far right:* Anna Selbdritt. 1921.
Oil on wood. 49.3 x 23.5 cm.
Private collection

Witch Scene. Circa 1920.
Lithograph. 54 x 37 cm.
Private collection

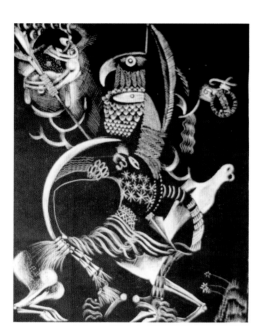

Three Ducks. 1921.
Lithograph. 28 x 37 cm.
Private collection

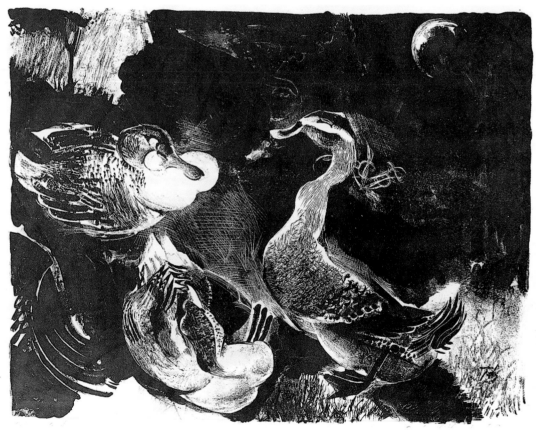

"Saint Peter." Circa 1919-23.
Water colors on paper.
30 x 34 cm.
Private collection

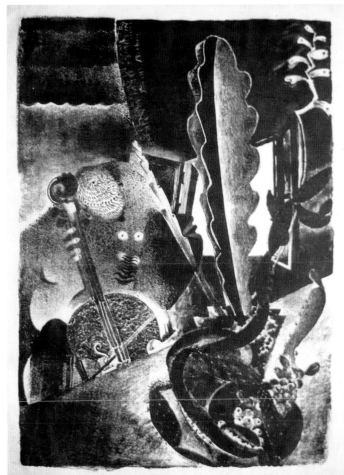

Cello and Cactus. 1921.
Lithograph. 37 x 26.5 cm.
Private collection

Study of a model. Circa 1919-23.
Charcoal on grease-proof paper.
39 x 38 cm.
University of Applied Art, Vienna

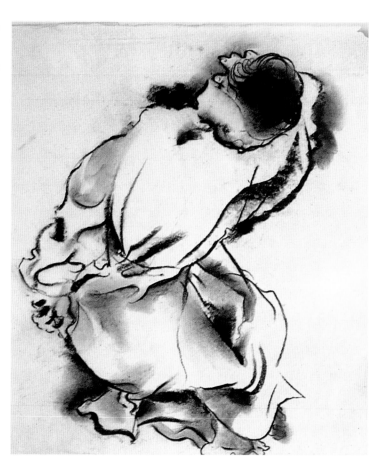

Study of a model. Circa 1919-23.
Charcoal on grease-proof paper.
50 x 34 cm.
Private collection

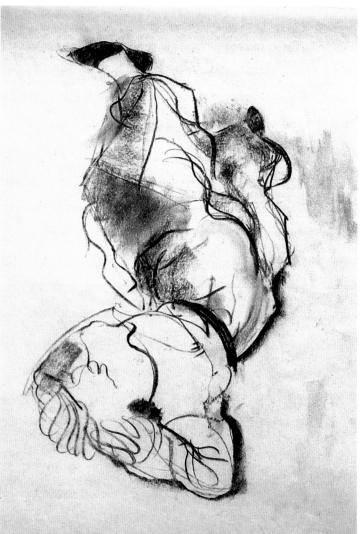

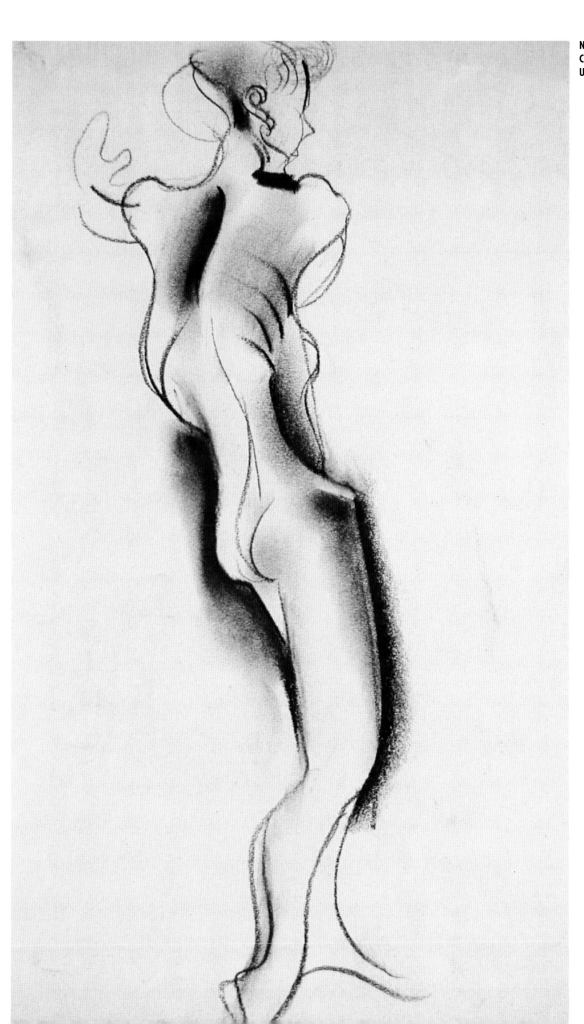

Nude. Circa 1919-23.
Charcoal on paper. 39 x 29 cm.
University of Applied Art, Vienna

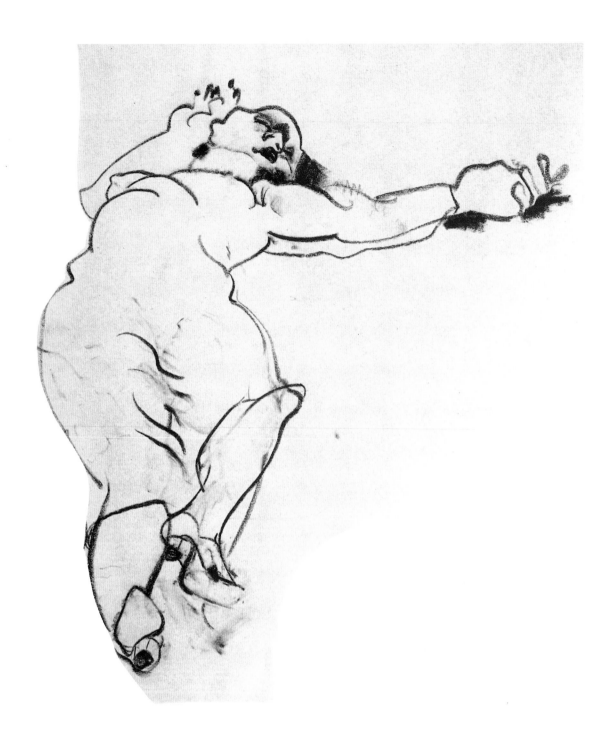

Study of a model. Circa 1919-23.
Charcoal on grease-proof paper.
50 x 42 cm.
University of Applied Art, Vienna

Study of a model. Circa 1919-23.
Charcoal on paper. 60 x 46 cm.
Private collection

*Until 1940 my mother [Anny Wottitz Moller] and I lived in London. She had bought works by Friedl Dicker from different periods: drawings, sketches, paintings. My parents were divorced. My father [Hans Moller] became a Zionist, and in 1938 he emigrated to Palestine with his second wife, Zipora. This was how some of Friedl's works reached Palestine.*

**JUDITH ADLER, NÉE MOLLER, IN CONVERSATION WITH E.M, SWITZERLAND, 1996**

*My mother [Margit Tery-Adler] lived in Germany for the entire war, and she lost most of what she owned to the bombing raids... Once Friedl was hiding from the police at our house in Vienna, and perhaps she left some of her works behind which we took when we emigrated from Vienna. We took everything from Vienna with us to London, then part of it went to Israel and finally wound up here in Switzerland.*

*I do not think Friedl would have ever shown the studies we have in our collection. They were exercises, studies, work with form. Perhaps she did them as preparation for works she never painted.*

**FLORIAN ADLER IN CONVERSATION WITH E.M, SWITZERLAND, 1996**

**Judith and Florian Adler.
Photograph by Rita
Ostrovskaya, 1998.
Private collection**

**Untitled. Circa 1923. Gouache,
colored ink and watercolors on
paper. 35 x 36 cm.
University of Applied Art, Vienna**

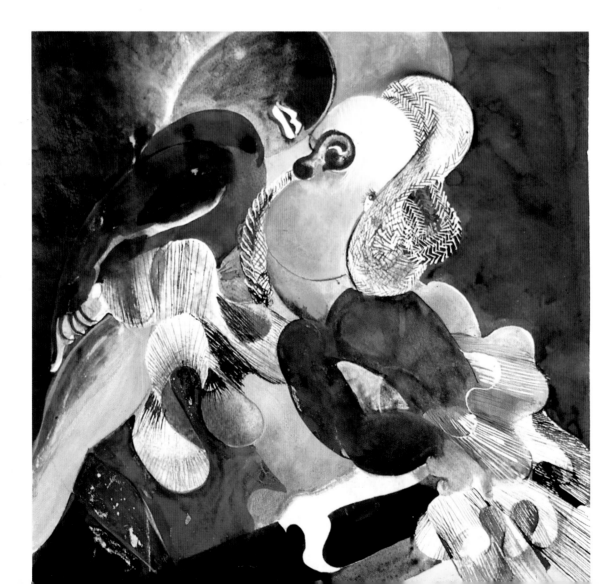

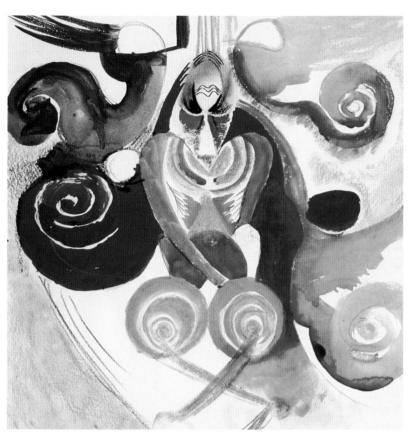

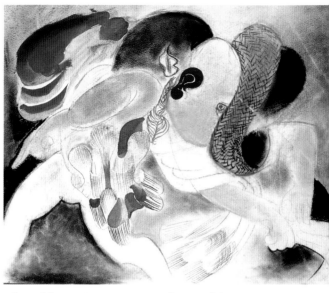

*Left:* Untitled. Circa 1923.
Gouache on paper. 39 x 35 cm.
University of Applied Art, Vienna

*Above:* Untitled. Circa 1923.
Gouache, India ink, and ink
on paper. 30 x 39 cm.
University of Applied Art, Vienna

*Below:* Untitled. Circa 1923.
Watercolors, gouache, and pencil
on paper. 35 x 48 cm.
University of Applied Art, Vienna

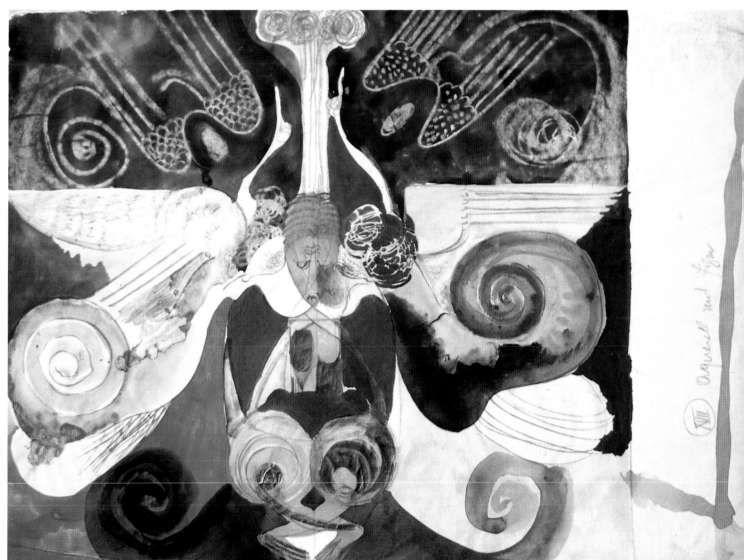

Untitled. Circa 1919-23.
Charcoal on paper. 34 x 42 cm.
Private collection

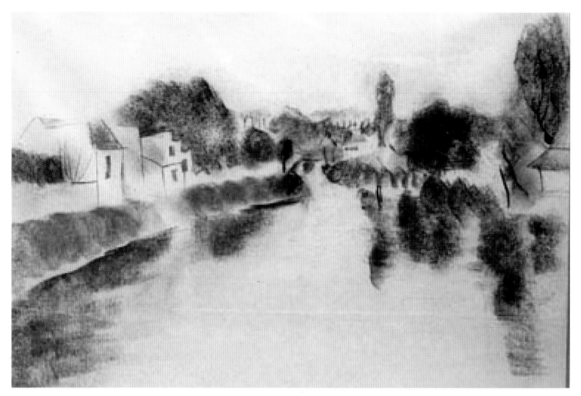

Untitled. Circa 1919-23.
Charcoal and pencil on paper.
48 x 39 cm.
University of Applied Art, Vienna

Untitled. Circa 1919-23.
Charcoal on paper. 19.8 x 21.3 cm.
Getty Research Institute,
Research Library, Los Angeles

Study of a model. 1919-23.
Charcoal on paper. 42 x 52 cm.
University of Applied Art,
Vienna

Study of a model. Circa 1919-23.
Charcoal on paper. 45 x 65 cm.
Private collection

*Opposite:* Study of a model.
Circa 1919-23.
Charcoal on paper. 60 x 43 cm.
Private collection

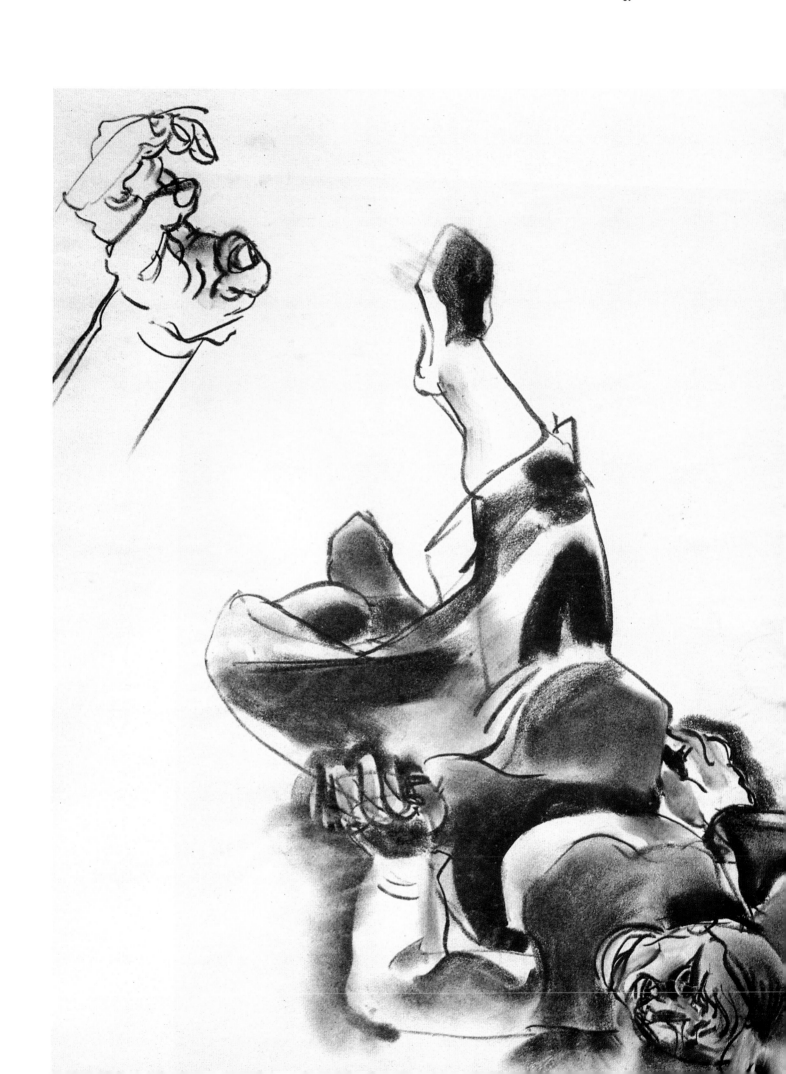

Portrait (Lea Swarowsky).
Circa 1920. Charcoal on paper.
50 x 37 cm.
Private collection

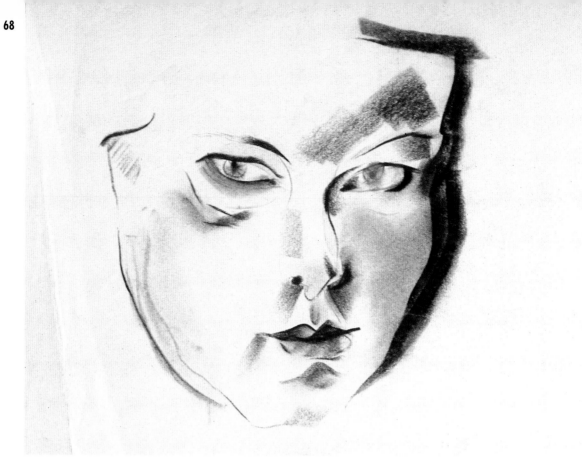

Portrait (Lea Swarowsky).
Circa 1920. Charcoal on paper.
50 x 37.5 cm.
University of Applied Art, Vienna

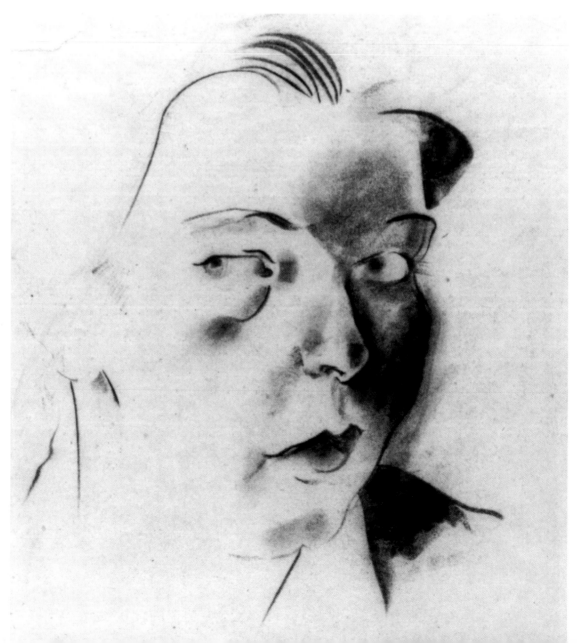

Nude (Lea Swarowsky). Circa 1920.
Charcoal on paper. 52 x 42 cm.
Private collection

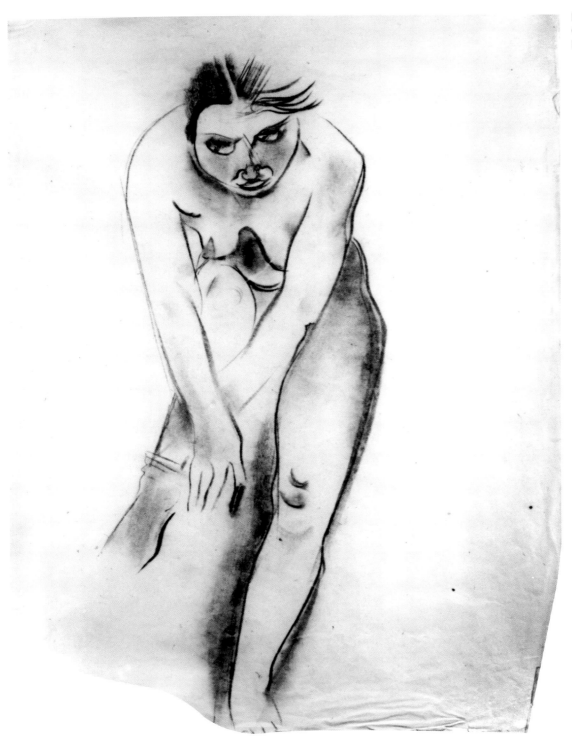

Sketch of a costume for William Shakespeare's "The Merchant of Venice," Berthold Viertel's theater "Die Truppe" (The Troop). 1923. Pastel on black paper. 50 x 60 cm. Private collection

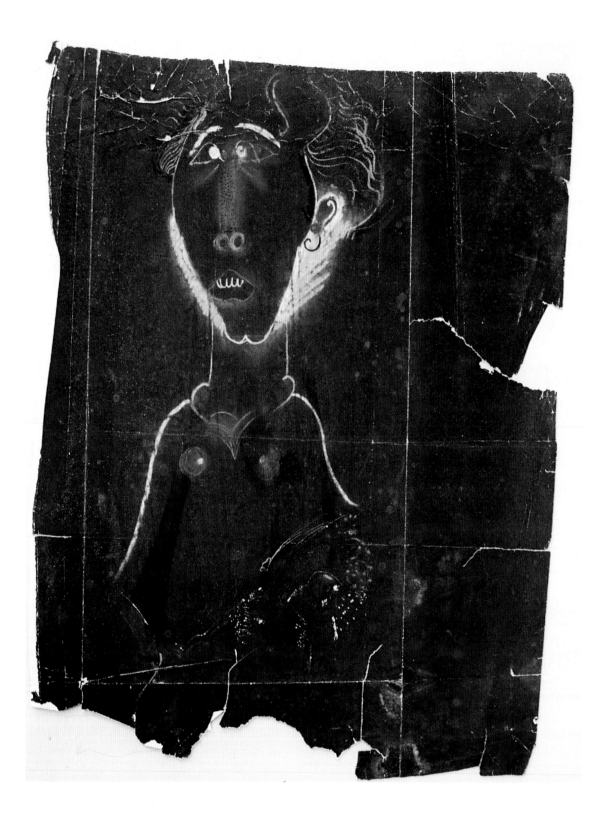

# WEIMAR–BERLIN/Theater

Friedl Dicker/Franz Singer. Sketch of a costume for William Shakespeare's "The Merchant of Venice," Berthold Viertel's theater "Die Truppe" (The Troop). 1923. Watercolors, tempera, pencil, ink, and collage on paper. 60 x 44 cm. Private collection

*I have photographed only the pictures and drawings. I worked on all the productions [referring to "The Merchant of Venice"] in cooperation with Franz Singer, and therefore do not want to reproduce them under just my name—at most a few costume sketches, which, however, are only meaningful in context.*

**FRIEDL DICKER TO AN UNKNOWN PERSON, PROBABLY THE EDITOR OF HANS HILDEBRANDT'S "DIE FRAU ALS KÜNSTLERIN" (THE WOMAN AS ARTIST). VIENNA, AUGUST 4, 1927.**

*Solanio u. Salerno*
W. Shakespeare: Der Kaufmann von Venedig

*Lorenzo*
W. Shakespeare: Der Kaufmann von Venedig

Friedl Dicker/Franz Singer. Sketches of costumes
for William Shakespeare's "The Merchant of Venice,"
Berthold Viertel's theater "Die Truppe"
(The Troop). 1923.
Watercolors, tempera, pencil, ink, and collage on paper.
Each approximately 60 x 44 cm.
Private collection

Porzia
W. Shakespeare: Der Kaufmann von Venedig

Jessica.
W. Shakespeare: Der Kaufmann von Venedig

*Right:* Sketch of a costume. 1923.
India ink on paper. 40.5 x 25 cm.
Private collection

*Far right:* Friedl Dicker/Franz Singer.
Sketch of a costume for William
Shakespeare's "The Merchant of
Venice," Berthold Viertel's theater
"Die Truppe" (The Troop). 1923.
India ink on paper. 40 x 25 cm.
Private collection

Sketch of a costume for William
Shakespeare's "The Merchant of
Venice," Berthold Viertel's theater
"Die Truppe" (The Troop). 1923.
Charcoal and pencil on cardboard.
43 x 32 cm.
University of Applied Art, Vienna

Friedl Dicker/Franz Singer. Pictures of scenes
for August Stramm's "Die Heidebraut"
(The Heathen Bride). Berthold Viertel's
theater "Die Truppe" (The Troop). 1921.
Watercolors, tempera and ink on paper.
Private collection

*Right and opposite top:*
Friedl Dicker/Franz Singer.
Sketches of scenes for
August Stramm's "Erweckung"
(Awakening), Berthold Viertel's
theater "Die Truppe"
(The Troop). 1921.
Gouache on paper.
Private collection

Friedl Dicker/Franz Singer. Sketch
of a scene for Henrik Ibsen's
"John Gabriel Borkman,"
Berthold Viertel's theater
"Die Truppe" (The Troop). 1923.
Watercolors and gouache
on paper. 52.5 x 66.5 cm.
Private collection

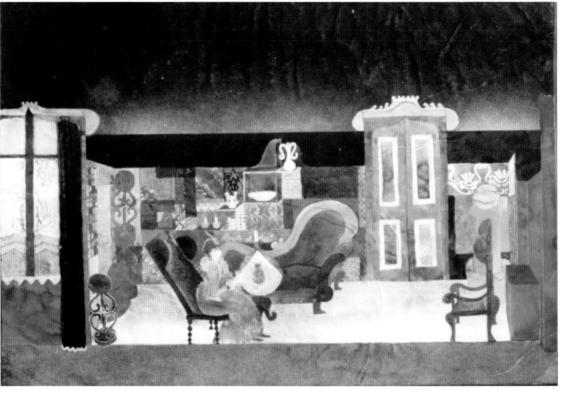

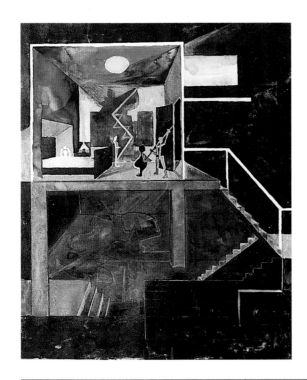

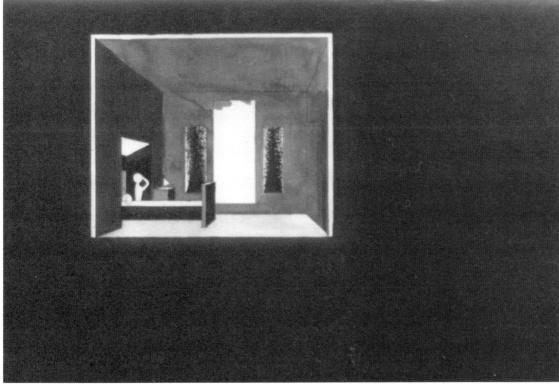

Friedl Dicker/Franz Singer. Sketches
of scenes for August Stramm's
"Erweckung" (Awakening),
Berthold Viertel's theater
"Die Truppe" (The Troop). 1921.
Gouache on paper.
Private collection

Performance of Bertolt Brecht's
play "Karriere" (Career).
Photographs, 1934.
Private collection

Friedl Dicker/Franz Singer. Sketches
of scenes for Henrik Ibsen's
"John Gabriel Borkman,"
Berthold Viertel's theater
"Die Truppe" (The Troop). 1923.
Pencil, charcoal, gouache and
India ink on paper. 30 x 40 cm.
Private collection

# BERLIN

Samples of covering fabrics.
1924/25. Textiles.
Private collection

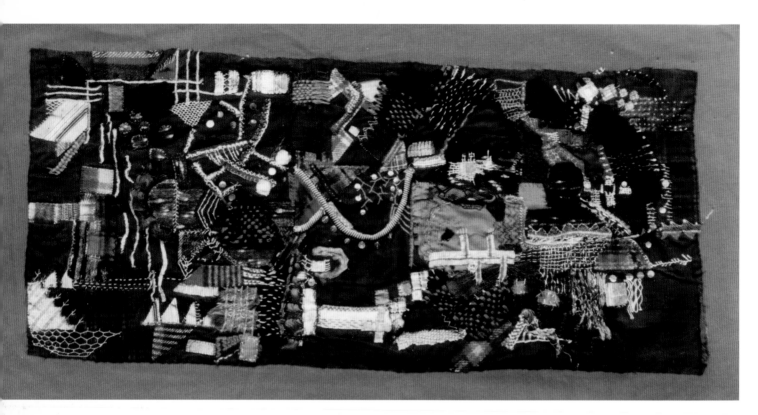

*Above:* Wall hanging.
1924/25. Embroidery. 28 x
64.5 cm. Private collection

*Right:* Showroom for the
"Workshops of Fine Art."
Photograph, 1924/25.
Bauhaus-Archiv, Berlin

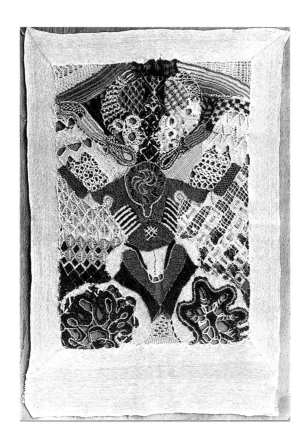

Weaving sample. 1924/25.
Lace (not preserved).
Bauhaus-Archiv, Berlin

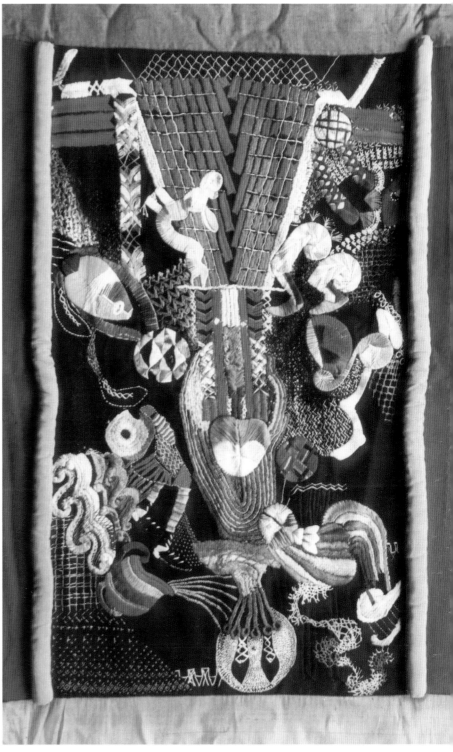

Wall hanging. 1924/25.
Embroidery. 34.5 x 27.2 cm.
Private collection

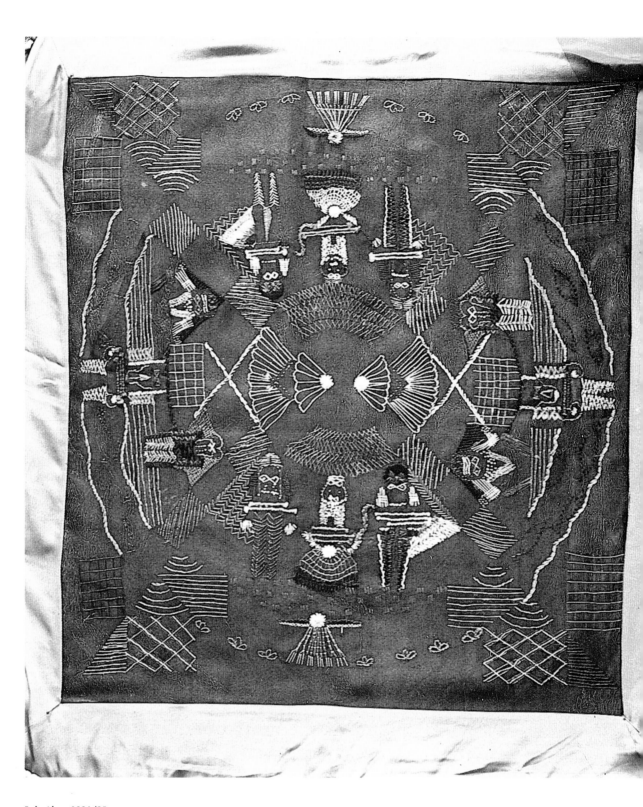

Embroidery. 1924/25.
Lace (not preserved).
Private collection

Sample. 1924/25. Patchwork of leather and fabric (not preserved). Private collection

Round lace tablecloth. 1924/25. Lace (not preserved). Private collection

84

Franz Singer/Friedl Dicker.
Poster "Tennis Courts," Tennis Club
House of Dr. Hans and Grete Heller,
Vienna XIII. 1927.
Lithography. 95 x 126 cm.
Private collection

Lithogr. Anstalt EMANUEL HELLER, WIEN X., Leebgasse 34.

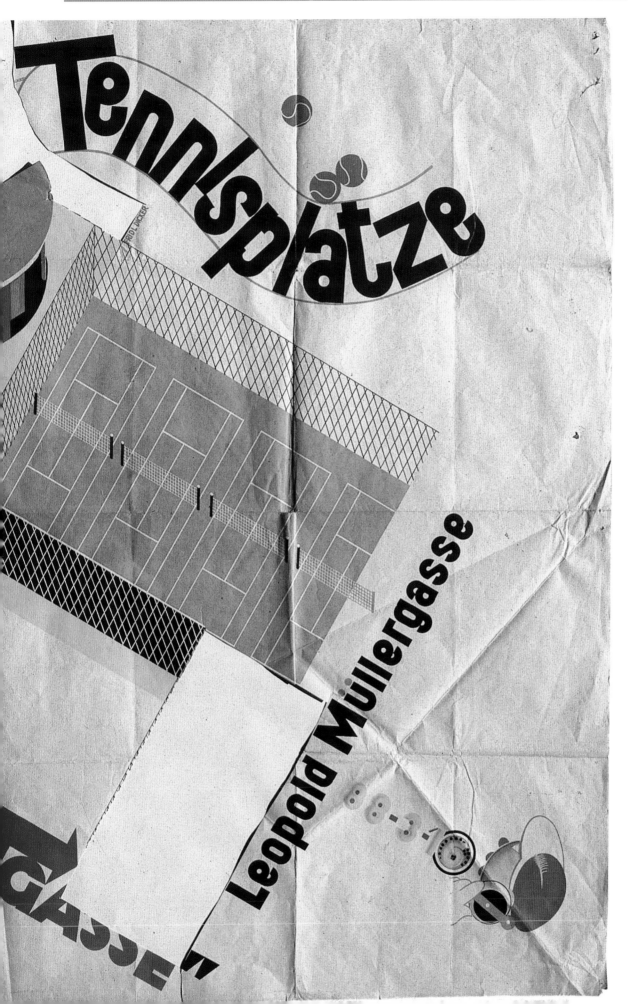

Franz Singer. Detail from the poster
"The Principle of Modern Living."
1925. Letterpress printing.
Private collection

## DAS MODERNE WOHNPRINZIP: ÖKONOMIE
### DER ZEIT, DES RAUMES, DES GELDES UND DER NERVEN
# FRANZSINGER MÖBEL

Aus den Schwierigkeiten der heutigen Wohnverhältnisse mußte notwendigerweise ein Stil entstehen.
Die Bewußtwerdung und Erfüllung aller aus dem Mangel entstandenen Erfordernisse hatten eine Kom-
primierung zur Folge gegenüber der Reduzierung des pseudo-modernen Stils. Die geringe Zahl meist
enger Räume gestatten nicht, sie für einen Einzelzweck dem ständigen Gebrauch zu entziehen. Ein
Wohnzimmer ist zugleich Eßzimmer, oft Gastzimmer, das Schlafzimmer ist zugleich Arbeitszimmer und

Franz Singer. Photograph,
1923/24. Private collection

Friedl Dicker in Hans Hildebrandt's car.
Photograph, end of 1920.
Bauhaus-Archiv, Berlin

Atelier Singer-Dicker. Axonometric view,
Tennis Club House of Dr. Hans and Grete
Heller, Vienna XIII. 1928.
Pencil and tempera on
transparent paper. 31 x 34 cm.
Private collection

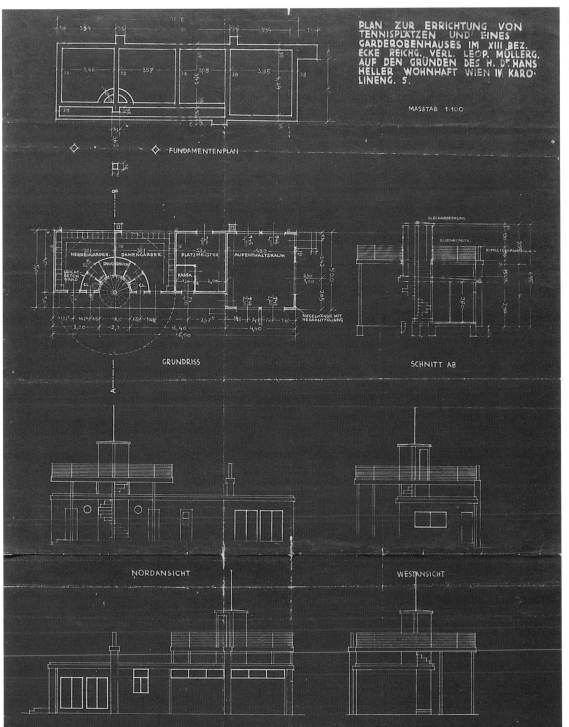

Atelier Singer-Dicker. Plan for submission,
Tennis Club House of Dr. Hans and Grete
Heller, Vienna XIII. To a scale of 1:100.
1928. Blueprint. 73.5 x 37.7 cm.
Private collection

Atelier Singer-Dicker. Guest house
of Auguste and Hilda Heriot,
Vienna II. Overall view.
Photograph, 1932-34.
Private collection

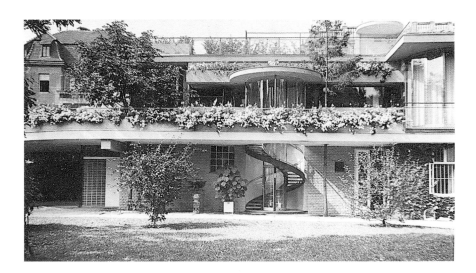

Atelier Singer-Dicker. Guest house of
Auguste and Hilda Heriot, Vienna II.
Photograph, 1932.
Private collection

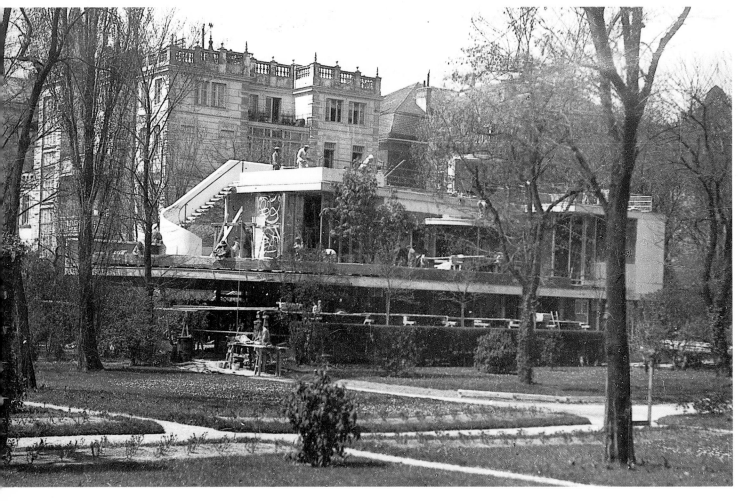

*After the Anschluss, Aunt Poldi could not stay in Vienna anymore…My aunt locked up everything from this atelier, as well as a few things from Franz Singer's atelier on Schadekgasse, in the photography darkroom. When she returned in 1945, she found everything untouched.*

*Friedl was a woman of many talents. She had her own ideas about everything, and she was not afraid to experiment. Her active presence is visible in everything she touched. Owing to her sense of modesty, she, unlike Franz, did not document her works and only rarely signed them.*

GEORG SCHROM, ARCHITECT, IN CONVERSATION WITH E.M., VIENNA 1991-1999.

THE SURVIVING ARCHIVES OF THE FIRM ATELIER SINGER-DICKER ARE IN VIENNA, IN THE OFFICES OF THE ARCHITECT GEORG SCHROM. HE TOOK CUSTODY OF THEM FROM HIS AUNT, THE ARCHITECT POLDI SCHROM, WHO WORKED WITH FRANZ SINGER AND FRIEDL DICKER FROM 1929 TO 1938

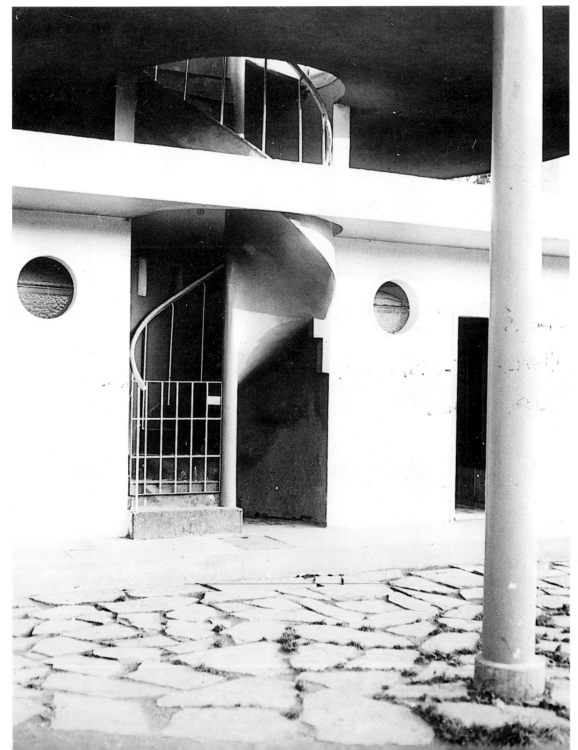

**Atelier Singer-Dicker. Tennis Club House of Dr. Hans and Grete Heller, Vienna XIII. Stairway. Photograph, 1932-34. Private collection**

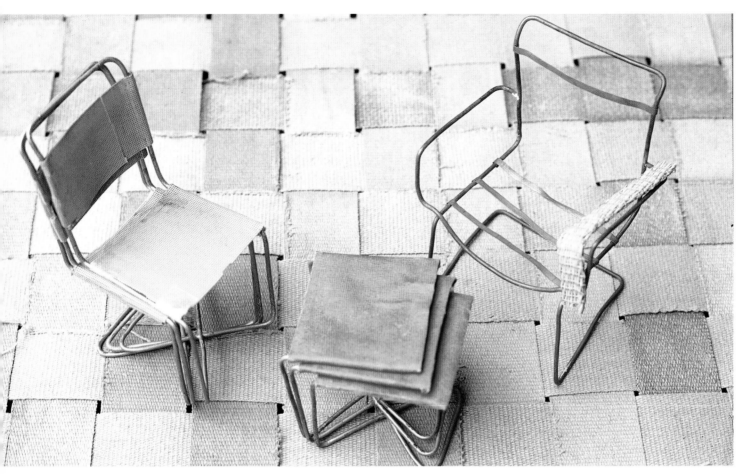

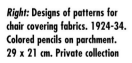

*Above:* Franz Singer/Friedl Dicker.
Models of chairs. Circa 1932-1934.
Metal. Private collection

*Right:* Designs of patterns for
chair covering fabrics. 1924-34.
Colored pencils on parchment.
29 x 21 cm. Private collection

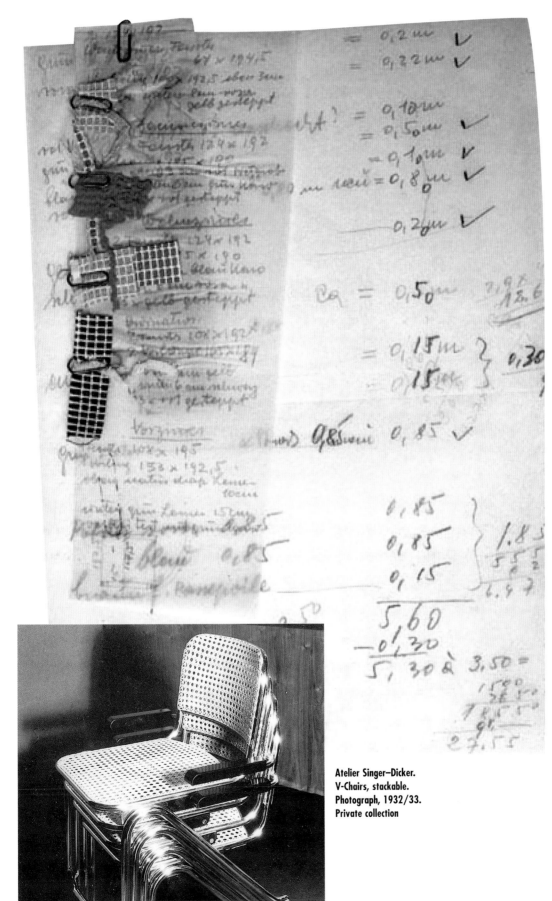

Letter to a customer with
fabric samples attached. Circa 1930.
Fabric, grease-proof paper.
Private collection

Atelier Singer–Dicker.
V-Chairs, stackable.
Photograph, 1932/33.
Private collection

*Dear Martha!*

*Mother [reference unclear] wrote to me that you would be kind enough to settle the unpleasant affair with the emptied cardboard box and fetch my suitcase from the forwarding agent. As far as I remember, the following items were in the box: the green dress with a zipper, the black dress with the Tibetan goat trim. Unfortunately only underwear was declared, insured for 500 M [marks]. I had the new underwear, made in Mössingen, inside and at least ten pairs of stockings. I only took the most necessary items with me to Cologne because I thought I would be leaving again in a few days.*

*My red leather vest was also inside and the blue man's shirt, which I wore as a blouse and the white, gray and black pajamas—all of this I know for certain—and twelve to sixteen new handkerchiefs.*

*The underwear is light, a ridiculous amount fits inside, and even if I get half of it back, 250 M, the deal will have been bitter and weak, but I am afraid I will not get so much. So please see what you can do, and I thank you very much in advance.*

*In order to release my suitcase, I sent my passport and asked Franz Singer to renew it for me right away. I also want all the beds: the bed from the earlier exhibition, open and closed, the children's folding bed... I have written all of this several times before.*

*It is also possible that I have forgotten something, so please remind Mr. Singer to add whatever is missing: prices, patent numbers for the furniture, and also those items that have been prepared in series or at least just calculated as such. I need everything very quickly; I would like very much to go away...*

*I received three dresses, but unfortunately not my black shoes. It would not make any sense to send them now. On Sunday I received a telegram stating I should bring my materials to Hans Moller on the train. I have no idea what it is about.Was something discussed at the atelier?*

**FRIEDL DICKER TO MARTHA DÖBERL, UNDATED, CIRCA 1925**

Atelier Singer-Dicker. Confectionery "Garrido & Jahne," Vienna 1., Operngasse. View from the street. Photograph, 1931. Private collection

Atelier Singer—Dicker. Confectionery "Garrido & Jahne," Vienna I., Operngasse. Interior view. Photograph, 1931. Private collection

Atelier Singer-Dicker. Living room
ceiling with colors, apartment of
Dr. Hans Epstein, Vienna IV. Circa 1933.
Pencil and tempera on transparent
paper. 37.5 x 48.5 cm.
Private collection

Floor design. Circa 1924-34.
Gouache and pencil on paper.
48 x 37 cm. Private collection

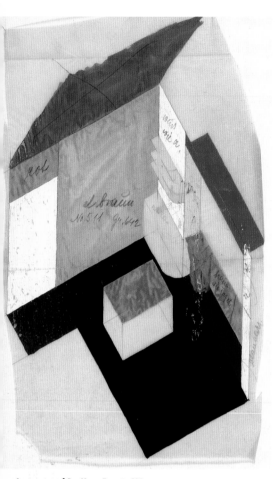

Apartment of Dr. Hans Epstein [?].
Axonometrical view of the bedroom
with colors. 1933. 48.5 x 31.5 cm.
Private collection

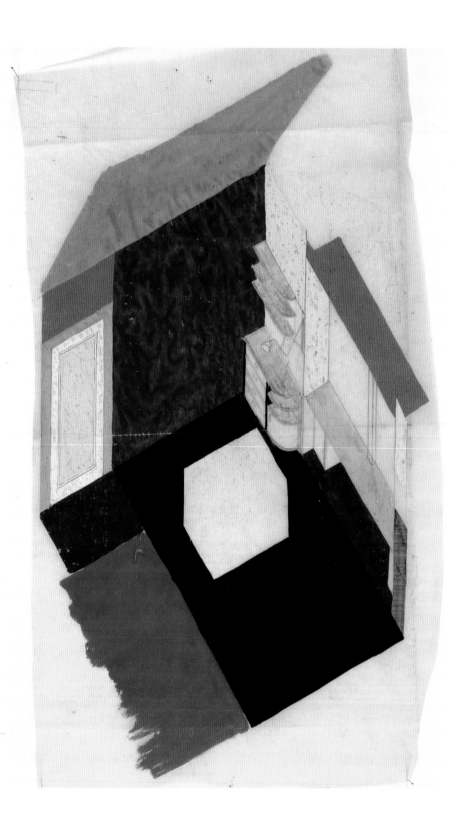

Apartment of Dr. Hans Epstein [?].
Axonometrical view of the bedroom
with colors. 1933. 50 x 28 cm.
Private collection

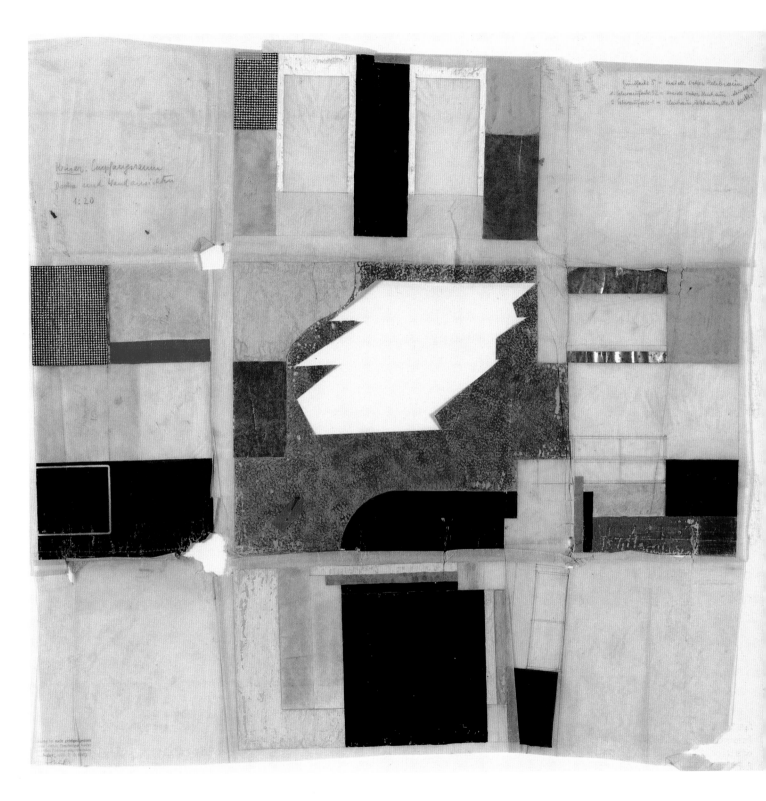

Atelier Singer—Dicker. Ground plan of the bedroom with the
walls folded down, apartment of Dr. Reisner, Vienna XIX.,
to the scale of 1:20. 1928.
Pencil and tempera on transparent paper. 32 x 41.2 cm.
Private collection

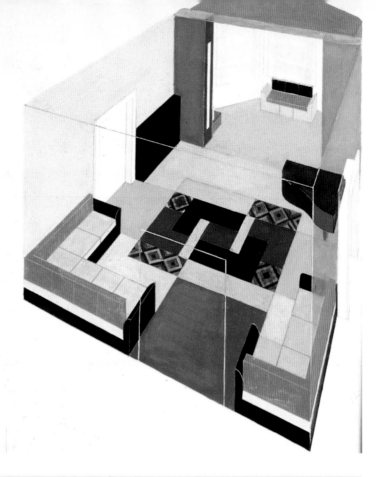

Atelier Singer–Dicker. Perspective
view of a room. Circa 1924-34.
Gouache and pencil on paper.
62 x 40 cm. Private collection

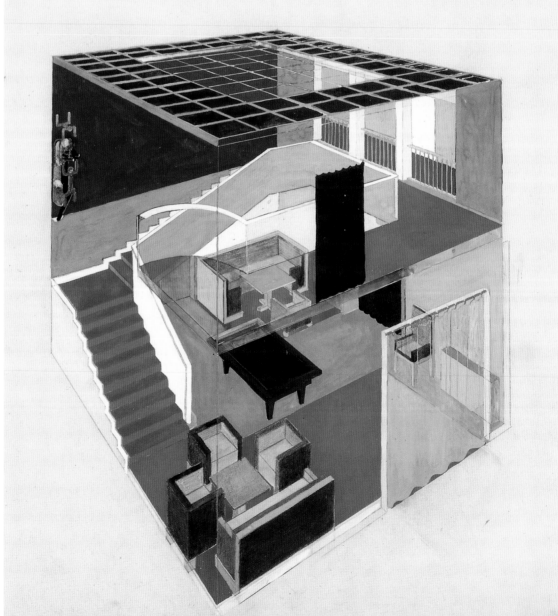

Franz Singer/Friedl Dicker. Hall in the
main house of Auguste and Hilda Heriot.
Perspective view with the sculpture
"Anna Selbdritt" above the first
landing of the stairwell. 1932.
Pencil, colored pencils, tempera
on cardboard. 50.5 x 47.5 cm.
Private collection

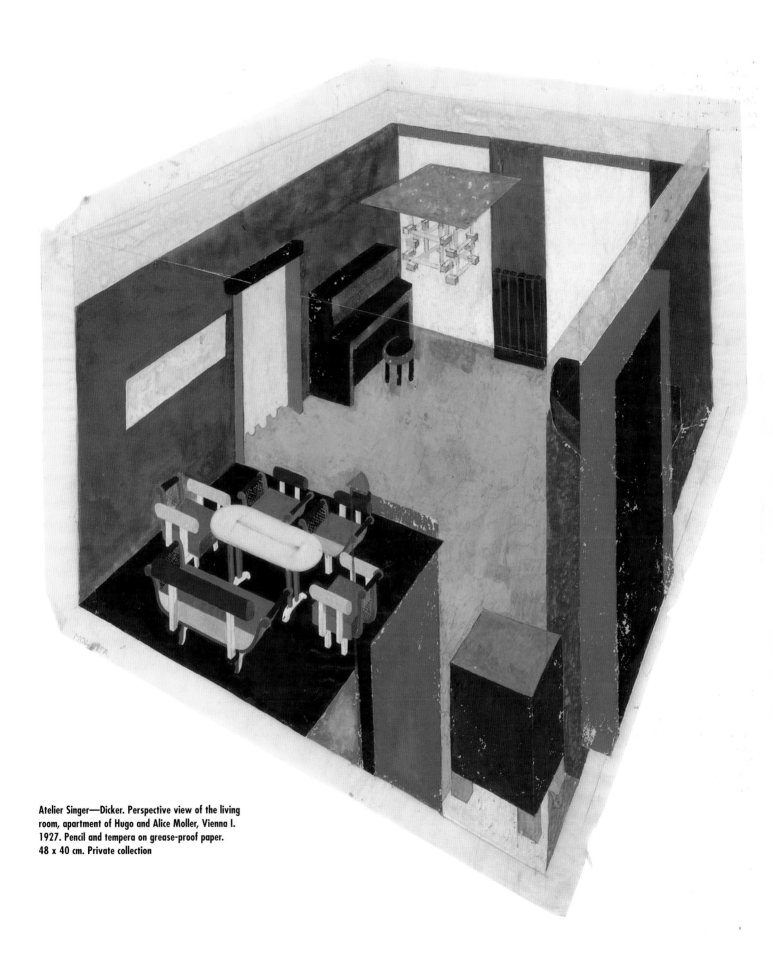

Atelier Singer—Dicker. Perspective view of the living
room, apartment of Hugo and Alice Moller, Vienna I.
1927. Pencil and tempera on grease-proof paper.
48 x 40 cm. Private collection

Atelier Singer—Dicker. Design
sketches for bench and armchair,
apartment of Hugo and Alice Moller,
Vienna I. 1927.
Pencil on paper. 24.5 x 47 cm.
Private collection

Woller Bort gebleicht
" natur
taupe
rosa
gelb
mit Baumwallfäden

1 Sept.

$\frac{26\frac{1}{2}}{30} \times 155 \times 1$

19½

160

8,50

210
415
695
14
835

| 50 | | 50 | 50 | 50 | |
|----|---|----|----|----|---|
| 60 | | | 60 | 60 | |

**Top left:** Atelier Singer—Dicker. Parts of the toy kit
"Phantasius." 1925. Gouache on paper. 16 x 21 cm.
Private collection

*Above left:* Atelier Singer—Dicker. The Rabbit—
Drawing for the toy kit "Phantasius." 1925.
Gouache and pencil on paper. 16 x 21 cm.
Private collection

**Top right:** Atelier Singer—Dicker. The Pelican—
Drawing for the toy kit "Phantasius." 1925.
Gouache and pencil on paper. 16 x 21 cm.
Private collection

*Above right:* Atelier Singer—Dicker. The Deer—
Drawing for the toy kit "Phantasius." 1925.
Gouache and pencil on paper. 16 x 21 cm.
Private collection

Atelier Singer–Dicker.
Toy Kit "Phantasius."
1925. Wood.
Private collection

Portrait of Ella Deutsch. 1931.
Charcoal on paper. 38.5 x 45 cm.
Private collection

Josef and Ella Deutsch.
Photograph, circa 1920.
Private collection

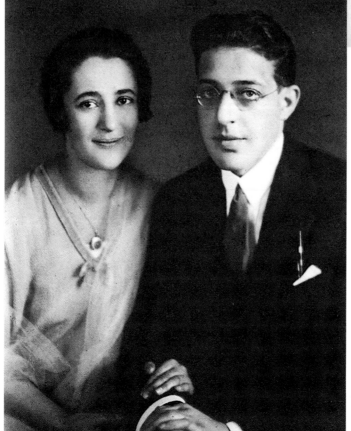

*Opposite:* Portrait of Josef Deutsch. 1931.
Charcoal on paper. 37 x 25.5 cm.
Private collection

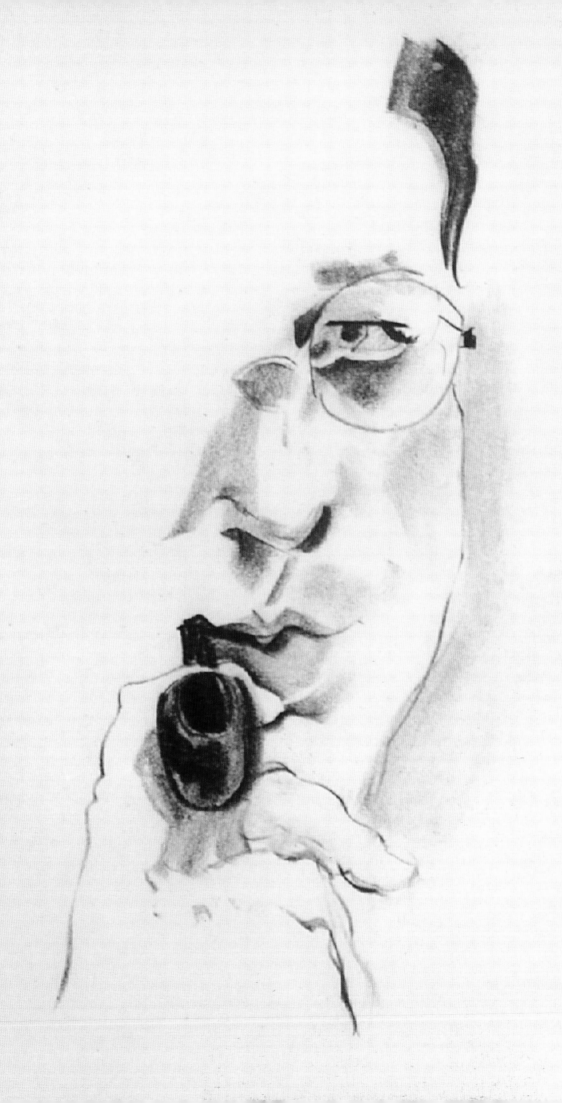

**The Infant Hanne Deutsch (married name Sonquist). 1931. Charcoal on paper. 23 x 23 cm. Private collection**

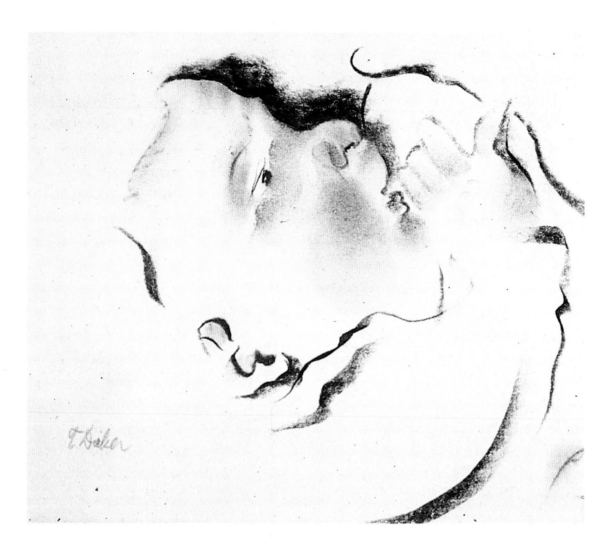

*My parents were both practicing physicians in Vienna. My mother was an internist, and my father a gynecologist. My father was an intellectual, who loved art and music and played the piano well. He and Friedl were close friends, and shared the view that art, philosophy and politics were intertwined. They also shared their beliefs in the ideas of Marx and Communism.*

HANNE SONQUIST, NÉE DEUTSCH, IN CONVERSATION WITH E.M., SANTA BARBARA, CALIFORNIA, USA, 1997

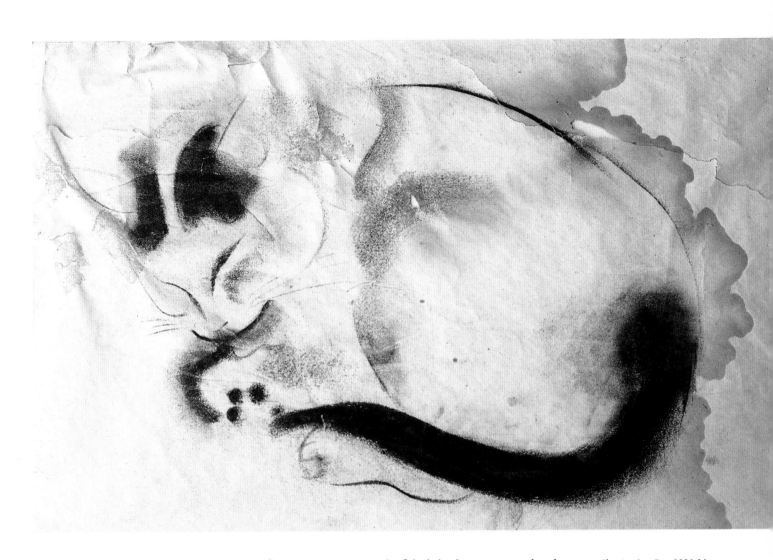

*Friedl threw this cat in the garbage. Her fellow student Anna Szabo fished the drawing out and took it with her to Budapest. From there she came to London, and finally she gave this wonderful cat to me.*

**GEORG SCHROM, ARCHITECT, IN CONVERSATION WITH E.M., VIENNA 1991**

**Sleeping Cat. Circa 1924-34.
Charcoal on paper. 26 x 39 cm.
Private collection**

Self-portrait on a cover for
drawings (gift to Ella and
Josef Deutsch). 1931.
Photocollage and tempera.
70 x 50 cm.
Private collection

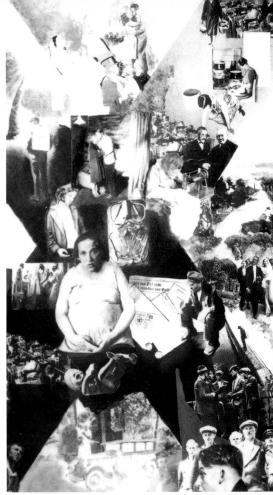

*Far right and below:*
Anti-capitalist poster. Circa 1930.
Photocollage. Private collection

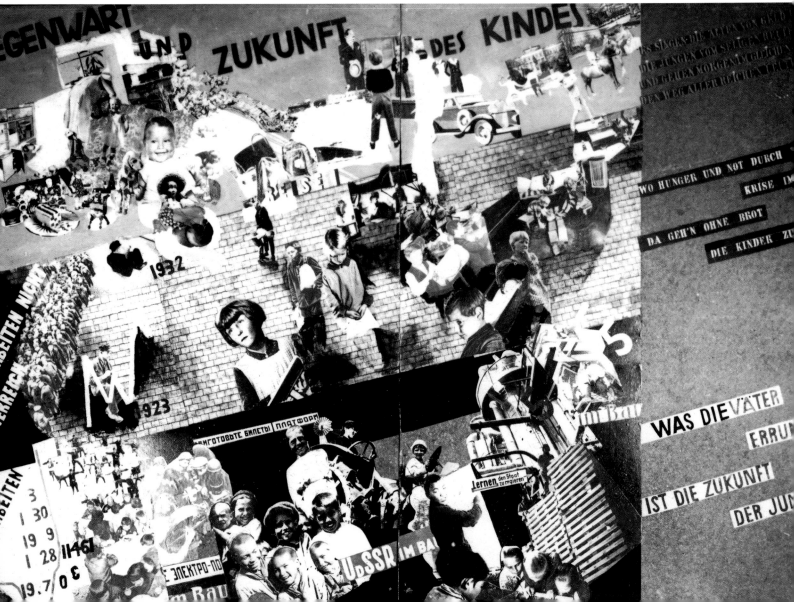

Wall hanging, gift to Hanne Deutsch
(born in 1931), married name Sonquist.
1925. Fabric. 90 x 155 cm.
Private collection

*Dear Prof. Hildebrandt!*

*Excuse me for writing with pencil, there is nothing else here. Unfortunately, I have been waiting in vain for the promised copies from Vienna, some of the costume designs, some of the replacements for the ones that turned out too dark. I do not know…the reason why they have not arrived. In the meantime, I am sending whatever I have that is usable. The four top ones have their mistakes marked on the back.*

*Perhaps you could be so kind as to wait until you receive the better ones before making your selection, because, if your are going to reproduce them, I consider the study of subjects (cellist) and the two pictures to be the best. Otherwise I do not think the photograph of the embroidery and rug turned out very well. Apart from that, I leave everything to your discretion.*

*Please be so kind as to return the photos to me when you no longer need them. I like looking at the reproduced pages.*

*Do you see Mr. And Mrs. Itten? Many warm greetings to them. In the meantime, many good wishes for your book!!*

**FRIEDL DICKER TO PROFESSOR HANS HILDEBRANDT, REGARDING HIS BOOK,
"DIE FRAU ALS KÜNSTLERIN" (THE WOMAN AS ARTIST), AUSSEE, SEPTEMBER 6, NO YEAR (CIRCA 1927)**

View of a Street in Prague-Nusle.
Circa 1934-36. Oil on cardboard.
59 x 41 cm. Private collection

# PRAGUE

*My dear Anny,*

    *The picture is of home… If we are uprooted, it is still home. Who says we are trees? We are mobile creatures… The struggle for survival, even when one does not have to fight it with all its severity, can force away one's laughter…*

**FRIEDL DICKER TO ANNY MOLLER, NÉE WOTTITZ, PRAGUE, UNDATED, BEGINNING OF THE 1930S**

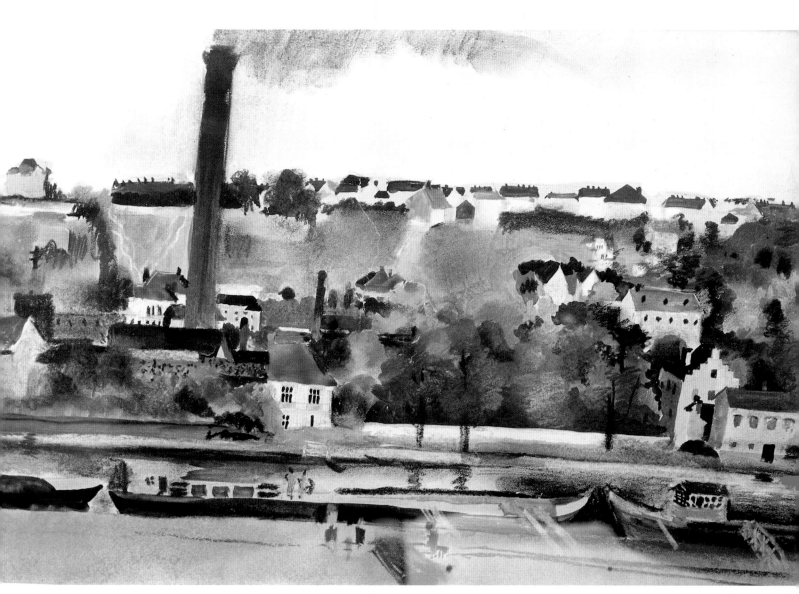

**View of the Moldau by Vyšehrad.**
**Circa 1934/36.**
**Oil on canvas. 32 x 50 cm.**
**Private collection**

Interrogation I. 1934.
Oil on plywood. 120 x 80 cm.
Jewish Museum, Prague

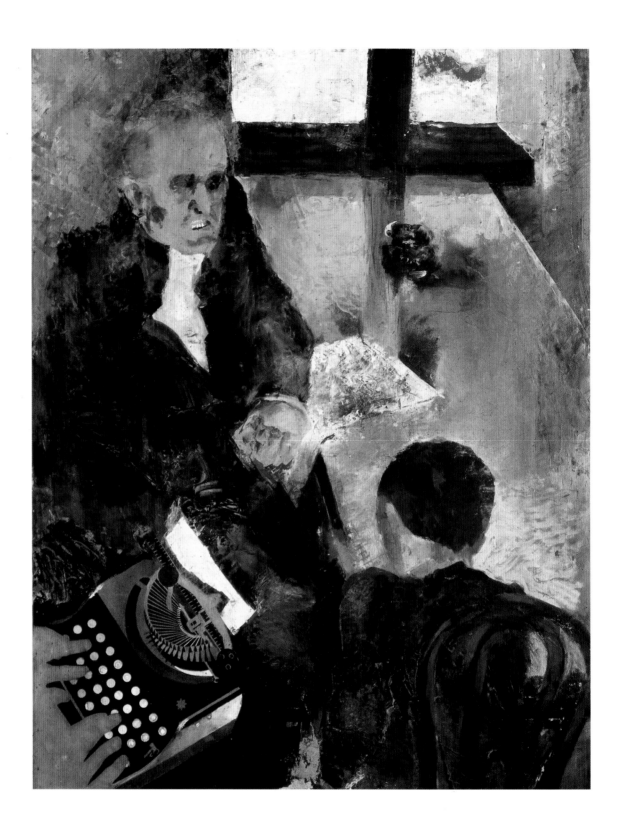

Interrogation II. 1934.
Oil on canvas. 75 x 60 cm.
Jewish Museum, Prague

*Good Poldi,*

*Friendly greetings! I always get a little soft in the area around my stomach = heart, when I think of you. How are you? What a splendid impression you will make in Palestine; there is certainly no one there who can speak half-Yiddish as well as you...*

*What is the atelier doing—with the exception of N. [Szabo]: I do not want to hear anything about her as long as she has not been analyzed—but what about the others? Fortunately most of them have been expelled from Vienna, otherwise it would have burst from overcrowding. With me things are, to put it in a friendly way, extremely so-so, but they are getting better. Prague does not want to be my friend.*

*Hopefully the blueprints will work out; perhaps something better than the high-rise building will occur to you...What is happening with your test?*

*Adieu Poldi. If you hear anything from Martha, I would really like to know about it.*

*Many greetings, your Friedl.*

**FRIEDL DICKER TO POLDI SCHROM, PRAGUE 1936**

**Detail of a photograph, 1919-23. Getty Research Institute, Research Library, Los Angeles**

**Acacia Tree. Circa 1936-38. Pastel on paper. 44 x 35 cm. Private collection**

View from a Window in Franzensbad.
1936/37. Pastel on paper. 43 x 45 cm.
Private collection

Quay along the Moldau.
Circa 1934-36.
Oil on canvas. 44 x 56 cm.
Private collection

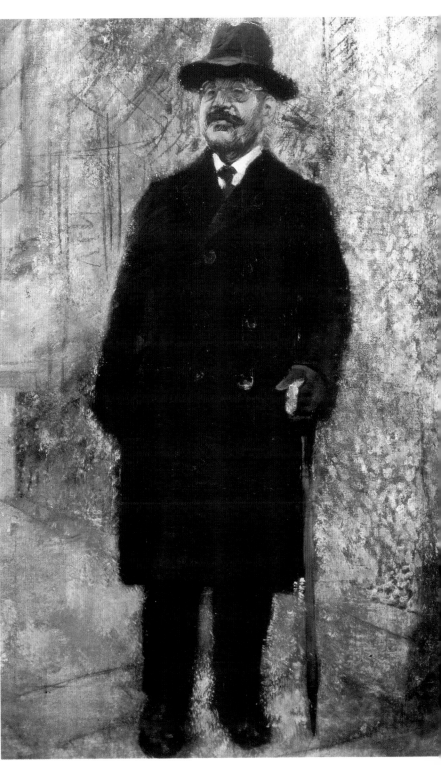

Unknown Man. Circa 1938-42.
Oil on canvas. 97 x 66.5 cm.
Jewish Museum, Prague

View from a Window in
Franzensbad. 1936/37.
Pastel on paper. 55 x 40 cm.
Jewish Museum, Prague

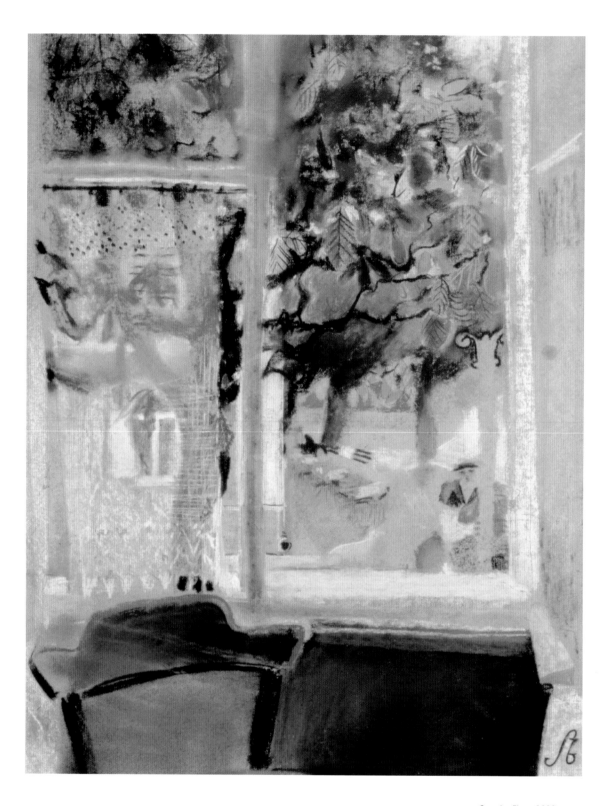

*Opposite:* Ficus. 1938.
Oil on canvas. 70 x 44 cm.
Private collection

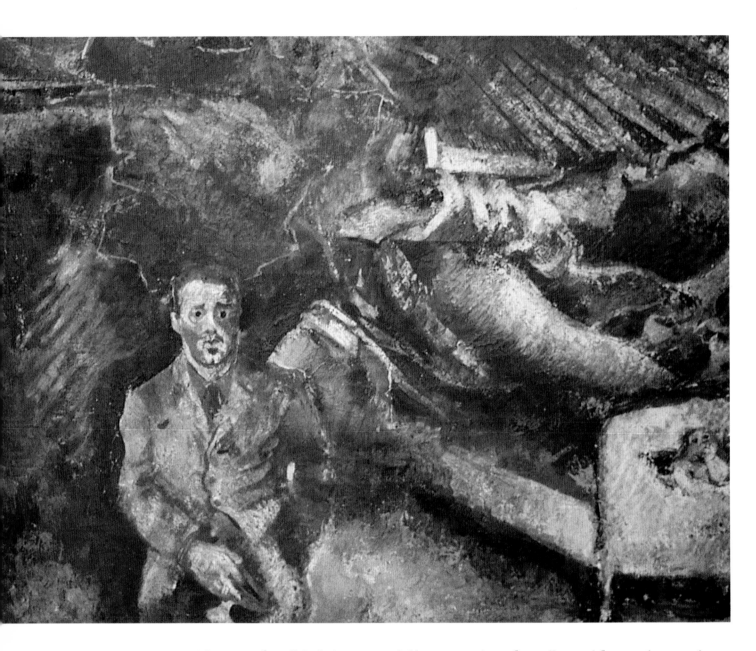

**Fuchs Studies Spanish. 1938.**
**Oil on canvas. 53 x 66.5 cm.**
**Private collection**

*This is one of Friedl Dicker's most remarkable paintings. A terrifying allegorical figure and a man who is reading a book. Albert Fuchs was our mutual friend, a young philosopher. Friedl caught him in a moment of reflection—should he set off for war immediately or wait a bit until he had learned Spanish better...*

**GEORG EISLER ON "FUCHS STUDIES SPANISH," IN CONVERSATION WITH E.M., VIENNA 1994**

Dream. Circa 1934-38.
Spray ink, gouache and pastel
on paper. 57.5 x 78.5 cm.
Jewish Museum, Prague

Window with Plants.
Circa 1938-42.
Oil on canvas. 71 x 53 cm.
Private collection

Children at the Zoo.
Circa 1935-36. Tempera
on canvas. 65 x 52 cm.
Bauhaus-Archiv, Berlin

*The gaze of Lazarus, this powerful feeling of Christ's greatness…expresses a tremendous fearlessness and a unity with Christ as well as a unity with oneself. There is no premeditation in this. The painting arose from such an emotional overflowing that its very subject matter is almost secondary; it is quickly grasped. In the course of a lifetime, there are events that form an artist and which take shape in his painting.*

FRIEDL DICKER-BRANDEIS TO HILDE KOTHNY, IN REFERENCE TO A COPPERPLATE ENGRAVING BY REMBRANDT, HRONOV, UNDATED

**The Big Griffin and the Small Griffin. 1936. Oil on canvas. 73 x 60.5 cm. Bauhaus-Archiv, Berlin**

***Above:* Still Life with Vases, Flowers and Pomegranate. 1936. Oil on canvas. 45.8 x 36.3 cm. Bauhaus-Archiv, Berlin**

The Resurrection of Lazarus. 1936.
Oil on canvas. 71.5 x 53.5 cm.
Private collection

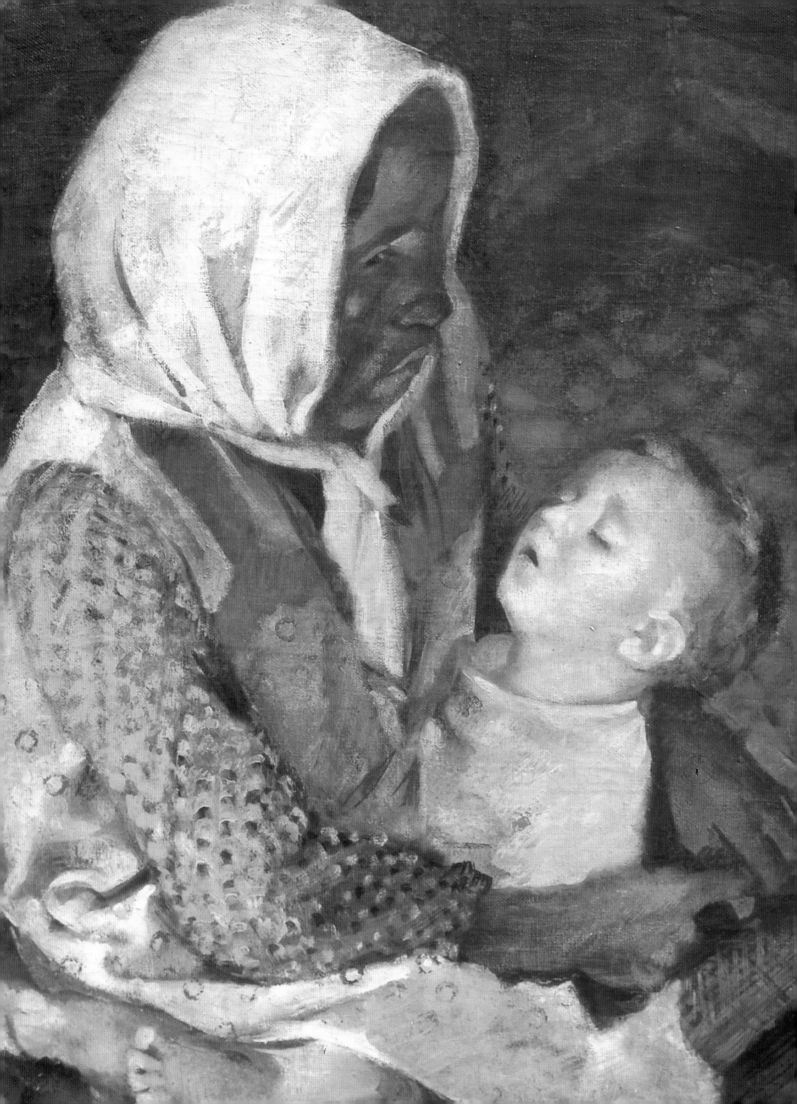

# HRONOV

*Friedl once gave me Kafka's "The Trial" to read. It was extremely oppressive to me. I didn't want to finish it. Kafka and that reality was too much…She loved Klee very much. I remember how upset she became when she learned from Johannes Beckmann that Klee had died.*

*In 1940, I was still a newlywed. Pavel and my husband, the artist Emil Tilsch, were working together in the textile factory and because of that, Pavel and Friedl invited us to visit. They were still in their first apartment. The windows had a view of the train station, and when you saw the train come in, you could run out of the building and still catch it in time.*

*Friedl Dicker was as small as a child, but she had enormous eyes. She greeted us happily, invited me in, and her room surprised and enchanted me. I had never seen anything like it. The furniture was very modern, very practical, and everything seemed to be the same size. If she ever had to move, she would be able to take everything apart and put it together again in the new place. She explained to me that the furniture came from the studio. Singer designed it and she decorated it. All of it formed an integrated whole.*

*The chairs were like crates—one could sit at whatever height one wanted; everything was easy to change. There were many pictures of her and her friends. An oasis of peace…*

*She always had many guests. We put the tables together end to end. Back then, the first time, everything amazed me—Friedl Dicker's appearance and those furnishings; everything belonged to a great whole. In this dark, somber time she was full of energy, wisdom and friendliness—feelings that seemed to come from another world and at the time were completely forgotten. She inspired everyone—simple people as well as artists.*

*Today an old married couple live in the building. The owner was an electrician. He met Friedl. Right before she moved, Friedl had to explain to him which fuses were where. One of the fuses was always blowing…*

*She drew so much! Even while she was preparing dinner, she would sit at the window and draw so that she would not lose any time. She loved flowers, and they were happy to model for her. She would take long walks so that she could draw, often with Zdena Turková.*

**ANNA SLÁDKOVÁ IN CONVERSATION WITH E.M., NÁCHOD AND JERUSALEM, 1989-1997**

**Anna Sládková.**
**Photograph, circa 1940.**
**Private collection**

***Opposite:* Gypsy and Child. 1937/38.**
**Oil on canvas. 71.2 x 51.5 cm.**
**Private collection**

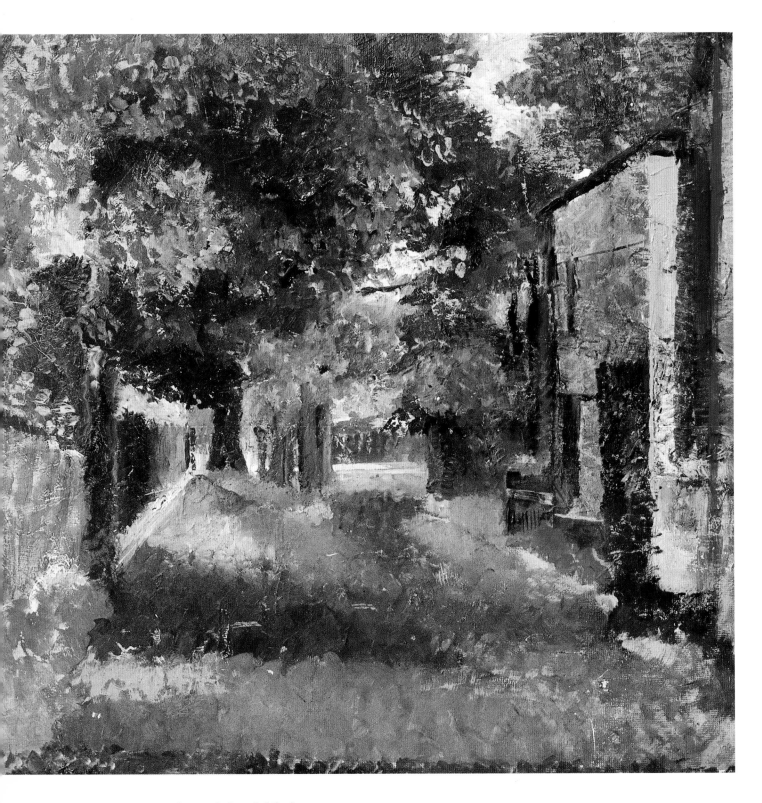

Street to the Evangelical Church
in Hronov. Circa 1938-42.
Oil on canvas. 53 x 57 cm.
Private collection

Friedl and Pavel Brandeis,
Laura Schimková (in the middle),
Elsa Schimková (left).
Photograph, circa 1941.
Private collection

*Once we visited Friedl and Pavel for the weekend. They spent the night at my mother's. It turned out to be such a memorable evening. We talked openly about everything. It was clear to us that the war was lost. We tried to persuade one another that everything would change for the better, that we just needed to hold on.*

*A young teacher was there, a pianist, and my husband, who was also a musician, not just a painter, and my brother who studied opera. The teacher played the piano and everyone sang. Laura was the only one who was sad.*

*When I came back the next morning, everything had been put back in its proper place. It was sparkling clean, and Pavel was almost finished with the washing up. He took me aside and said that Laura's friend had been arrested. Later, we learned he was murdered.*

**ANNA SLÁDKOVÁ IN CONVERSATION WITH E.M., NÁCHOD AND JERUSALEM 1989-1997**

*My very dear,*

*I am sitting with my little boxes of pastels, with unspeakably beautiful geraniums in front of me. I am deeply moved, excited…and I am thinking about you. It is such a pity that you are not here, and we cannot rejoice together. Behind me lies the quietest Protestant cemetery with its big, spreading trees and individual branches breaking loose from the lush crowns…and all around, air that is simply indescribable.*

*It is no wonder… that a dying person shouts, 'Air, give me air!' having forgotten the main thing—in order to rid yourself of the fear of death, you first of all need to breathe.*

**FRIEDL DICKER-BRANDEIS TO ANNY MOLLER, NÉE WOTTITZ, UNDATED, 1938/39**

*My dear girl,*

*I am sitting by two candles. It is warm, and the stove is singing its protracted songs. After the hundredth breakdown of the plumbing, after the hundredth short circuit, the stove went out. Despite everything, you need to choose what is important.*

*It is much more pleasant for me here with this quiet than Prague and all its noise. Blessed be Hronov! When you weigh the important and the unimportant, then you ought not to be so fastidious…ultimately, that is the whole point.*

*I have now buried myself in a small picture, in a small speck of brownish fir trees. I am painting it from the window. Everything started with the brownish speck that suddenly stood out distinctly against the background of the pink and blue twinkling of the snow.*

*The trees are so dark and, therefore, everything behind them looks unusually delicate, and the blue in the distance emphasizes even more strongly the violet brownishness…but it does not look dull, since the brown is next to the violet, and the chimneys are the same color, only more intense. Those bits that stick up are not lost in the painting—and do you know why? Because the light brown and a very elegant ribbon of smoke links them to the top of the hill that stands opposite. The smoke cuts the sky with its patch of light gray and that acts as a counterweight to the snow in the foreground.*

*And so I paint and paint, breathing more and more quickly as I think about the little twinkling patch— but where is it? Where has it gone? It has disappeared.*

*Now I want to describe for you a bit of my life here. I have settled in and got everything in order. It is so beautiful. I tidy up and cook. My cooking is improving so you would derive colossal pleasure from my kitchen. You cannot imagine how much goes on around here! And when nothing is happening, then at the very least Peggy (the dachshund) goes running off somewhere. She now is focused on one thing only, and that is finding a mate. With ladle in hand or whatever I may be holding at the time, I go running after her in my boots into the forest. I go running through half the town, whistling and yelling 'Peggy'! Peggy is chasing after bicyclists, strolling about town, sniffing something…*

*And I again settle down to paint before it gets dark. A tiny eighty-year-old man, a former worker, comes to visit me. He wears a work shirt that is light blue and still very clean. He is poor and is forced to beg alms… and here he sits with me, toothlessly mumbling something or other.*

*When he thinks that I am drawing him, he tucks up the lip that hangs down and puts his face in order. He has such an attractive face—with big, dark-skinned ears and violet eyes. Each time he looks more and more 'proper'. Last time, to my horror, he arrived wearing a white collar that pinched his neck and a tie. And what is more, his hair had been cut and his face shaved clean.*

*He drinks coffee or a small glass of vodka and tells me about his misfortunes, of which there is no lack. My God, when I am that old I probably will not even be able to crawl and will probably be senile.*

*I am also studying Czech, but I am not exactly racking my brains over it, and so the successes, alas, are commensurate. Sometimes we go for a walk, and that is so wonderful. A couple of times we went skiing in the moonlight. The snow crunches softly under Peggy's feet while we take cockroach steps through the forest and the great silence.*

**FRIEDL DICKER-BRANDEIS TO JUDITH MOLLER, THE DAUGHTER OF ANNY MOLLER, NÉE WOTTITZ, HRONOV, JANUARY 7, 1939. JUDITH MOLLER WAS LIVING IN LONDON AT THE TIME**

*Opposite:* **Friedl Dicker-Brandeis with her dog Julenka. Photograph, circa 1940. Private collection**

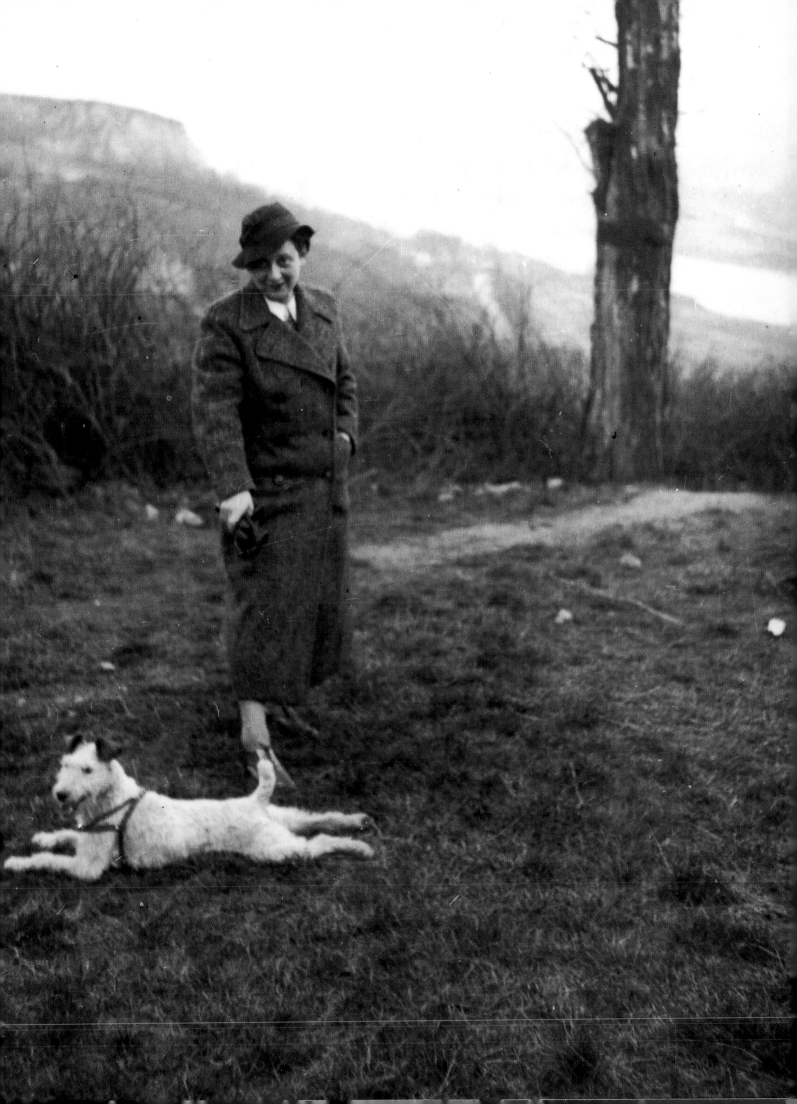

*Dear Anny,*

*It is peaceful here. Everything is covered in deep snow. Spring began yesterday. Something is wrong with my eyes. But every day I hear the singing birds. It is indescribable. When I go to the bakery at 7 o'clock in the morning, I hear the cackling and clucking in the hen house. This is all so connected to my childhood, school holidays, happiness and freedom.*

*Life here, its trifles and beauty, is precisely what I can handle. As I listen to the rooster's crow, I would not believe even in my final hour that something evil was taking place…*

*My life in art has redeemed me from a thousand deaths. Through my painting, which I have practiced diligently, I have atoned for a guilt I do not know the origin of.*

*If I had a child, I would have a bit more fighting spirit. I would believe that whatever I was unable to manage, my child would manage.*

*I belong, like mortar or stone, to the small building of life.*

**FRIEDL DICKER-BRANDEIS TO ANNY MOLLER, NÉE WOTTITZ, HRONOV, MARCH 2, 1938**

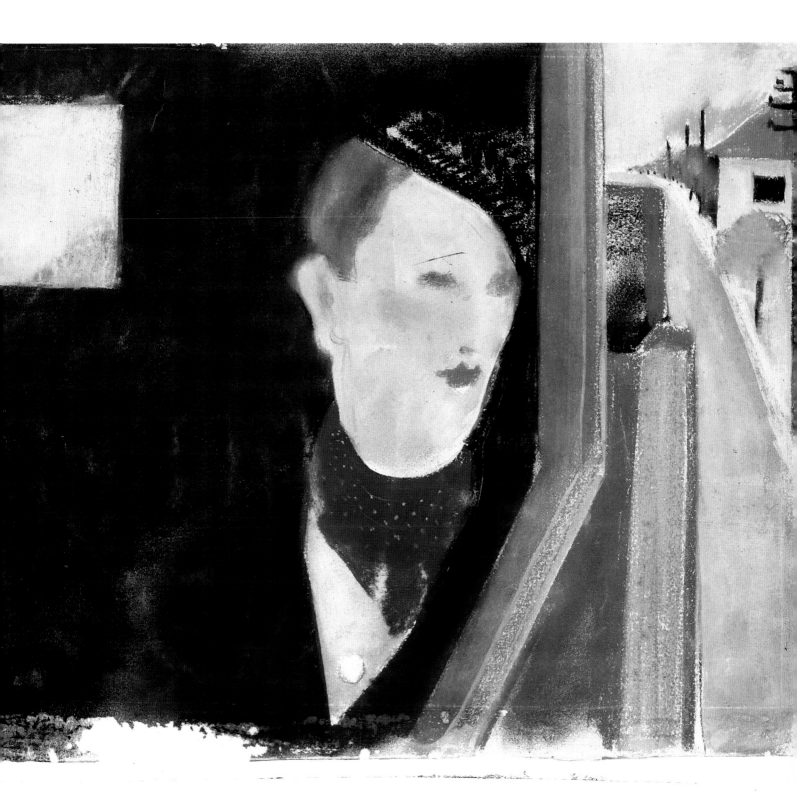

*I am grateful and happy to be alive. It seems that I have managed to slip out of the net…and I still have enough strength to work. You see my courage in "Auto." You see how determined I am…*

**FRIEDL DICKER-BRANDEIS TO HILDE KOTHNY, HRONOV, DECEMBER 9, 1940**

**Self Portrait in a Car. 1940. Pastel on paper. 43.5 x 56 cm. Jewish Museum, Prague**

*Once we wanted to give the priest [Jan Dus] a present. He was moving from Hronov to Kutná Hora. Friedl asked us to tell her what she should draw, and then she would draw it. She sat right down and drew "View of the Ostaš" in pastel colors; oil colors were too expensive. I do not know why anymore, but I had told Friedl once that people from the area compared the Ostas˘ mountain with a coffin. And she was such a sensitive person— the picture turned dark. Pavel asked Friedl: 'Why is it so black?'*

**ZDENA TURKOVÁ IN CONVERSATION WITH E.M., NÁCHOD 1988**

**View of the Ostaš. 1939.**
**Pastel on paper. 44 x 61 cm.**
**Private collection**

Portrait of Zdena Turková. 1940.
Pastel on paper. 46.5 x 33 cm.
Private collection

Vicarage in Hronov, 1939.
Pastel on paper, 45 x 55 cm.
Private collection

A Negative and a Positive Form
of a Force Field. 1941.
Wood, wire, gouache. 43 x 48 cm.
Private collection

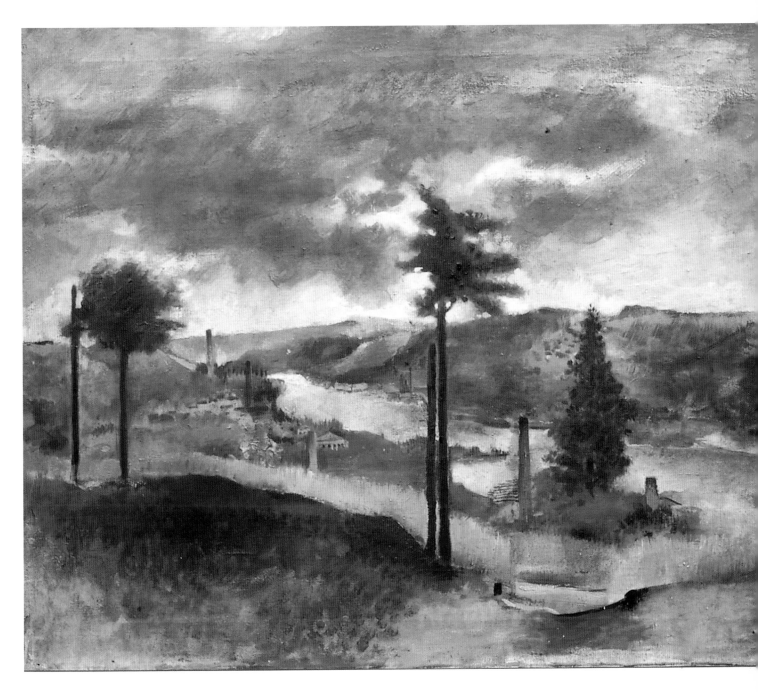

I am sending you several contact prints. They need to be looked at through a magnifying glass.

"A" is especially for you—a negative and positive variation of the same form held by a force field with a ribbon hovering above it. Do not look for any particular message; you'll understand it later when you see it in color.

"B" is the Vltava landscape as seen from Vysegrad. Unfortunately, I painted it from memory.

**FRIEDL DICKER-BRANDEIS TO HILDE KOTHNY, HRONOV, UNDATED**

**Landscape with Moldau. Circa 1940.
Oil on linen. 59.5 x 72.5 cm.
Private collection**

*Above:* The Future Queen Alexandra
and the Future King Eduard VII.
Photograph by Messrs W. & D. Downey,
circa 1880

*Right:* Double Portrait from a Photo
(Queen Alexandra and King Edward VII).
Circa 1938-40. Oil on canvas.
111.5 x 80 cm.
Jewish Museum, Prague

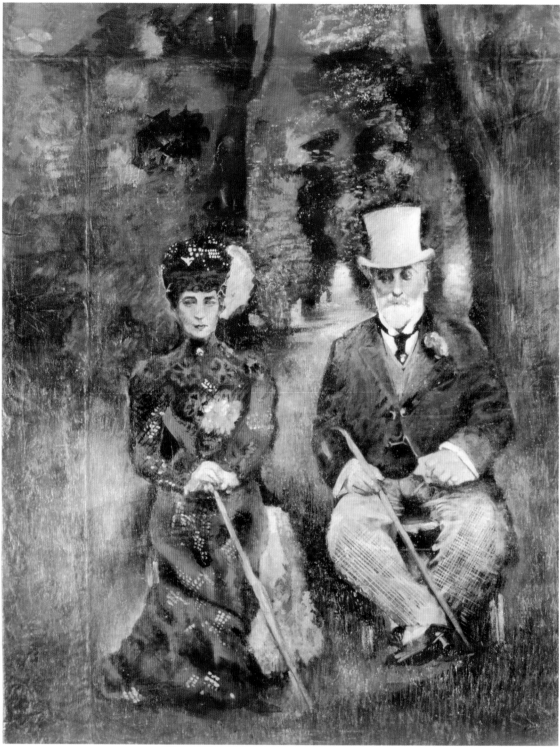

# HRONOV/LETTERS TO HILDE

*My dear Hilde!*

*I think of you constantly! Your letter, which came such a short time ago, was also a happy surprise!*

*Today I will not write you a painterly letter, since it has been gray and foggy since the fifth, just wind and driving snow; not a philosophical letter, because sometimes one does not have the breath; I will not even write a human letter! It is just that I do not want the thread to be broken or for you to believe that I was not thinking about you. But I am very sad and simply paralyzed when I think of you, my splendid, courageous girl: how you sit there alone working diligently and persistently. I feel so sorry that I cannot wind up the gramophone and play the beautiful overture from Leonore for you, or just give you a caress…*

*I can think of any number of books that I should have mentioned to you. Now that we have known each other for quite a long time, what is foremost in my memory is the beautiful walk we took.*

*I am not in any condition now to draw pictures (precisely because I am paralyzed), but I have found in you my audience, one to whom I can turn when things need to be said. The next time you come, we will talk about the moderns—modernism—in more detail. There is so much that it intuits in advance, and even the most badly executed explain quite a bit that cannot be fully exhausted in text alone.*

*As soon as I have sent this letter I will start a new one to you with all the nonsense and trifles one can collect here in this desert, this beautiful desert.*

**FRIEDL DICKER-BRANDEIS TO HILDE KOTHNY, HRONOV, JANUARY 19, 1940**

**Hilde Angelini-Kothny. Photograph by Rita Ostrovskaya, 1998. Private collection**

*Dear Hilde!*

*I so stubbornly search for the path which would help to lead you to art. …Sometimes just one (unmotivated) transformation of the everyday will suffice—and you move from contemplation to vision.*

*Unfortunately, schools of thought do not suffice for me, i.e., the ability to systematize, organize, select… As regards your process of perception, you ought to have defined starting points from which you break down this complicated process into its elements.*

*For example, you like Michelangelo and the Bohemian masters a great deal. Ask yourself why, and answer to the best of your ability what it is precisely that you like in both of them. Try to compare them—what precisely does one have that the other lacks?*

*When you look at a picture, pay attention to the colors. Do they have an overall color scheme? What figures are painted in which colors? Does this result in a special, striking composition? Chiaroscuro—how does it serve the interpretation? For example, in Rembrandt, the secondary figures are often more brightly lit than the central ones.*

*Pavel is planning to do carpentry work. I am working a great deal, under the delusive hope that maybe I will manage to paint portraits or sell something else. Maybe something would have worked out in the Reich. It is altogether likely that this is impossible as well; people have different worries now.*

*I am working on four pieces at once. One is entirely in my style, the second is not coming out at all, the third is sheer madness, and I cannot even imagine what will come of the last one…*

*I have a little pupil, an unruly, sweet boy. If I had not set myself the accursed task to teach him how to see "correctly," I would have learned so much from him! But it is so hard to change your point of view when you are pursuing some definite goal.*

But back to the boy: at first we learned about mixing paints so he could define his concept of color and thereby enrich it. Then we began to paint abstractly in order to create a place for the object, which he ought to see in a new way. Now I am showing him the color reproductions on the cigarette packs. It is simply too bad that you did not save those cigarette boxes. You would have already two to three volumes of colorful magnificence. The text is also very interesting. Pavel reads it too, as a contrast to "Gestalt" and in order to form his own ideas.

He [the boy] has literally fallen in love with Raphael's "Madonna and Child" and…tries to draw it. Everything is going well, but there is that little bit of red in the sleeve that peeps out from under the mantilla. He has drawn it a dozen times and always with one long stripe. Each time I erase it, he stubbornly draws it again. I need to observe and understand why he does this. He has formed some sort of idea of his own about the relationship of this shape and color.

**FRIEDL DICKER-BRANDEIS TO HILDE KOTHNY, UNDATED (1940)**

*My dear old woman!*

Do not be surprised that I've been silent for so long. Only now I am writing you sixteen pages. At the end of the month, Pavel is leaving his job. (He is plunging right into carpentry and is very happy about it.) This news is slowly penetrating through every level of my being, well-padded as I now am… The death of Diva's [Laura Schimková] husband took much from me.

**FRIEDL DICKER-BRANDEIS TO HILDE KOTHNY, APRIL 26, 1940**

**View in Hronov. Circa 1938-40.**
**Pastel on paper. 36.5 x 46.5 cm.**
**Private collection**

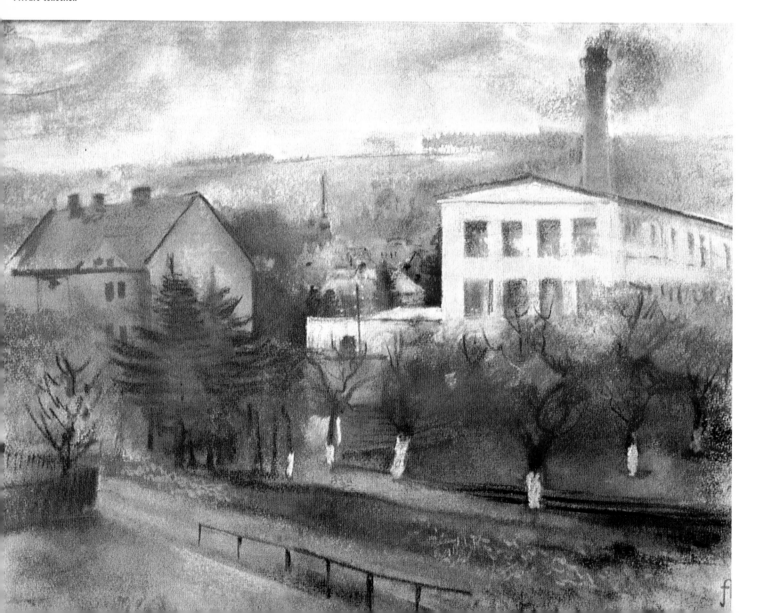

My dear good girl,

What joy your interest in art gives me. This is such an interesting task for me, to acquaint an uninitiated person, one who does not draw, with art—moreover, to do it at a distance. You are making me put in order various things, and I see how much remains to be corrected in my teaching methods.

I sleep badly now. I often wake up and think about where I should begin with you. Your remark not to begin with contemporary art leads me to assume that you (as evidently any person) want to have an idea of the history of art in order to introduce some sort of primal order into the chaos of forms that you have grasped during the course of a lifetime. My chief principle consists in the belief that the student, not through 'study' or working on his own, can plunge fearlessly into this chaos...

It is important that you become acquainted with each style separately—chronology is not the most important thing in art history. On the other hand, it is not always correct to assume simplicity to be the starting point and complexity the end result. It is important not to let yourself become entangled in details, to know how to see everything in the aggregate...

I find another method more congenial: to take one thing, for example African sculpture, and through it become acquainted with proportions and rhythm...

That you like Michelangelo...is already good. The one bad thing is that you are accustomed to looking only at the finished works, but not at sketches. Finished perfection, alas, is not easily attainable. The scale is lacking to judge or analyze the work's details—and that is important if you want not only to see, but also to understand...

Would it be possible to get a reproduction—a postcard or something like that—of the picture that the

**Landscape in Zdárky. Circa 1938-42.
Oil on canvas. 48 x 63.
Private collection**

*Führer bought at an exhibition in 1939, a nude (female) with a helmet, I think. An allegorical figure? People here are interested in contemporary German art. If yes, send one or two very cheap ones.*

**FRIEDL DICKER-BRANDEIS TO HILDE KOTHNY, UNDATED (1940)**

*About Salvador Dali…It is not worthwhile to look at his pictures from the point of view of whether you would hang them in your apartment. For my part, I can say: not for anything in the world. But the time will come when they will hang in a museum alongside the greatest representatives of spiritual culture of his time. If these pictures do not give pleasure, then the issue is not the artist, but the time that he represents.*

*The present day in Salvador's pictures is represented, for example, in the portrayal of the piano with the terrible creature under the lid, or the automobile driving along the destroyed bridge, or the woman with the hole in her body through which a part of the landscape is visible, or the small child in the sailor's outfit with feces on his head, or the railroad by the Greek columns, or the collection of mounted butterflies on the background of a seascape. These signify, one, the consonance of all these things with the aesthetic consciousness; and, two, complete freedom from any inhibition or complex…*

*In this sense, Salvador is an extreme, if not a clinical, case…of when aesthetics appear to be the only defense against chaos. However, not the most powerful one. Aesthetics are the ultimate authority, the moving force, the motor capable of creating production, while defending man from forces over which he has no control.*

**FRIEDL DICKER-BRANDEIS TO HILDE KOTHNY, HRONOV, DECEMBER 9, 1940**

*Right now I am not getting on at all well! I feel like a caged wild animal, and that is how I act. I get into such fits, but they pass. I hope that I will not commit some folly, although that is exactly the mood I am in. It is already five months or even longer now that I have not been working…*

*I do not know what will happen with the apartment. Everything has been abolished again, and in such a vile way. People nowadays are worthless.*

*I ask myself whether art in general will exist in the newly created regime. The sacrifices it demands are so huge, so excessive, and require such an enormous number of victims.*

**FRIEDL DICKER-BRANDEIS TO HILDE KOTHNY, UNDATED (1940)**

**Landscape. 1938.
Pastel on paper. 48.2 x 62 cm.
Private collection**

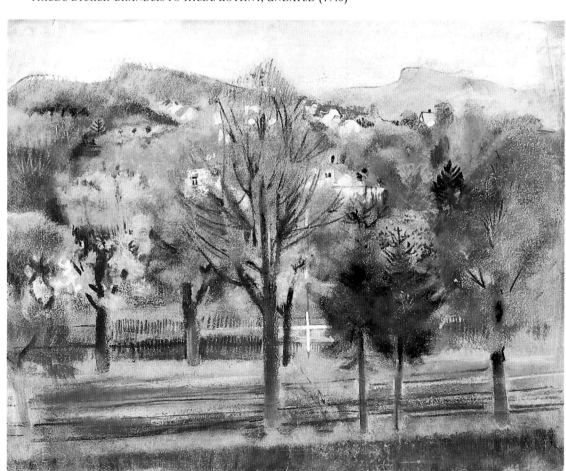

*Pavel needs a gray hat. For our walks, the only things we lack are a knapsack and two pairs of woolen socks. Apart from that, we have everything…*

*If we might still have half a year, that would be perfect….*

*I will draw a lot—to fill the unbearable void…Oh, how I dream of drinking a cup of tea with you, or water, or beer and gorging on fish. Sometime the day will come when you and I will sit in silence and look out the window…*

**FRIEDL DICKER-BRANDEIS TO HILDE KOTHNY, HRONOV, UNDATED (EXCERPTS FROM LETTERS FROM 1941)**

*I think about you constantly during the intervals between letters. I talk with you and picture your life to myself—all this expands the world around us. It is as if the tale of "A Thousand and One Nights" had never come to an end, since Scheherazade is as inexhaustible as life itself…*

*What you write about your idea of God, about your unshakable belief, soothes me deeply. I wish that everyone had the freedom to say it…*

*I dreamed of you. We seemed to be traveling by train. We had hidden ourselves from everybody, from the collapse. Again we were together. We were wandering around some Gothic city. There was some sort of illumination, a flash of lightning, like on Brueghel's "Crucifixion." Around us you could hear the Hitler Youth singing. Then we ended up in a train… and we laughed awfully loud at your extraordinary elegance…*

*And when it is already impossible to see any sense in this life, there remains only one thing—love. And love is so wonderful that you should never grieve. "Fame" is only meaningful for a certain period of time, but searching is always meaningful. If I could put up a monument to you, I would inscribe on it the following: Look, here is a person who lives…*

*I am writing with a pencil because it helps me save paper. If it annoys you, tell me, particularly if it is illegible…*

**FRIEDL DICKER-BRANDEIS TO HILDE KOTHNY, HRONOV, SPRING 1942**

**Landscape by Zdárky. Circa 1938-40.
Pastel on paper. 38 x 58 cm.
Private collection**

*Your point of view is clear and unambiguous. You have this fixed point of view, but it is not the same for me. I waver back and forth between the two, and this is where my paralysis and disquiet comes from.*

*...My "persecution complex" lies in the fact that I am afraid to deceive my friends who trust me or to be caught by them unawares...You call upon me to answer, but at times I am seized by such powerful doubts...*

*Why does a person believe in Paradise? For now I am saved by painting and fresh air...A person seeks some authority which would be incorruptible and would meet the very highest demands. That is why a person needs God!...*

*Now is the time when belief needs to be put into practice. There are a thousand manifestations which could be either true or false, as implementation alone teaches: love your neighbor as you would love yourself; do not judge each act or person by different standards. That is the principle for the conduct of a believer. But if as a believer you still have doubts, act according to the dictates of your conscience.*

*They say that one lives only to die. So let us die for the Right Thing!*

*No one person has privilege over another, nor one nation over another nation. It is impossible to use as a measure something which changes at will.*

*We have so much time to think about everything important. Everything is questioned—I mean, how it will end—and because of this everything connected with religion now seems the most important. Questions about politics and responsibility now have to be decided by oneself...It seems to me that I will still break out of here.*

**FRIEDL DICKER-BRANDEIS TO HILDE KOTHNY, HRONOV, MAY 1942**

**Pavel with a Book. 1939.**
**Pastel on paper. 49 x 61 cm.**
**Simon Wiesenthal Center, Los Angeles**

# Regarding books, your help is invaluable. I am interested in everything. We read voraciously, as we keep in mind that too little time remains before we are sent further on.

FRIEDL DICKER-BRANDEIS TO HILDE KOTHNY, HRONOV, UNDATED

In letters to her friend Hilde Kothny, Friedl Dicker-Brandeis mentioned the following authors and their works amongst the reading she had done in Hronov:

PHILOSOPHY:
Wiesengrund,
Trott, Kierkegaard's *Fear and Trembling*,
Hegel,
Paul Kammerer,
Kütemeyer's *Panorama*,
Weizeker's *Doctor and Patient*,
Dallago's *Great Ignoramus*,
Levy-Brühl's *The Thinking of Primitive Peoples*,
Moses Mendelssohn (essays on Lessing),
16 lectures by Simmel on Kant, Voltaire on education,
Herder's *Ideas*,
Gandhi…

ART:
Van Gogh's letters,
Max Dvorak and Wilhelm Hausenstein on the history of art,
Alois Riegel's *The Dutch: A Group Portrait*,
Ludwig Münz's *Caravaggio*, *Art of the Blind*,
Goethe's *Italian Journeys* with illustrations,
the journal *Kunstblatt* for the year 1918…

LITERATURE:
Leo Tolstoy's *War and Peace* and *Resurrection*,
Dostoyevsky's *Notes from the House of the Dead*,
Josef Roth's *Radetzky March*,
Franz Kafka's *The Castle* and *The Trial*,
Murger,
Jean Barrois,
Anatole France (with Brandt's introduction),
Marcel Proust's *Swann's Way*,
Flaubert's *Sentimental Education*,
Roger Martin du Gard's *The Thibaults*,
Kleist,
Maxim Gorky's *My Universities*,
Bertolt Brecht…

… *Can you borrow Dvorak and Riegel for me (it does not matter about what, because they treat work methods, give a good history of art, they are proper books that give the historical background).*

…*Read Herder's "Ideas"! I would give a lot to get it. I do not want to burden Duckie [Lizzie Deutsch]. Get Flaubert's Sentimental Education. Do you have any Kleist? I already found him and will send it to you if you want.*

…*Ardent thanks for the Herder! …He arrived just at the moment I especially fervently longed for him…*

…*I had hoped to send you Degas, but was not able to get it. I am sending Manet, it is a hideous edition, the color is bad and the paper is gray… Did you receive the poor, dull reproductions of Paul Klee along with the Rouault picture? …I am sending Kafka; read him. If you are not in the mood, read the chapter "The Cathedral" and send it on to Margit, from whom I have not heard anything.*

…*Do you have any more books by Trott? I would read them with pleasure.*

*Above:* Begonias on a Windowsill.
Circa 1934-36.
Pastel on paper. 49.5 x 60.5 cm.
Jewish Museum, Prague

*Opposite:* Portrait of Maria Brandeis.
Circa 1938-40.
Pastel on paper. 60 x 45 cm.
Jewish Museum, Prague

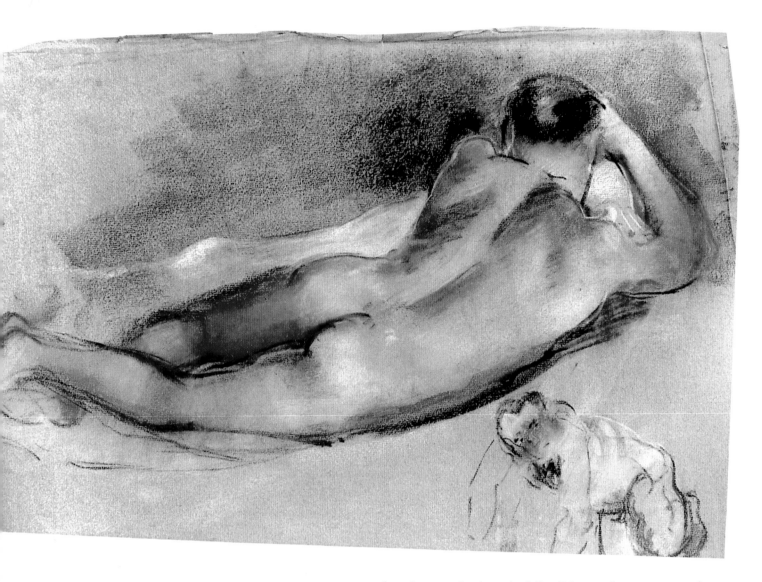

**Nude of Pavel Brandeis. Circa 1938-42.
Pastel on paper. 49 x 61 cm.
Simon Wiesenthal Center, Los Angeles**

*Beginning June 1st, Pavel will work for a farmer and only in the fall will he start his carpentry work. In the village where Pavel will work we have rented a little house that consists of one room and a shed for goats (there are four charming kids there now), a hall, and bathroom. If we do not find other housing here, we will move to Nachod in the fall or even to Neustadt. The little house has everything we need. We will keep our furniture in storage so as not to be tied down...*

**FRIEDL DICKER-BRANDEIS TO HILDE KOTHNY, HRONOV, APRIL 26, 1940**

*I saw a simple blue milk jug and, without a model, I painted it blue with the sense that I was falling down from the fourth floor and was just about to break my neck.*

**FRIEDL DICKER-BRANDEIS TO HILDE KOTHNY, HRONOV, UNDATED**

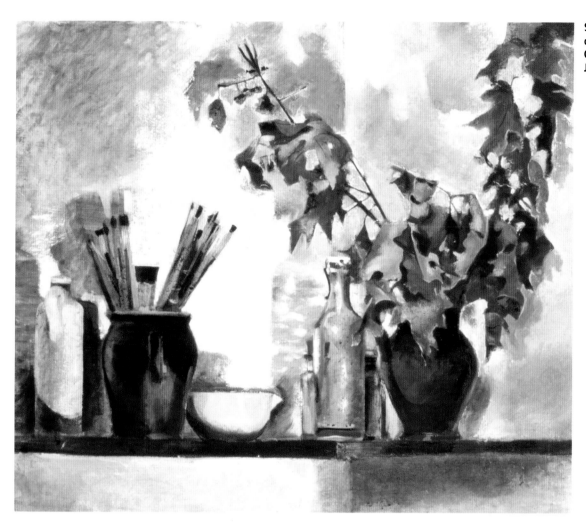

Still Life with Brushes, Bottles
and Leaves. 1940.
Oil on canvas. 69.5 cm x 82.5 cm.
Jewish Museum, Prague

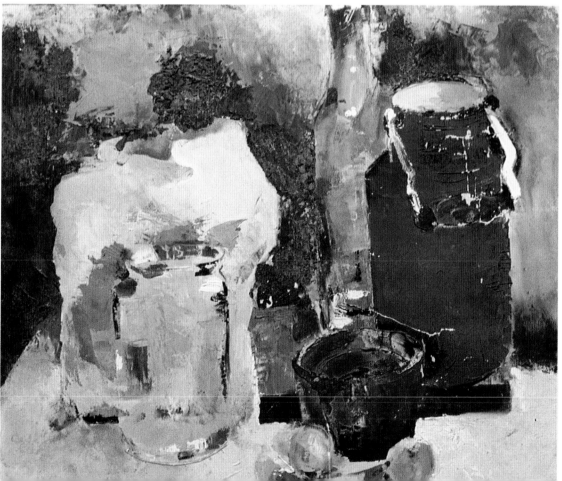

Still Life with Blue Milk Jug. 1941.
Oil on cardboard. 42.5 x 54 cm.
Private collection

I am tired beyond all measure. Therefore, I will answer the questions briefly. The expression "Impressionists" comes from the title of the picture "Impression." Later it was applied to a group of artists whose task was to convey a feeling, an impression.

Another group, the Expressionists, give expression to that which takes place within them as they contemplate an object in formal terms. Both of these movements, as you can see by their names, are of a purely personal nature, i.e., psychologically, they are exceptionally pure and honest. I will tell you more about their theories and what they achieved when you are here and I can show you examples…

Then come the Futurists, who, strictly speaking, are the same as the Impressionists, only they focus on "objects" and their dynamics, their movement. Almost every contemporary modernist picture, to some degree or another, is cubist.

The Surrealists have their own clearly defined program. They primarily like to portray that which is psychological, including such things as dream visions, that is, things that do not exist in reality, as well as everything that visually attracts and disturbs.

However, among all these "isms" there are too few great artists and too many names…

Yet another day has passed. I sit in the country castle by the kerosene lamp. There is a thunderstorm now and all around deep (I almost wrote peace), deep rest. The magic of the landscape here would enthrall you… and I would be able to show you all of the movements in art…in order to experience, to understand better than what is written in these ruins of letters, these ragged thoughts…

We gathered six kilos of mushrooms in just five minutes and made a dish that would have been the peak of perfection if somebody we love could have enjoyed it with us…

**Josef Knytl's Farm in Zdárky.**
**Circa 1940-42.**
**Pastel on paper. 59 x 60 cm.**
**Private collection**

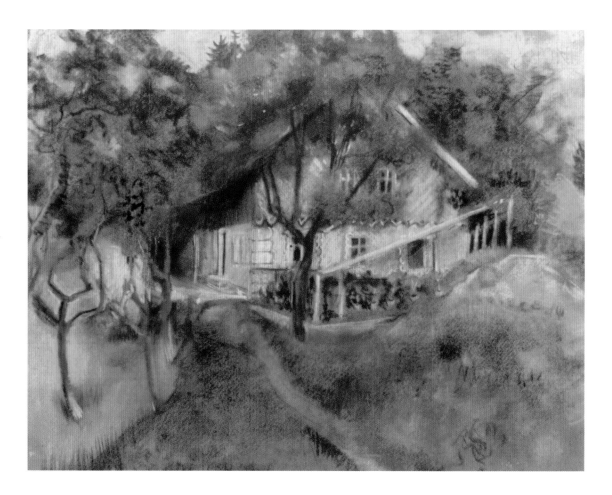

*...I am reading an interesting book about education. I remember thinking in school how I would grow up and would protect my students from unpleasant impressions, from uncertainty, from scrappy learning. Today only one thing seems important—to rouse the desire towards creative work, to make it a habit, and to teach how to overcome difficulties that are insignificant in comparison with the goal to which you are striving...*

FRIEDL DICKER-BRANDEIS TO HILDE KOTHNY, IN MAY 1940

*Far left:* Josef Knytl in front of his farm. Photograph by Elena Makarova, 1988. Private collection

*Left:* View of Zdárky. Photograph by Elena Makarova, 1990. Private collection

*The people were very helpful. Under the Protectorate, Jews were only allowed to live in designated houses. We had a large house at Palackéhostrasse 3, by the theater... Laura, Zdena, Friedl and I shared a path six kilometers long, and Friedl stopped again and again to sketch something. She painted a beautiful picture: the Knytl's cabin.*

LYDIE GOLZNEROVÁ IN CONVERSATION WITH ELENA MAKAROVÁ, JERUSALEM 1992

*Below:* Landscape near Zdárky. Circa 1938-42. Pastel on paper. 33 x 59 cm. Private collection

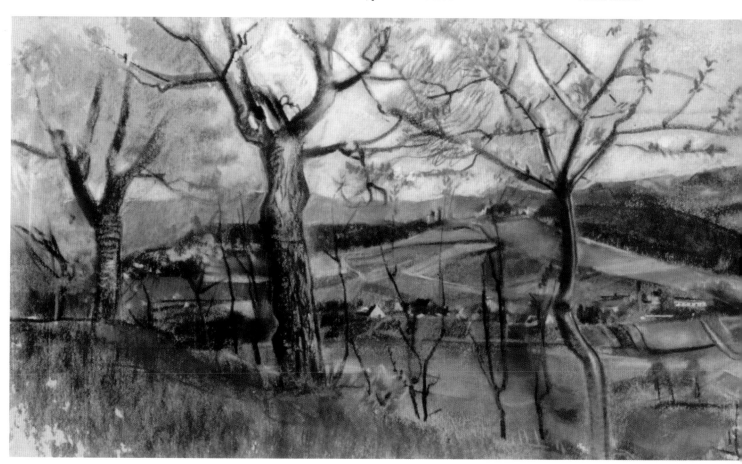

**Pavel and Maria Brandeis. 1939.
Pastel on paper. 46 x 62 cm.
Private collection**

*My dear!*

*I am taking another day off! I am sitting in the sun with a small pipe…A bee climbs up the window pane and buzzes angrily. It is amusing to watch how this silly creature tries to break through the glass and not the open window.*

*In reality, I am thoroughly depressed, and this expresses itself in such 'forbidden' but instinctive little joys which separate me from the whole world and its passions, cares, smugness. Pangs of conscience are simultaneously my punishment and my paradise—and now there is a second bee!*

*At the present moment, I am absolutely removed from everybody , and in this I am like the bee on the windowpane. The only difference is that I do not have a choice. My consciousness has been deadened…A person who is not afraid more often than not takes the right step: I would choose the open window—the bee just found it and flew away…*

*…There was a time when I so wanted to be in the know…I was torn between earning my bread, lessons, running around, painting and my personal life. I did not have enough breath to dedicate myself to piety.*

**FRIEDL DICKER-BRANDEIS TO HILDE KOTHNY, HRONOV IN APRIL 1942**

*All the things you come up with on the subject of religion, hell and such horrors, do not exist for me. What you say about the form of life (Christ and the Apostles) is not at all the way you paint it for yourself... They did not live on a deserted island like Robinson Crusoe... Each of us lives on the island he chooses.*

    FRIEDL DICKER-BRANDEIS TO HILDE KOTHNY, HRONOV, JULY 29, 1942

*Pavel has been sick for five days now. He fell on a board and bruised his ribs, In addition, he has a cold and is sneezing. Still, he is full of good intentions. Thanks to him I can still breathe and maintain the remnants of equilibrium.*

*I tidy up our single room. I read at odd moments, standing on one leg like a goose until my conscience starts bothering me and then I start doing something again: darning, mending, not much can be done...*

*Recently I sorted through some old rubbish—because of the housework I am unable to be away from the house. Several times I managed to hear some lectures on art, and I have spoken to a few young people about art. Earlier I was studying English, but I gave it up out of frustration and lack of money and a teacher. I have sat down to learn Czech many times.*

*I constantly have the feeling that something needs to be done, and I am neglecting it. For the last 14 days I have mopped the steps and yard in front of the house. Every fifth day I go shopping. I see a certain decent woman [Anna Sládková] unfortunately, only once a week.*

    FRIEDL DICKER-BRANDEIS TO HILDE KOTHNY, HRONOV, SEPTEMBER 24, 1942

*...It is white all around; the skiing is delightful...One of the most enchanting places is Peklo, which means 'hell' in Czech. Although everything, from the wonderful food to the marvelous little mountains, does not resemble 'peklo'.*

*...In the evenings heart-to-heart talk and instantaneous slight intoxication...*

*Your birthday is coming soon. I wish you everything you deserve. May everything be fine. I will describe for you everything that you will receive from us as a present, since I do not know when this will happen or how exactly...*

*From Pavel, a sweet print of El Greco's 'Lady.' From me, Tintoretto and a silly, but I think attractive, brooch, and a picture that I once began for Duckie [Lizzie]. Its completion depends on egg whites...*

*Your last letter was terribly disturbing. In it, one sees all of your sadness, irritation, and the lack of what is most essential, all your paralyzed energy, including your relationship with me.*

*You write that you read my letter three times, trying to understand where you can help. It is not always necessary to act; often it is enough to understand. Besides you probably do not remember that you had asked me about several things; the letter was a reply. It is not surprising that it was so incoherent and that the facts are not set forth in the expected order. All my strength was spent on recognizing those facts.*

*You have helped me so much during this last year to bring order within myself (as far as that is possible). Instead of a desire to help, you may rest on your laurels, knowing that the result has been achieved and that I would not have coped on my own...Your anxiety is to blame for all this, the grounds of which, unfortunately, color the surrounding circumstances. As well, it is true that I regard all of this more lightly, though I think the same way as you all do...*

*You ask, what is God for me? I will hardly be able to answer. Kierkegaard could have helped me here, with his precise definition of three spheres: aesthetics, ethics and only then religion; and Dallago with his quietly broad understanding... For me God is, one, a certain scale without which everything is askew and vague; two, a direction of movement, because without direction any movement is arbitrary and senseless; three, a thirst for mercy, because its short supply drives one mad. I do not know why my faith has been shaken; perhaps I blame Him for the scope of the present suffering...*

*You correctly sensed from my last letter that the cramps have eased, in large measure thanks to you. I thank you with all my heart. It is all the sadder that in all your difficulties, there is not a person to whom you can turn, like I can to you...*

*Your assertion that faith is passive seems false to me. In all times there have been militant believers. That faith can be preserved in passivity is merely one of a hundred possibilities...*

**FRIEDL DICKER-BRANDEIS TO HILDE KOTHNY, HRONOV, NOVEMBER 16, 1942**

*It was Friedl's dream. She jumped out of bed and immediately started to paint, right on the canvas. Friedl was always creating allegories: Don Quixote, the development of Pythagoras... her never-ending allegories.*

*I begged her to sell me that painting, but she could not be persuaded. After prolonged arguments, she finally gave it to me a short time before her deportation.*

**HILDE KOTHNY ON "DON QUIXOTE AND LENIN," IN CONVERSATION WITH E.M., GENEVA, MOSCOW, VIENNA 1988-1999**

**Flowers on the Edge of the Forest.
Circa 1938-40.
Pastel on paper. 46 x 57 cm.
Private collection**

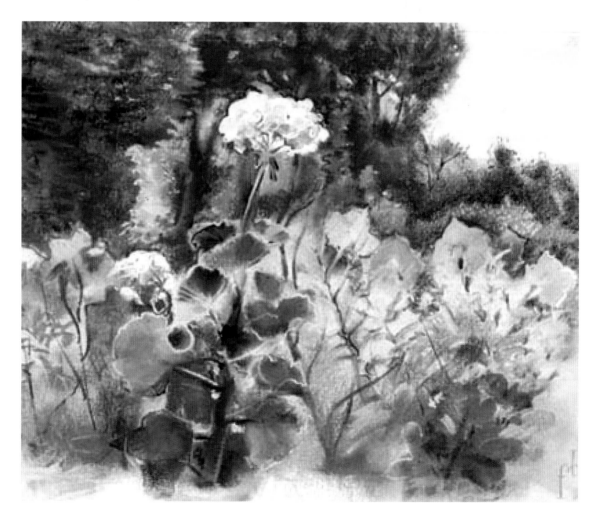

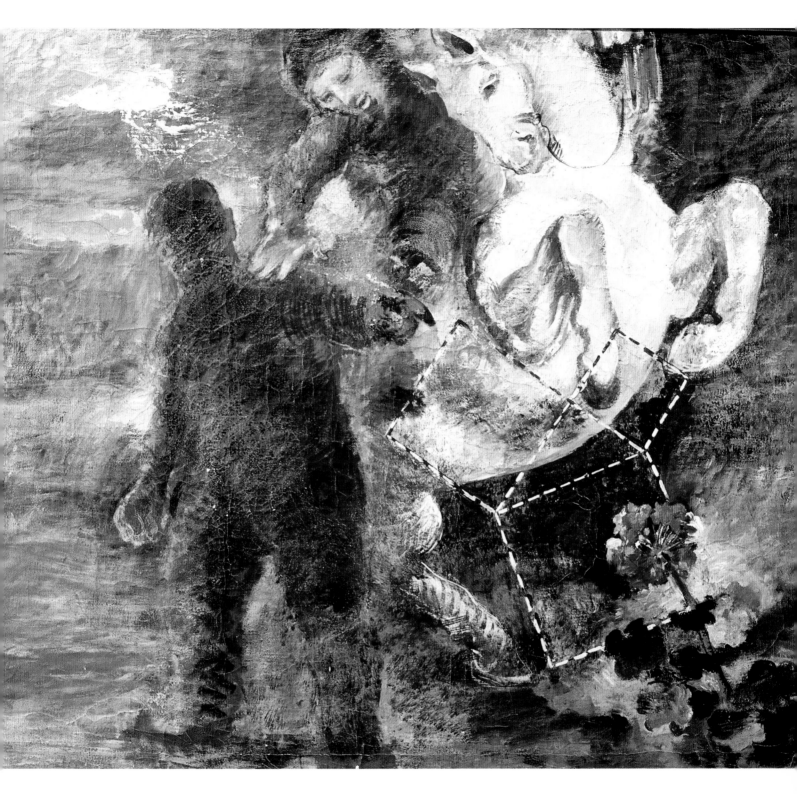

Don Quixote and Lenin. Circa 1940.
Oil on canvas. 77 x 100 cm.
Private collection

Pavel Brandeis. List of Pavel Brandeis's
personal possessions for the transport
to Theresienstadt. 1942.
Pencil on paper.
Simon Wiesenthal Center, Los Angeles

# THERESIENSTADT

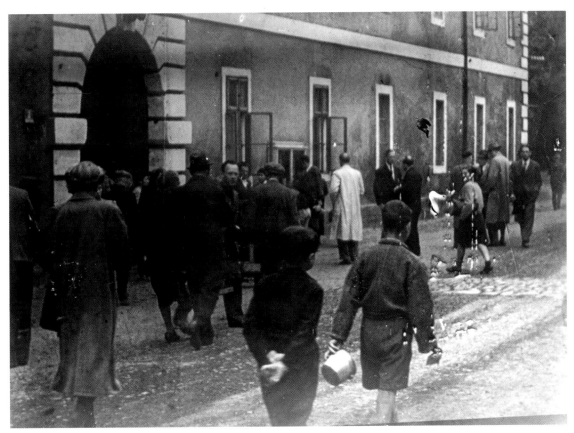

Main street in Theresienstadt.
Photograph, 1944.
Yad Vashem Archive, Jerusalem, Israel

*Below:* House L 410:
View from the Window. 1944.
Pastel on paper. 32 x 49 cm.
Simon Wiesenthal Center, Los Angeles

Theresienstadt, town center.
Photograph by Rita Ostrovskaya, 1998.
Private collection

View of Theresienstadt. 1943/44.
Watercolors on paper. 30 x 44 cm.
Simon Wiesenthal Center, Los Angeles

Untitled. 1943/44.
Watercolors on paper. 27.5 x 41.5 cm.
Simon Wiesenthal Center, Los Angeles

House L 410: View from the
Corridor Window in
Friedl Dicker-Brandeis's Room. 1944.
Pastel on paper. 49 x 32 cm.
Simon Wiesenthal Center, Los Angeles

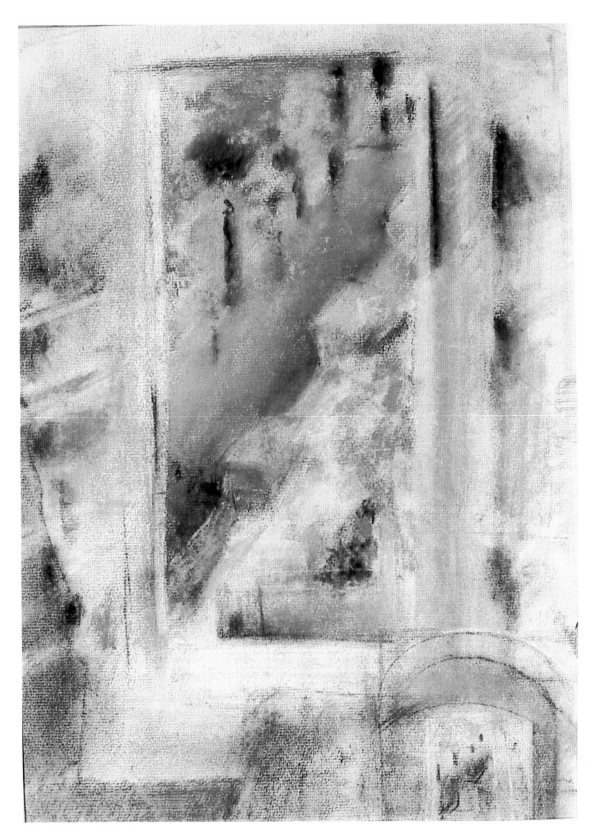

Untitled. 1943/44.
Pastel and pencil on paper. 28 x 22 cm.
Simon Wiesenthal Center, Los Angeles

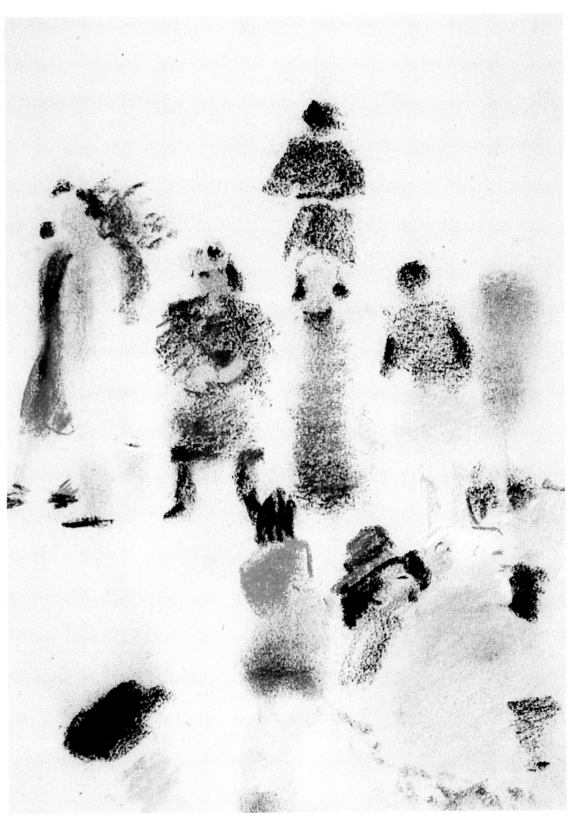

Plan of the room. 1943/44.
Pencil on paper. 14 x 18.5 cm.
Simon Wiesenthal Center, Los Angeles

Plan of the room. 1943/44.
Pencil on paper. 15 x 21 cm.
Simon Wiesenthal Center, Los Angeles

Design for a folding bed. Circa 1942-44.
Pencil on paper. 36 x 12 cm.
Simon Wiesenthal Center, Los Angeles

Portrait of a Woman. 1943/44.
Gouache and tempera on cardboard.
43.5 x 33 cm.
Simon Wiesenthal Center, Los Angeles

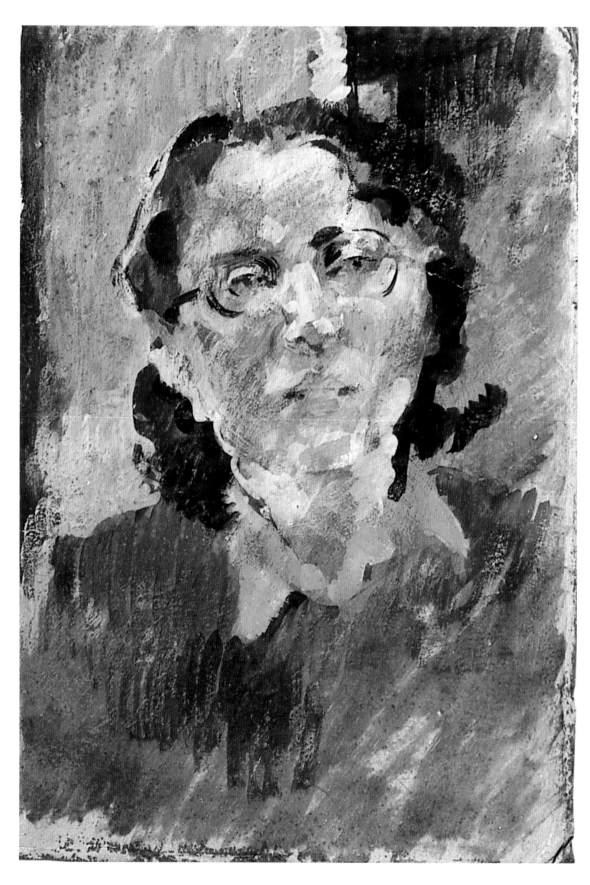

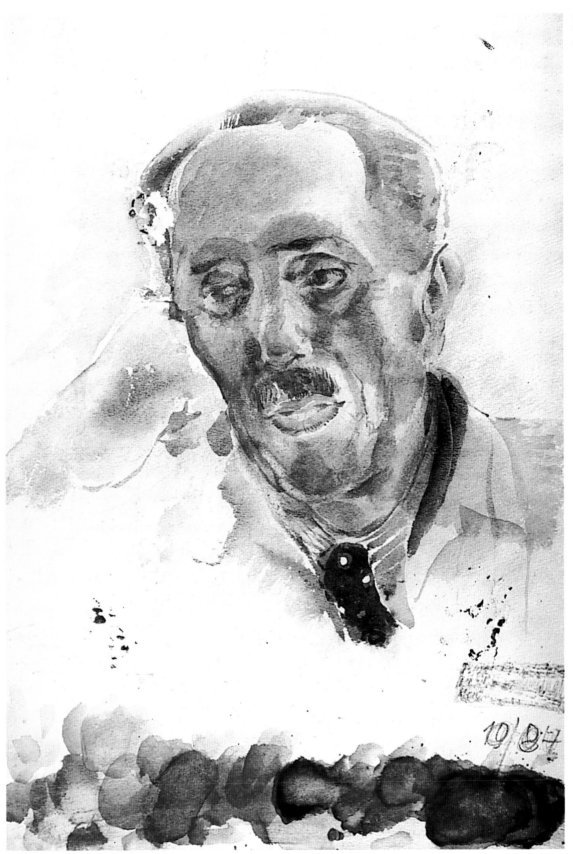

Portrait of a Man. 1943/44.
Watercolors on paper. 44 x 30 cm.
Simon Wiesenthal Center, Los Angeles

Nude Sitting. 1943/44.
Pencil on paper. 45 x31 cm.
Simon Wiesenthal Center, Los Angeles

Nude Sitting. 1943/44.
Pencil on paper. 45 x 32 cm.
Simon Wiesenthal Center, Los Angeles

Portrait of a Man. 1943/44.
Pastel on paper. 43 x 32 cm.
Simon Wiesenthal Center, Los Angeles

Portrait of a Young Man. 1943/44.
Pastel on paper. 42 x 31 cm.
Simon Wiesenthal Center, Los Angeles

Sketches for a Portrait of a Young Man.
1943/44. Pastel on paper, cut out
and stuck together. 39 x 25 cm.
Simon Wiesenthal Center, Los Angeles

View in Theresienstadt. 1943/44.
Gouache on paper. 44 x 29.5 cm.
Simon Wiesenthal Center, Los Angeles

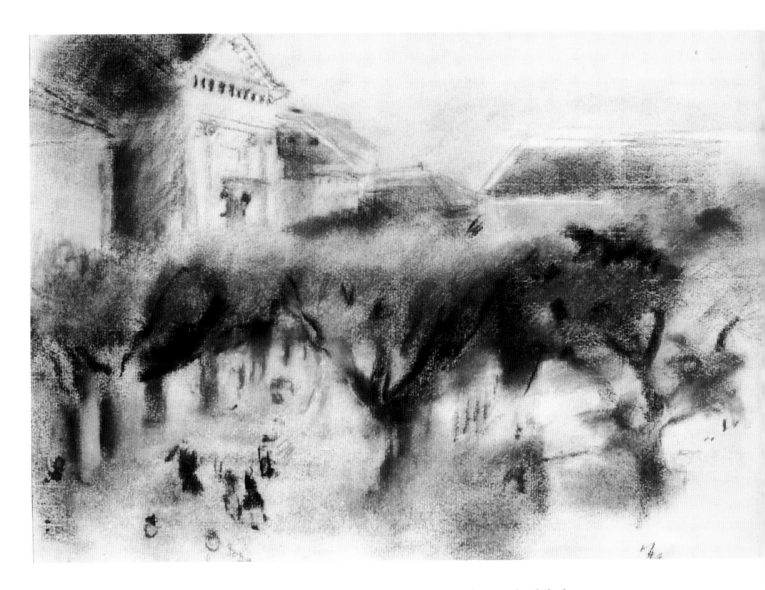

View in Theresienstadt with Church.
1943/44. Pastel on paper. 32 x 49 cm.
Simon Wiesenthal Center, Los Angeles

Four pictures of scenes:
"IV Negotiations with the Landlord,
V Banquet, VI Dream,
VII The Next Morning"
(possibly for "A Girl Travels
to the Promised Land"). 1943.
Watercolors and pencil on paper.
21 x 30 cm.
Simon Wiesenthal Center, Los Angeles

Sketches of costumes for
the performance of
"The Little Beetles." 1943.
Pencil on paper. 44.2 x 30 cm.
Simon Wiesenthal Center, Los Angeles

SEPTEMBER 1943

EIN MÄDCHEN REIST

INS GELOBTE LAND.

KINDERREVUE

IN 14 BILDERN

VON HELLI HALBERSTADT

UND HEINI DEUTSCH.

Regie: W. Freud
Ausstattung: Arch. Fr. Zelenka
Kostüme: Prof. Friedl Brandeis.

Es spielen:
Jugendliche aus L 414
6 Wiederholungen.

Walter Freud. Poster for the
performance of "A Girl Travels
to the Promised Land." 1943.
25 x 20 cm.
Památnik Terezin, Theresienstadt

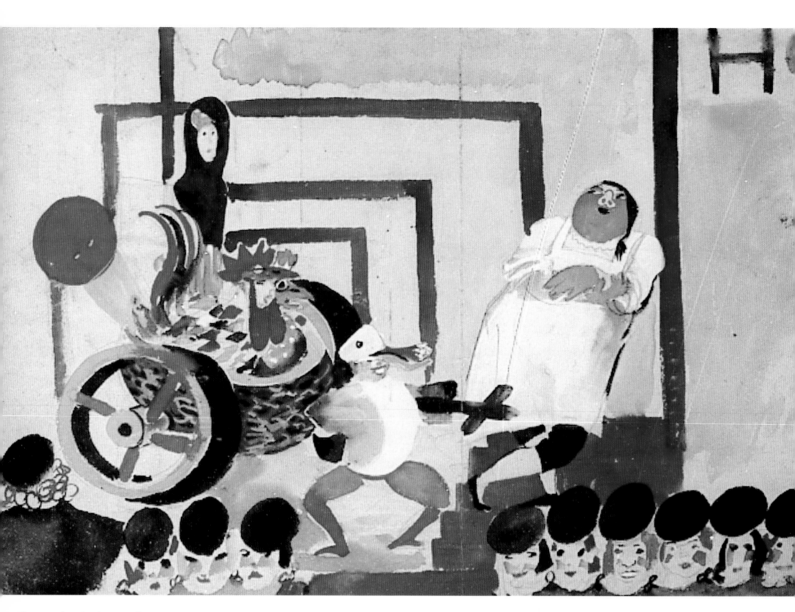

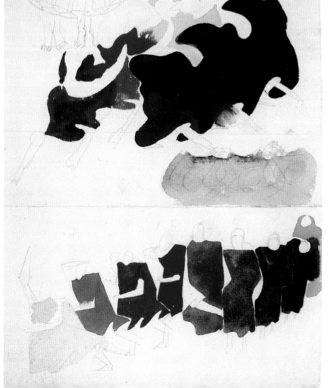

*Above:* Set design and costume design (possibly for "The Adventures of a Girl in the Promised Land"). 1943. Gouache on paper. 27.5 x 42 cm. Simon Wiesenthal Center, Los Angeles

*Left:* Design for a Ballet by Kamila Rosenbaumová. 1943/44. Watercolors and pencil on paper. 30 x 23 cm. Simon Wiesenthal Center, Los Angeles

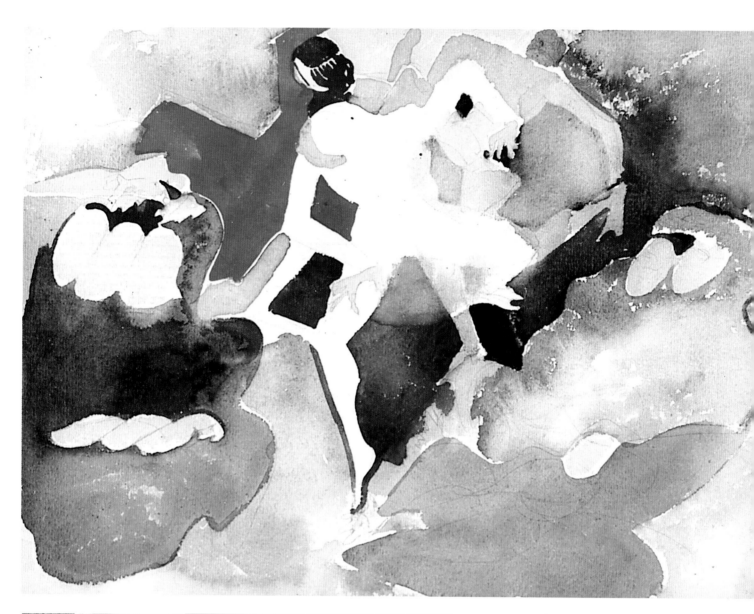

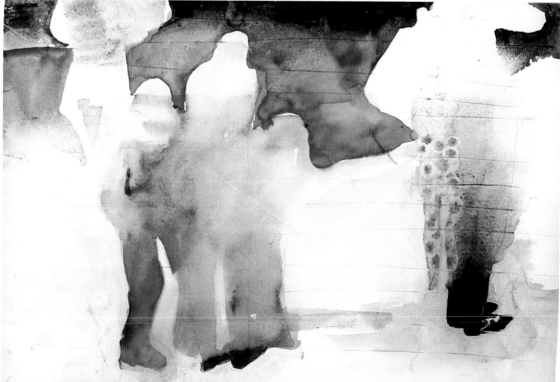

*Above:* Design for a Ballet by
Kamila Rosenbaumová. 1943/44.
Watercolors on paper. 22 x 30 cm.
Simon Wiesenthal Center, Los Angeles

*Left:* Untitled. 1943/44.
Watercolors on paper. 22 x 30 cm.
Simon Wiesenthal Center, Los Angeles

Design for a ballet by
Kamila Rosenbaumová:
"Line and Surface." 1943/44.
Watercolors and pencil on paper.
30 x 23 cm.
Simon Wiesenthal Center, Los Angeles

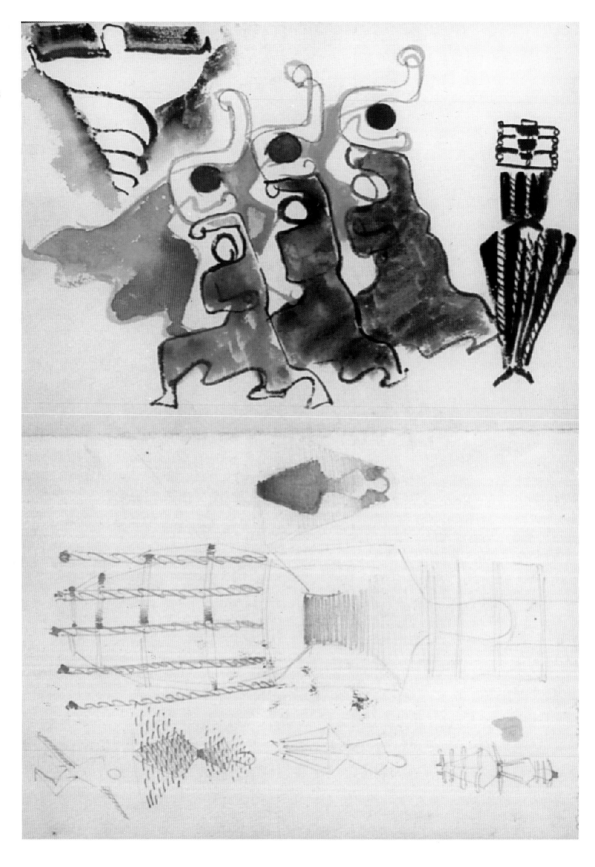

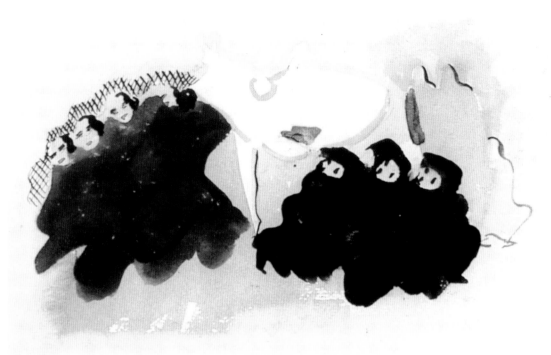

Design for a ballet by
Kamila Rosenbaumová:
"First warm / warm cold in 2 /
battle lines / then mixed rows..."
1943/44.
Watercolors and pencil on paper.
30 x 23 cm.
Simon Wiesenthal Center, Los Angeles

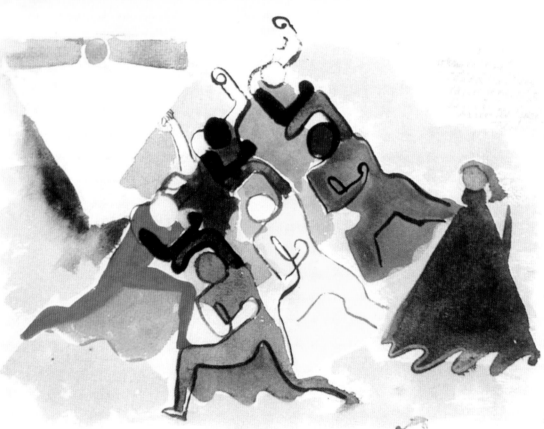

Courtyard of Girls' Home L 410.
Photograph by Rita Ostrovskaya,
1998. Private collection

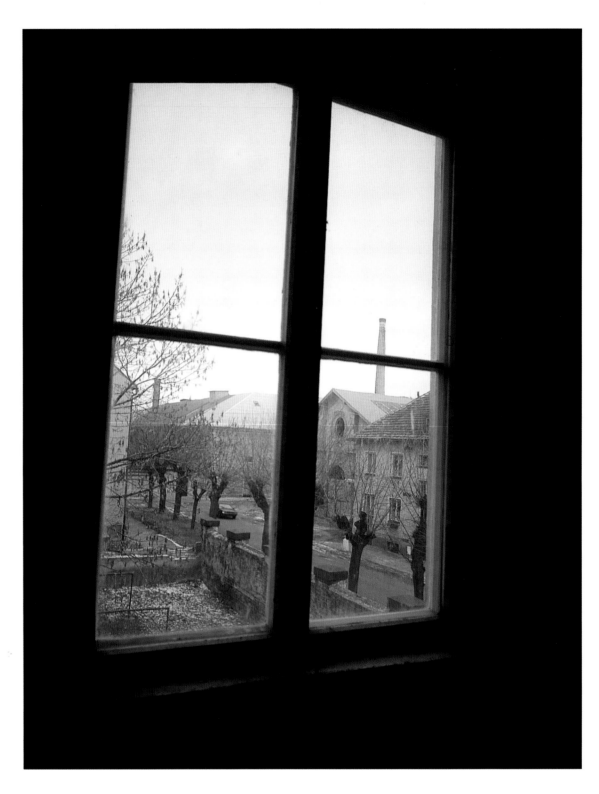

*Opposite:* View of the Courtyard of Girls' Home L 410. 1943/44.
Watercolors on paper. 44 x 30 cm.
Simon Wiesenthal Center, Los Angeles

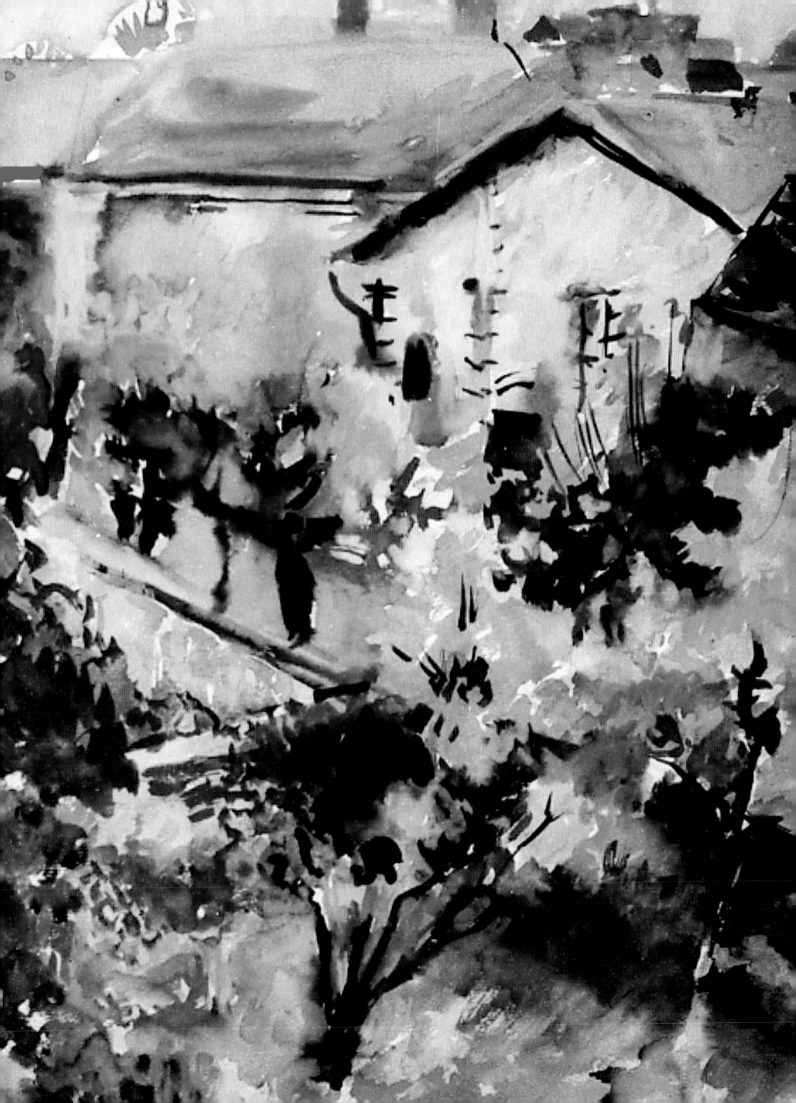

Bouquet of Flowers with Keys. 1944.
Watercolors on Paper. 39 x 28 cm.
Simon Wiesenthal Center, Los Angeles

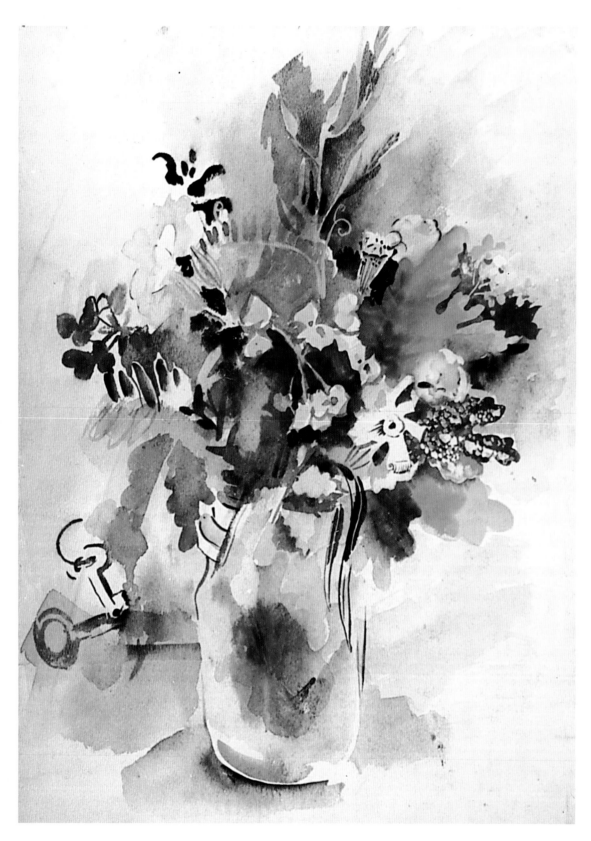

*Opposite:* Bouquet of Flowers with Key. 1944.
Watercolors on paper. 28 x 28.5 cm.
Private collection

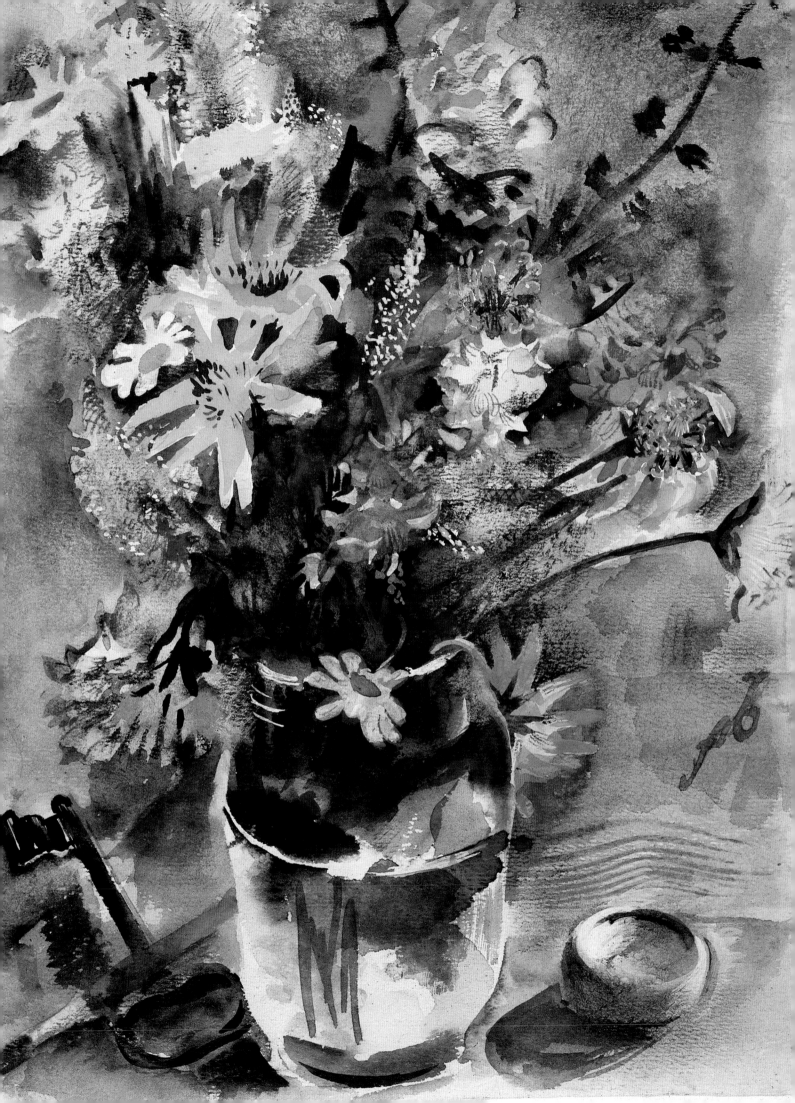

**Postcard from Friedl Dicker-Brandeis
to Otto and Maria Brandeis. 1944.
Private collection**

*Hello to both of you!*

*We are happy to have suddenly formed a small family. Both girls [Otto Brandeis's daughter Eva and her friend Gerti] are very pleasant and funny and have adjusted well. If things remain as they are, they will really gain something from their time here.*

*I am happy about the good foundation you have laid with Eva. It is much easier for her than for Gerti. She does well with everything. She is a sound, strong, reliable, warm, dear woman. What they did not learn at home, they are learning here. They make us very happy. I draw and paint with all possible intensity.*

**FRIEDL DICKER-BRANDEIS TO OTTO AND MARIA BRANDEIS. THERESIENSTADT, AUGUST 6, 1944**

Untitled. 1943/44.
Watercolors on paper. 22 x 30 cm.
Simon Wiesenthal Center, Los Angeles

**Letter from Friedl Dicker-Brandeis to Willy Groag from August 8, 1944. Beit Theresienstadt, Kibbuz Givat Chaim, Israel**

*Dear Willy!*

*If I were a fairy, I would have presented you with a magic gift on your birthday…But how is one to receive a magic gift? First, I'll explain what it is. This magic gift certainly is to be found in your soul and seeking signs of its presence alone will bring you joy.*

*…You did not choose religion or science; you did not choose a simple life or a career in politics. You are attracted by creativity. Those who are carried away by religion, science, an easy life or politics advance along their own paths. Therefore, my constant piece of advice: unravel the tangle of difficulties, being guided by inspiration and instinct. A thread per day—and the tangle will gradually unravel, and this will enrich you.*

*Our internal resources can seem pitiful and meager, which causes anguish. But you must believe that we will lose our foundation for building life—we will lose our life-giving force—if we fear that our search within ourselves will reveal some sort of unexpected filth or turn up empty.*

*Let us look at three hypotheses:*

*1. Talent was not given to us by nature in the cradle.*

*2. Now is not the time to discover it.*

*3. A long time is required to discover it.*

Personal card from the Auschwitz Archive. 1944. Private collection
The card contains three mistakes: Friedl Dicker-Brandeis's date of birth, profession and probable transport number (actually Eo)

*Talent is a longing for something. (Sometimes the limitation lies not in the talent itself, but the look within gives birth to bitter disillusionment.)*

*The right moment can be at any time, for longing creates an essential free area on the outside of the dense life material…If your spirit is not weak, you will constantly accumulate experience. Even if you temporarily do not create anything in this sphere, you will always be ready to plunge into it.*

*A long time: It is true that it is even greater than we suppose. But if you have a direction—or what is even better, your own path—then each success, even a little one, will support you.*

*Do not think that I believe that this approach of mine is the only correct one. I also find myself constantly searching…*

*Only here did I come to realize how complicated and queer these transformations are…Ultimately, everything is determined by endurance and overcoming extraordinary obstacles. That sounds banal, but that is the conclusion to which I have come based on my own experience…*

*On your birthday, I wish you all the very best, and mainly, long and deep breathing, which is the most essential thing.*

**FRIEDL DICKER-BRANDEIS TO WILLY GROAG, THERESIENSTADT, AUGUST 8, 1944**

*I visited her painting class. She drew a child's face in my album. I cannot remember asking her for it. She just drew it.*

WILLY GROAG, FORMER DIRECTOR OF GIRLS' HOME L 410 IN THERESIENSTADT,
IN CONVERSATION WITH E.M., 1988-1998

*Opposite:* Child's face. 1944.
Watercolors on paper. 25 x 18 cm.
Beit Theresienstadt,
Kibbuz Givat Chaim, Israel

Hana Lustigová (7/12/1931-10/6/1944).
Color exercise. 1943/44.
Watercolors on paper.
Jewish Museum, Prague

# THE TEACHING

T IS IMPOSSIBLE to undertake an evaluation of drawings by children condemned to death from the perspective of art criticism —this is the logical conclusion that comes from studying the 5000 children's drawings from Theresienstadt. Yet, some evaluation must exist.

When I studied these drawings, I tried to create an image for myself of the world for children in Theresienstadt—of their spaces, their lines, their colors, as well as the influence Friedl Dicker-Brandeis had on them both as an artist and as an art therapist.

The world of these children, who had lived for years under the Nazi protectorate and were finally deported to Theresienstadt, had been broken and had lost its balance without any hope of improvement. This shows itself clearly in the drawings by children on free themes, in which they mostly depict their earlier lives, their beloved homes, their families and familiar landscapes. Coordination and composition, as one knows them from "normal" children's drawings, are distorted and sharply diminished in the pictures by the children of Theresienstadt. Children who have grown up "normally" give their pictures clear coordinates and define themselves in terms of their current reality. The children of Theresienstadt, whose lives had been influenced by existence in the ghetto and by its disrupted space-time continuum, were deprived of this opportunity.

The absence of perspective, an uncertain future, the loss of all orientation and fear of being "transported to the East" had a strong influence on the composition of the children's drawings. Objects are regularly shown from diverging perspectives, and the overall view lacks a clear center. Unlike "normal" children's

Hanuš Perl
(1/8/1932-10/13/1944).
Girls' Home and Church in
Theresienstadt. 1943/44.
Pencil on paper.
Nederlands Instituut voor
Oorlogsdocumentatie, Amsterdam

Ruth Birnbaumová
(8/6/1934-12/18/1943).
Arch and Track. 1943/44. Pencil
on paper. Jewish Museum, Prague

drawings with coherent structure, the drawings from Theresienstadt seem to break down into their individual parts.

The break in the space-time coordinates of the drawings also shows itself in the almost compulsive repetition of a motif, whether ornamental or representational, and in the sudden interruption of lines: the lines of streets as well as the lines of trains, the outlines of mountains, the horizon, etc.

Another motif appears in these drawings that evokes several explanations. A frame that surrounds the picture, taking on the shape of the paper, is perhaps the reflection of the children's lives, fenced in by barbed wire; or, more plausibly from a psychological point of view, their attempt to protect themselves from the reality of the ghetto. Strangely, this motif appears most prominently in pictures by children whose deportation to Auschwitz was imminent, although they did not know it at the time.

Another instance of the spatial distortion is in the placement of the sun. Like the children themselves, it has lost its usual place. It wanders over the paper, sometimes blinking in the barrack room and only seldom smiling.

Children usually perceive reality intuitively, without conscious thought. While the adult artists in the ghetto tried to describe the great tragedy of their people, their outrage, their despair, as well as to express their protest, the children often represented reality exactly as they saw it. Their pictures were often schematic,

Kurt Wurzel
(5/6/1932-10/23/1944).
Girls' Home and Church in
Theresienstadt. 1943/44.
Pencil on paper.
Nederlands Instituut voor
Oorlogsdocumentatie, Amsterdam

and sometimes reality and dream mixed or augmented each other.

Art lessons, a matter of course in every school, were a challenge in the general chaos and the destroyed harmony of Theresienstadt. By revealing the distressed state of her children, Friedl Dicker-Brandeis was able to modify the constraints they had experienced and to break down their tensions. Because they were allowed to express their innermost fears, the children learned to deal with them more fully, and then, to let them go.

For us, when we examine the results of Friedl Dicker-Brandeis's lessons, these spontaneous drawings are also a valuable source for judging her teaching—the method and effect of her lessons. We can clearly recognize how the artist approached the various psychological disruptions of her children and what remedies she used as an art therapist.

It was not enough for Friedl Dicker-Brandeis to reveal the distress within the consciousness of the children. Her goal was to restore consciousness. Rhythmic exercises, drawing from a known fairy tale or a story she invented for the children, model drawing, the study of old masters, freely chosen themes—she applied all the artistic and pedagogic methods she had at her disposal.

The system of her mentor Johannes Itten proved to be indispensable. In Theresienstadt his "theology" of the battle between the sun of light and the sun of darkness became all too real. Friedl Dicker-Brandeis made practical use

Milan Eisler. Burial. 1943/44.
Pencil on paper.
Private collection

of his rhythmic exercises as a device in her battle against the chaos of time and space.

The children reacted to Friedl Dicker-Brandeis's voice. Her high and deep overtones produced spiral lines, graphically shaped, but at the same time almost impossible to recognize. She motivated the children to emotional concentration on the essence of the exercise— the rhythm of Friedl Dicker-Brandeis's voice and breath had an almost hypnotic effect. It drew the children's attention to it and spirited them away into the magic of her teaching.

Friedl Dicker-Brandeis told fairy tales and stories that made the children want to draw. To make them even more attentive, she sometimes asked them to listen for—and then to draw— the objects that appeared twice in a story. She introduced "dictations," which increased the children's sense of the material. From a list she read aloud, the children were to choose only objects of a certain predetermined size and surface composition and to draw them. Another time the list consisted entirely of objects from the same range of application (for example: hammer, nail, file), and the children were to incorporate them into their drawings, i.e. they were supposed to invent a story around these objects. Such lessons changed the children's emotional state and helped them focus on a clear goal. They also learned to analyze simple

forms and bring them together in a harmonious composition.

Monograms appear in many of the drawings. The constant repetition of their names in different graphic combinations returned to the children a feeling of identity and strengthened their disrupted sense of self. Not a single drawing bears a child's concentration camp number, even though their everyday lives were determined by all kinds of different numbers and stamps.

Through books, Friedl Dicker-Brandeis brought the children closer to "great" art utilizing reproductions of Giotto, Rembrandt, Vermeer, Cranach and others. Copies in different techniques (collage, watercolors and prints) are evidence of the extremely demanding, professional level of the lessons, lessons which occurred not in an artist's studio, but in Theresienstadt.

In Friedl's lessons, copying did not mean the mechanical repetition of lines. It was instead a means of grasping a painter's inner world, to show a different understanding of reality in the midst of the damaged everyday reality of the camp.

Friedl Dicker-Brandeis devoted special attention to sketches from nature—landscapes, still lifes and living models. The experience of being able to capture a real object with a pencil

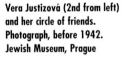

**Vera Justizová (2nd from left) and her circle of friends. Photograph, before 1942. Jewish Museum, Prague**

or a brush gave a child self-confidence and took away the fear of the "dead" objects that surrounded him.

Friedl Dicker-Brandeis called upon the children to remember images from "normal life." Kind people, the sky, trees—all of these things once existed in their lives, and existed still: one only needed to refocus on these things.

For the children in the ghetto, the past was cut off from the present, as one often observes among the elderly. The past seemed like a fairy tale. If they now drew this fairy tale in all its details—the apartment furniture, the clock on the wall, the market stall across from the building—they gave real contours to the past, moved closer to it, and gradually rebuilt a connection to it. The borders between past and present were opened up.

The themes in the drawing lessons were chosen in order to provoke reactions from the children. These themes were familiar to the children. Among them were motifs from nature (flowers, butterflies and animals), landscapes and natural events (storms and rainbows), the four seasons, streets, train stations, houses (from inside and from outside), family portraits and holidays (Seder and Christmas), events (the circus, the theater, carousel and Ferris wheel)—everything that belonged to a child's treasury of experience and what each child could express in his own entirely personal way.

Collective artistic work was also part of the Bauhaus tradition, and Friedl Dicker-Brandeis incorporated it into her lessons where it allowed her to pursue several different goals at once: the shortage of materials could be balanced out and philosophical ideas could be conveyed at the same time. During periods of collective work, each child was assigned a

Petr Freund
(6/9/1932-10/6/1944).
Morgue. 1943/44.
Pencil on paper.
Nederlands Instituut voor
Oorlogsdocumentatie, Amsterdam

Eva Wollsteinerová
(1/24/1931-10/23/1944).
Street in Theresienstadt with
Hearse. 1943/44.
Pencil on paper.
Nederlands Instituut voor
Oorlogsdocumentatie, Amsterdam

Anonymous (Vilém Eisner [?]).
Bread Delivery. 1943/44.
Pencil on paper.
Nederlands Instituut voor
Oorlogsdocumentatie, Amsterdam

Anonymous. Food Distribution. 1943/44. Colored pencils on paper. Nederlands Instituut voor Oorlogsdocumentatie, Amsterdam
Writing: "Lavatory for men and women / Hand washing / Morning Coffee/ In the Afternoon / In the Evening / Disinfestation

specific role so that all of them could take part in the group project. The roles were always assigned differently so that no one felt neglected. As in the Bauhaus, after a work was completed, it was discussed by the group. This was an important part of the lessons for the children—they learned precision and tolerance simultaneously.

Friedl Dicker-Brandeis's work "Children's Drawings" gives an explanation of the basic principles of her art therapy. The complete manuscript consists of two parts. The artist wrote the first part on a typewriter in Theresienstadt. In July 1943, she presented it to the teachers and tutors of Theresienstadt at a seminar commemorating the one-year anniversary of the founding of the children's homes in the ghetto. The second part, written by hand, takes up the same ideas again and analyzes the character of different children according to their drawings (which were part of the exhibition in July 1943).

Friedl Dicker-Brandeis began it with these words: "Unfortunately, due to their format, the available children's drawings cannot be used as visual aids. Please excuse that [...] there will be more discussion of the opinions than of the results."

Not knowing the origin of this essay, one could easily mistake it for a scholarly work written by a respected professor during peacetime. There is no mention of hunger, cold, death, or transports to the East. This essay must, in addition to its actual theme, have a further, therapeutic effect on us. If, under the worst conditions of wrongful detention, someone is able to think about proper education, about creativity as an expression of inner peace, then souls can rise from the ashes, evil can be conquered and mankind can survive.

"Children's Drawings" is a short essay full of ideas and observations. For the sake of comprehensibility we have divided the text into ten sections which represent Friedl Dicker-Brandeis's thoughts on children and their creativity, and which also clear the way for adults to arrive at a better understanding of children through their drawings.

Rudolf Laub
(5/20/1929-12/18/1943).
Exercise. 1943/44.
Pencil on paper.
Jewish Museum, Prague

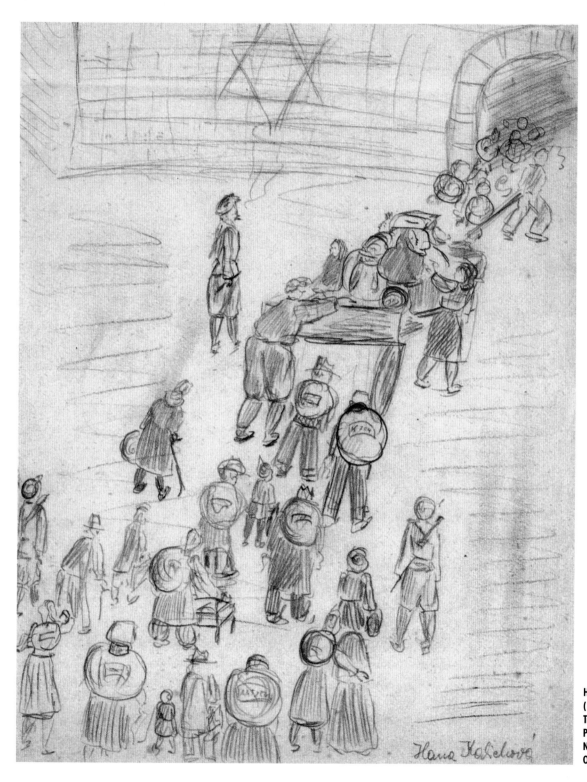

Hana Kalichová
(11/18/1931-5/15/1944).
Transport. 1943/44.
Pencil on paper. 27.5 x 20.3 cm.
Nederlands Instituut voor
Oorlogsdocumentatie, Amsterdam

*Right:* Erna Furman. Drawing after Cranach's "Portrait of a Young Woman." 1943/44. Pencil on paper. Private collection

*Far right:* Sonja Spitzová (2/17/1931-10/6/1944). Drawing after Cranach's "Portrait of a Young Woman." 1943/44. Pencil on paper. Jewish Museum, Prague

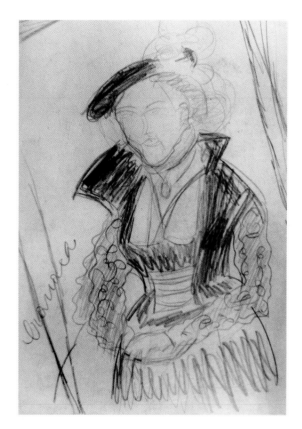

*Right:* Anny Wottitz. Drawing after Cranach's "Portrait of a Young Woman." Circa 1920. Charcoal on paper. Bauhaus-Archiv, Berlin

Judith Swarzbaratová.
Barracks with Bunkbeds. 1943/44.
Pencil on paper.
Nederlands Instituut voor
Oorlogsdocumentatie, Amsterdam

Vera Justizová
(4/6/1932-10/6/1944).
Arrival of a transport in Prague.
1943/44. Pencil on paper.
Jewish Museum, Prague

*Text reads, from the top left corner, counterclockwise:*
That is a house for important people—
You are doing it beautifully!—
It smells good—You can do every-
thing!—It is good—Prague has come,
the baggage is heavy

*Left:* Friedl Dicker-Brandeis or one of
her students. Sketches for monograms.
1943/44. Pencil on paper.
Simon Wiesenthal Center, Los Angeles

Drawing after Vermeer's
"The Girl with the Wineglass."
1943/44. Watercolors on paper.
Jewish Museum, Prague

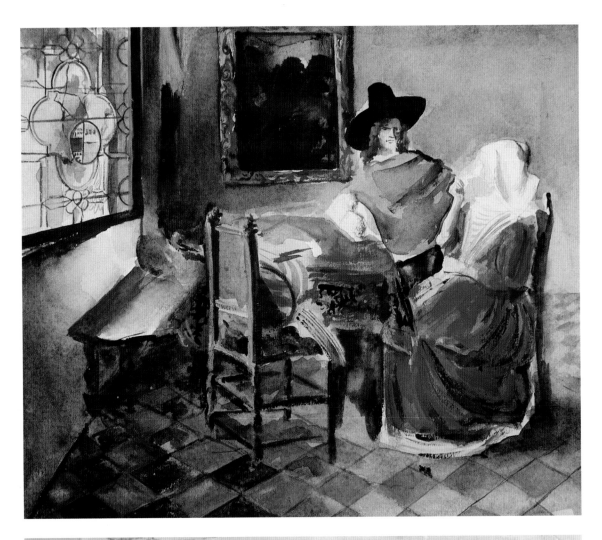

Maria Mühlstein
(3/31/1932-10/16/1944).
Collage after Vermeer's
"The Girl with the Wineglass."
1943/44. Collage.
Jewish Museum, Prague

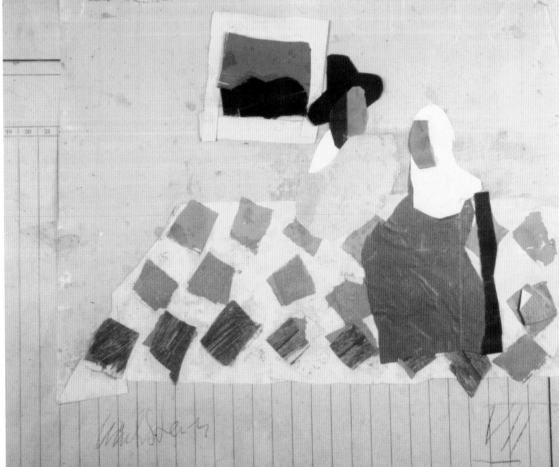

# CHILDREN'S DRAWINGS

## Everybody put us in boxes—she took us out of them.

—EDNA AMIT, STUDENT OF FRIEDL DICKER-BRANDEIS

### 1. WHAT SHOULD ONE EXPECT FROM CREATIVE DRAWING?

First of all, the expression of all-powerful freedom. The drawing classes are not meant to make artists out of all the children. Their task is to free and broaden such sources of energy as creativity and independence, to awaken the imagination, to strengthen the children's powers of observation and appreciation of reality.

The shortage of materials and technical facilities here is compensated by the teacher's talent. The child's lack in means of self-expression is a more essential problem.

The beauty of the material for drawing, the beauty of the clean sheet, calls forth a thirst for creativity; a smudge or soiled spot only intensifies it.

Given an independent choice in the placing and elaboration of the form, the child becomes steadfast, sincere. He develops his imagination, intellect, powers of observation, patience, and later, much later, his taste. And that will facilitate his approach to beauty.

I believe that you can direct only the process, and the correct and unhampered process will bring about the desired results...

Edita Polláková (6/19/1932-10/4/1944).
House on a Leaf. 1943/44. Watercolors on
paper. Jewish Museum, Prague

Robert Bondy
(5/1/1932-10/6/1944).
Carousel. 1943/44.
Watercolors on paper.
Jewish Museum, Prague

Ruth Guttmannová
(4/13/1930-6/10/1944).
Still Life. 1943/44.
Pencil on paper.
Jewish Museum, Prague

## 2. THE TEACHER, THE EDUCATOR, SHOULD ATTEMPT TO INFLUENCE THE CHILD AS LITTLE AS POSSIBLE

A teacher ought to be restrained to the utmost when it comes to influencing his pupils. The power and naiveté of the child tempts [even a teacher] with taste and artistic qualities either to lead the child towards certain primitivism or to push him into a confined expression, be it some "ism" or serious academic drawing.

A child may be repeatedly shown a work of real art, of any genre or form, realistic or abstract. This will only enrich him. He will choose himself what he needs. Do not foist

Anonymous (Hana Kalichová [?]).
Children's Room in Theresienstadt.
1943/44. Watercolors on paper.
Nederlands Instituut voor
Oorlogsdocumentatie, Amsterdam

your own opinion on him! He is pliable and trusting. He reacts to any direction: that way it is easier for him to achieve the result.

He believes that with "adult methods" he will win the competition that has been thrust upon him. But then he will move away from himself, from his needs, and he will no longer be able to express spontaneously that which he experiences. Ultimately he will forget the experience itself.

I believe that in this way one starts the process that concludes only much later. When drawing in school, once the lesson has been concluded, all work on that drawing ceases. As everyone knows from his own school experience, this creates a barrier that is very difficult to remove and sometimes cannot be removed at all.

The teacher, the educator, should attempt to influence the child as little as possible…

## 3. THE CHILD SHOULD BE FREE TO EXPRESS WHAT HE HAS TO SAY ABOUT HIMSELF

The ideas of children cannot be directed. Not only would one rob oneself of the chance to gain access into the world of the child's ideas, but one would also lose an overview of the current degree of the child's openness and ability and his psychological state. If the pedagogue has sufficient experience in the translation of the objective back into the causal, the drawings provide important insights into the life of the child's soul. Otherwise, the teacher is better off relying on his daily observations.

Although the child happily takes up every expansion of his world of ideas, such expansions cannot be forced upon him. Knowledge brought to the child at an inappropriate time, whether

it is beyond his powers of comprehension or when he is preoccupied with something else, will be perceived as an invasion into his world and will be met with a lack of enthusiasm and with failure.

Therefore, the child should be trusted without any restrictions. If we want to do what is best for the child, we should give him the materials and encourage him to begin working. In this state, all of our aesthetic valuations are senseless.

## 4. THE DEVELOPMENT OF TASTE

Habit can represent a significant inhibition, which is something I experienced in a class of 10-12 year old girls. Some of them played with big celluloid baby dolls. Once we decided to make dolls so that we could create something together; for example, a theater.

The girls did not like it—the dolls were not

Lea Pollaková
(3/21/1930-5/18/1944).
Study for a Still Life. 1943/44.
Pencil on paper.
Jewish Museum, Prague

**Eva Schurová
(6/2/1933-5/15/1944).
Naked Woman and Man
with Pistol. 1943.
Colored pencils on paper.
Jewish Museum, Prague**

any fear of being ridiculous—then a new fountain of creativity will spring forth, and this is also a goal of our drawing lessons.

The best allies against ready made production, against cliched aesthetic conceptions, and against becoming paralyzed in the stagnating adult world, are true artists and, once they have been freed of their habits, the children themselves.

## 5. THE POSITIVE INFLUENCE ON MALE AND FEMALE EDUCATORS IN THERESIENSTADT

(Using examples)

This house with its windows and doors shut tight, the individual flowers, clothes and furniture; everything without continuity, without space or a relationship to the other objects. Irene Kraus says that the child was in an orphanage where the children were treated very severely, where they were often not let out and where all of their money and possessions

pretty. Everybody wanted princesses, and they were unhappy with what they had made. Finally, they showed me their baby dolls—fat, smooth, with long lashes, rouged cheeks. Their rag dolls certainly could not compete. I proposed that we take one of the rag dolls who was considered ugly and make a figure for a procession of mummers. Soon the attitude changed. That was how we came to have a water-carrier, a cook, a magician and animals, even a toilet attendant.

Non-conflicted, uncritically accepted, substanceless "beauty" does harm here, there and everywhere. Everything that stands in opposition to the "ready-made article" is welcomed by us...

To be aware of creative power and to have tested it, to have it arise from oneself without

were locked away.

After some time in Theresienstadt, where the child was assigned to good guardians, the child painted a nice table and a lamp—obviously in a room, as the picture on the wall shows. The things belong together, and there is an abundance of them. Instead of a dull line everything has breadth and extension.

The transformation of the other child has been just as favorable. She was separated from a teacher she loved very much. In the first drawing, the house (which always represents the child himself, Dr. Bäumelová says) is pushed far into a corner, the doors are shut tight, the windows empty, all the lines depressively bent.

In the second picture, drawn after the child received loving treatment and was able to emerge from a numbing sorrow, the house moves into the center. There are now curtains in the windows, the door has a peephole, there are flowers in the meadow and even the sun is no longer as faint as in the first drawing.

Eva Schurová
(6/2/1933-5/15/1944).
Naked Woman and Man with Pistol.
1943. Pencil on paper.
Jewish Museum, Prague

## 6. ON THE DIFFERENCE BETWEEN AGES

If we are talking about a child under the age of 10—I have in mind the degree of maturity and not the age—then the teacher must first of all see to it that he does not experience failure in his play, in his beginnings. To teach, to make such a child learn, is useless because at this narcissistic age any invasion into his soul will be answered by turning away from the activity altogether. At this age, drawing and painting are the primary means of self-expression.

A child over the age of ten already finds his own expressive means to be insufficient; the entire world has become imbued with meaning for him—not the world as seen in his imagination, but in reality. Now is the time for teaching form; however, it should not exceed simply breaking ground. The technique in both drawing and painting ought to be given to the child in

Robert Bondy
(5/1/1932-10/6/1944).
Landscape. 1943/44.
Watercolors on paper.
Jewish Museum, Prague

**Margit Ullrichová
(6/18/1931-10/16/1944).
Autumn. 1943/44.
Watercolors on paper.
Jewish Museum, Prague**

**Robert Bondy
(5/1/1932-10/6/1944).
Untitled. 1943/44.
Pencil on paper.
Jewish Museum, Prague**

Just a year ago this thirteen-year-old girl was drawing such fascinating pictures— freshly, spontaneously. She had such unexpected subjects: For example, a girl in a toilet that does not close—with one hand she is holding up her skirt, she holds the door with the other hand, holding the paper in her teeth and balancing on one leg. Now the girl's expression is restrained by technique and dignity. She does not want to risk a mistake. Striving for guaranteed success is one of the most dangerous reefs.

## 7. ON PSYCHOLOGICAL DIFFERENCES

A gifted, imaginative child often draws things that are real for him but which do not exist in reality. For example:

A girl who lives by her fantasies is prepared to explain why she drew something this or that way instead of expressing what she actually sees. In front of her is a plate with a bunch of greenish yellow flowers. I ask why she did not choose just one flower, that it would be easier to draw. She said, "Easier, but it is only pretty when

exact correspondence to his needs. The elements with which the child works during his lessons, naturally, are the same as those in 'great art'; and in this way, the path remains open to him. It all comes down to size, proportions, rhythm, chiaroscuro, eurythmics, space, color, means of overstatement and understatement.

Unequal stages of development in the same child: a twelve-and-a-half-year-old girl draws from nature like a fifteen-year-old, but on a free subject draws like a seven or eight-year-old.

**Hanuš Kauders. Woman with Dog.
1943/44. Pencil on paper.
Jewish Museum, Prague
Written comment: "Exercise:
Theme: "Woman, dog, street, bird"**

Klein K. Color Exercise.
1943/44. Watercolors.
Jewish Museum, Prague

there are a lot of them."

I asked, "And what are these white stripes?" She answers scornfully, "Do you really not see? They are the sunrays falling on them."

Children rarely see the whole. What catches their eye are individual objects which they situate next to each other randomly. They are seized by the subject, and they fill up the entire sheet.

A reverse situation is self-education from which I expect a lot. A terribly vain girl began to draw using a ruler so that she would construct the things in perspective correctly and drew mechanically. But soon she understood that she would not succeed here that way. The children criticize her work. They draw independently! The girl, realizing this, stopped using the ruler, and she has started to do some work that is not bad.

EXAMPLE [See drawings pg. 202 & 203]

"X" number of hours can go by without any results before a child who seemed to be indifferent suddenly responds. In the case of this child, a single question slammed shut a

door she wanted to open.

Eva shows me her paper. On it there is a naked woman under a tree. She looks sadly into space at the absent landscape. Behind the tree there is a man in some sort of knight's costume. He is in a light and amiable mood and has a revolver in his hand. I carefully asked where the woman was looking and what would happen next.

Eva answered like any child in a similar

Susi Degenová
(3/10/1934-10/23/1944).
Animals. 1943/44.
Pencil on paper.
Jewish Museum, Prague

Hanuš Weil. Man with Dog. 1943/44.
Pencil on paper.
Jewish Museum, Prague.
Written comment: "Exercise: Theme:
woman, dog, street, bird"

*Background:* Erna Furman.
Motion Study. 1943/44.
Pencil on paper.
Private collection

situation: It does not mean anything, there is no reason behind it, and she wants to draw in something else.

On the 'improved' drawing there is a sea, by which sits the deeply thoughtful woman; however, her naked knees are covered by a kerchief, there is a cloud in the sky and the pistol has disappeared from the man's hand. I said that this was a completely new and different drawing and that it was a shame about the old one. She very obligingly said that she could draw the old one over again from memory and that it would come out exactly as before—and, indeed, once again appeared the same thoughtful naked woman and the amiable man with a revolver.

In this situation, there is no sense in focusing on good form or any form in general. All this is merely a spontaneous expression of sexuality. Although children need to be educated, nevertheless, they must, above all, be free in the expression of that which is essential for them to express.

EXAMPLE

This child does not have much desire to draw. She is actually one of the few, but this home has drawing as a compulsory subject, and she does not want to have a single hour unaccounted for, so she has come to terms with drawing and is slowly starting to enjoy it.

EXAMPLE

In contrast, a child who is clearly talented, with some stiffness, whose talent emerges no matter what the requirements are. It would be futile to want to influence this child. She feels and sees so powerfully what she wants to do that if someone tried to give her advice she

would probably stop working rather than follow it.

EXAMPLE

A child who is obsessively precise: because we were dealing with character traits, there were three themes: spring—winter—storm, revolt and deep silence. This child, ten years old, is incredibly violent and hot-tempered. Whenever I hear her speak, she is always passionate and screaming. Her father, a former butcher, is also terribly hot-tempered. But she is still a good-hearted child. She draws everything aggressively and hard: the spring, leaves and blossoms, even the snowflakes in winter. With the deep silence, everything is too much and too big. Her stillness attacks one almost like her storm.

EXAMPLE

A lively, gruff girl. It seemed that it would be very difficult to work with her, but now she is wonderful to work with. It turned out that for a while she was suffering from great difficulties with her parents.

EXAMPLE

A thirteen-year-old sees a pretty book with pictures of flowers, [...] in lines of delicate color, very strictly from nature, but not impressionistic, instead more like natural history. The children only look at the books for a few minutes while we discuss characteristic traits in drawing, color and form. This is what she kept from it, this landscape, which seems delightful to me.

## 8. GROUP WORK COMMUNITY INSTEAD OF CONFLICT

It is better to work in large groups: the children inspire one another, a more stable environment is created, the disciplined children almost always rally against the "bad ones". The children get useful ideas from one another. Merely the fact that the teacher is not overburdening the children with his attention makes them rely more on themselves and on each other.

In this way, something appears that later in life will play an enormous role—namely, working in a group, which is a cooperative and not a competitive unit. In this situation, they are also prepared to overcome difficulties that arise from shortages of materials, to help others, and to keep order among themselves.

The remarkable group in block VI wants to paint. There are not enough brushes, paints, drawing pads. The boys… must know that everybody is accepted here, regardless of the degree of talent. They split up into groups and wait their turn. They accept the superiority of those who are passionately interested in painting and are prepared to stand behind them and help. Preparing the drawing pads and mixing the paints satisfies them completely.

Independently or on somebody's advice, they find out how to use their abilities: one keeps the list and organizes the classes, distributes the material and is responsible for it; another keeps a journal; a third assists during the drawing or makes sketches; somebody is sent to find materials. Everybody feels that he is participating in the classes and patiently waits his turn to draw.

The boy's group doubles in size. They have to borrow brushes. Before, paper and cardboard were being pilfered in this house. Now the boys are more reliable. Also, it was arranged for the gifted boys to work with the weaker groups.

Children who work independently instantly forget the malicious and ridiculing form of criticism. One can adopt much that is useful from the life and view of another person.

### RHYTHMIC EXERCISES AS A UNIFYING FORCE

Since I am often asked about the rhythm exercises, I want to focus on them in particular. They transform a crowd into a working group that is ready to devote itself jointly to the matter at hand rather than bother and spoil each other's work. As a by-product, they make the hands and the entire artist inspired and supple.

Besides this, the child is removed from everyday life—later we will see how helpful this is— and is set a simple task replete with playfulness and fantasy. The execution of the task gives the child pleasure, and the concentration necessary to do this makes him self-disciplined.

The dictations must be simple, unambiguous. They must be variable. This task is in no way commonplace. No child is ahead of any other. The equality of this not only pleases them but puts them on the same emotional level.

## 9. MOTIFS AND EXERCISES

The children were to acquire a sense of proportion. With this goal in mind, I asked them to draw an apartment house with many floors, a villa, a farmer's house and a hut.

Animals: a line that turns into a cock. A line is drawn according to mood… rhythm

Ruth Guttmannová (4/13/1930-10/6/1944). Composition with Color Circle. 1943/44. Watercolors on paper. Jewish Museum, Prague

and momentum. The children see something in this and complete the line accordingly.

Animals that illustrate oppositions: for example, an animal that is round and one that is angular—a pig and a goat; big and little—an elephant and a mouse; prickly and smooth —a hedgehog and a rabbit

The theme is the desert, caravans […] using cards that depict nature: one of the students has been unable to keep up, has bad language skills and at the beginning could not even draw stick people—instead he would just scrawl. Now he

is drawing spatially. Here are a few examples of illustrations for a chapter on cave children, which I narrated quickly and succinctly: the pursuit, the blow with the stone, and the cave.

I require that all the objects I have listed appear on the paper or sometimes only those items I mention twice. I sketched a butterfly costume for one child who does not like to draw. That lay the groundwork for our success. Now in assignments that require quick reactions, there is no equal.

## 10. AND IN CONCLUSION: HOW WE, THE ADULTS, SHOULD REACT TO CHILDREN AND THEIR CREATIVITY

One does not need to direct the sparks of children's inspiration. Knowledge thrust upon the child without taking into account his level, or when he is absorbed by something else, is perceived by the child as an intrusion into his world and provokes the response of unwillingness and poor behavior.

Let us not be in a hurry with definitive judgments regarding form and content. It is better to look at the drawings with pleasure and see their usefulness—study them in silence, ponder over what goes into them.

Our demands, to a large extent, stem from false notions about the child himself and about what he is capable of communicating. Adults have deep-rooted opinions on "aesthetic values". At one time, they themselves did not cope with their difficulties. Motivated by fear, they simply suppressed them. Why do adults want to make children be like themselves as quickly as possible? Are we so happy and satisfied with ourselves?

Childhood is not a preliminary, immature stage on the way to adulthood. The demands of adults, even when they are justified, often concern wrong spheres. For example, cleanliness, precision, the ability to convey a certain content, all belong to the realm of drawing geometrical ornament or fashion illustration but have nothing to do with creative drawing.

By prescribing the path to children, we are leading them away from their own creative abilities and we prevent ourselves from understanding the nature of these abilities.

*Above:* Notes for the lecture "Children's Drawings" by Friedl Dicker-Brandeis. 1943. Jewish Museum, Prague

*Left:* Hana Kalichová (11/18/1931 - 5/15/1944). Scene from "The Little Fireflies." 1943. Water colors. Jewish Museum, Prague

Once I drew a boat and candle in darkness, and it did not come out right for me. Friedl said: "Here you need light to define the darkness, and darkness here to define the light."

— EDNA AMIT

Lilly Bobašová. Candle and Ship.
1943/44. Watercolors on paper.
Jewish Museum, Prague

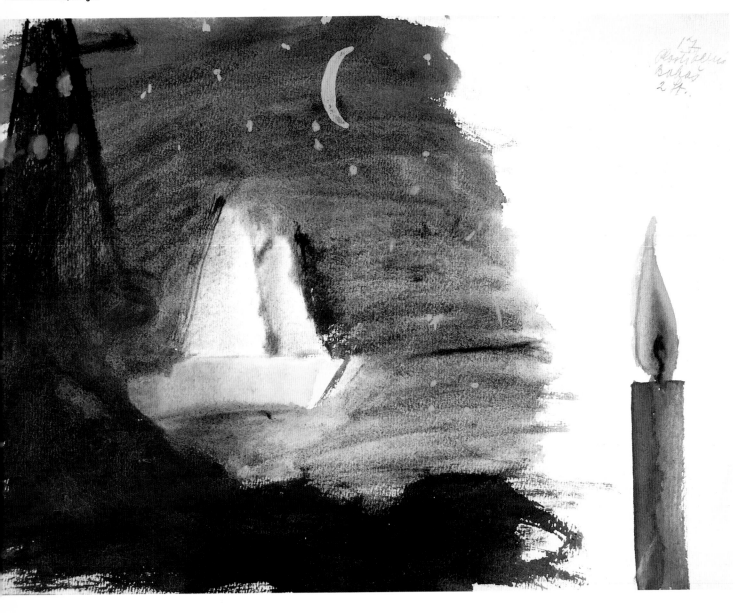

## THE CHILDREN SPEAK

# She came from another planet. —EDNA AMIT

### FRIEDL WAS MY MEDICINE

*Friedl spoke little, but I remember what she did say: "Every person has his own world. Everybody and everything on earth has its own world. Each thing is a separate system. The insatiable desire to grasp the essence of a thing can drive you mad. Beauty is mysterious. A beautiful thing is a mystery. Beauty is not a mold or a portrait of nature; it is manifest in variations, in diversity. There are no absolute things…There is no static beauty. The breadth of a drawing is to be found in its gaps, in the denial of the superfluous."*

*Now I recognize this in my work. She said a piece of paper that was ripped out was much more alive than one that was cut out. Scissors cut mechanically. Why did she say this? Perhaps because there were not enough scissors [...] but to this day I still rip the paper when I make a collage.*

*When I would ask Friedl too many questions, she would become reserved and withdraw into herself. In that sense, she was a difficult person. She seemed very strange; I simply did not fully understand her.*

*And maybe that is why everything she said then comes back to me now. For example, she said that there were many colors in black and white. I did not understand that then; how could that be? I asked her again, but she did not respond. Now I understand.*

*A person can be defined through their influence on others. Sometimes I had the same sort of feeling you get with a doctor: Friedl herself was the medicine. To this day, the mystery of her sense of freedom remains incomprehensible to me. It flowed from her to us like an electric current.*

*Her soft voice induced some sort of special state. You wanted so much to get close to her, to size her up. And now, when we remember her, each person remembers something personal—different lessons, different words, as if we cannot fit her all into one person. I do not have in mind her eyes and voice… Friedl did not tell anything about herself. She was from another planet.*

**EDNA AMIT IN CONVERSATION WITH E.M.**

**Lilly Bobašová. Photograph circa 1943. Private collection**

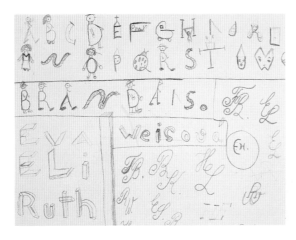

**Ruth Weisová
(3/16/1931-5/18/1944).
Study for alphabet and monogram.
1943-44. Pencil on paper.
Jewish Museum, Prague**

*Above text reads:* "Entry into the World of Prosperity" – Admission 1 K—Ice Cream—Chocolate—Nuts—Punch—Rum—Sardines—Honey—Cherry Bonbons—Sugar—Milk—Cocoa

**Ilona Weissová
(3/6/1932-5/15/1944).
"Entry into the World of Prosperity."
1943/44. Pencil on paper.
Jewish Museum, Prague**

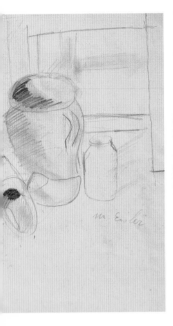

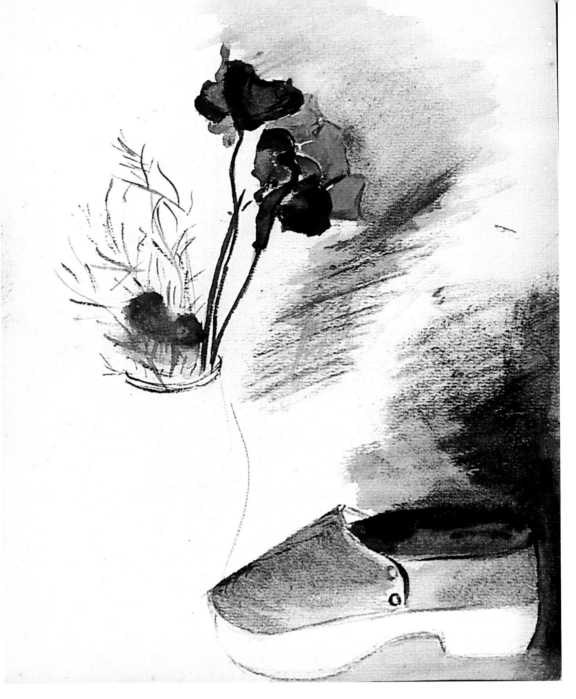

*Above:* Anonymous. Flowers with
Wooden Shoe. 1943/44.
Watercolors on paper.
Simon Wiesenthal Center, Los Angeles

*Right:* Milan Eisler. Still Life
with Pot and Wooden Shoes.
1943/44. Pencil on paper.
Private collection

## FRIEDL'S MYSTERY

*I was in Theresienstadt from the spring of 1943 until the summer of 1944. We worked in the garden, and after work we would go to the lessons and various cultural events. At the beginning these would take place sporadically—musical evenings with Gideon Klein, lectures on literature by Professor Zwicker. People from many different blocks would come to these lectures. In 1943, systematically structured classes were introduced in each block, first for Hebrew, then for Czech. Professor Kraus and Professor Zwicker taught history, Laura Schimková taught Russian, Friedl Dicker-Brandeis taught the visual arts and Irena Krausová taught the art of rhetoric.*

The lessons would take place in the evening after work and on Sundays. Early in the morning we would clean our room, and then the lesson would start. We received grades, and now and then we would write class papers to test our knowledge and comprehension of the appropriate theme.

I remember Professor Zwicker. He would often visit Friedl in her room. Every day I was allowed to see her in her room was like a holiday for me. It spurred me on. Perhaps it is the reason I became a teacher and taught for thirty years.

I believe that my lifelong love of learning comes from Theresienstadt. Despite everything, the year I spent there was one of the best of my life; it was very productive. I am convinced that it was only because of our teachers, who succeeded in making the impossible possible [...] My memories of them are full of love and respect. [...]

Irena Krausová saved me by sending me to Friedl Dicker-Brandeis as an assistant. I organized drawings. Friedl was very friendly, and the children adored her. She always found words of praise. She spoke with them like they were adults.

Friedl did not speak Czech well. Because of this many people did not understand her, but it did not mean anything more than this: I spoke Czech to her, and she would answer me in German. We always understood each other. Only now is it clear to me that she was trying to keep the children calm and that she often discussed this with her colleagues.

She was small, and she created a unique atmosphere in her lessons. She brought the materials. I handed them out. After the lessons, I collected the drawings and added the date at the bottom. Then I would prepare everything for the next group. There were always between 12 and 15 male and female students in a group. They would all paint at the table. She also taught in other children's homes. I helped her for two months, and then I was sent to Auschwitz.

Friedl would assign the children a theme and then let them go on working independently and without any further instructions. I remember how the children drew a paintbrush. She did not show them a paintbrush, but she told them that a paintbrush has bristles. When I collected the drawings, I noticed that every child had drawn the bristles differently.

It was always difficult to get paper, and paints were also in short supply. Friedl did not give much thought to equipment and materials, perhaps because there were so few materials and we did not have much choice anyway. The children would often just draw with a pencil, no matter what the theme was. In what were called the free lessons, no theme was given. The children were not even supposed to think—simply draw, collect themselves, dream, and then draw again, whatever came of it. The goal of these lessons was spontaneous expression, which was supposed to lead to the freeing of the spirit.

Irena Krausová. Photograph, circa 1940. Private collection

Helga Pollaková. Plowing with a Horse. 1943/44. Collage. Jewish Museum, Prague

*I do not remember that she ever told fairy tales; she would simply present a theme. In her lessons, the children would never make noise; they were wrapped up in silence as they worked. Sometimes she would interrupt them to show or explain something and then work on the drawings would resume. It was not a game; it was work.*

*I remember embroidery on paper. She did not teach the children how to embroider; they already knew it. A drawing would be prepared and then it would be embroidered. Perhaps she showed them samples. She never drew anything in the children's drawings, or at least I never saw her do it.*

*It was not her technique that made the difference; it was the feeling of freedom that she conveyed to the children—her own inner feeling of freedom, not the technical skills.*

EVA ŠTICHOVÁ-BELDOVÁ IN CONVERSATION WITH E.M.

**Helga Kinsky (Pollaková). Photograph by Rita Ostrovskaya, 1998**

## THE POWER OF FREEDOM

*One morning a small woman with very short hair and big hazel eyes suddenly appeared in our room. The determination of her walk and her energy excited us and introduced a completely different rhythm. We immediately accepted her and gave ourselves up to the will of this new force.*

*Friedl flew into the room, and of course she talked to us as she was handing out the materials. She was with us the whole time that we worked. The lessons were short. We worked intensively and, as I recall, in silence. She would give us a subject, to stir our imagination. For example, a field with a horse roaming about... or maybe she would show us some model or picture.. I remember precisely the collage with the horse. Friedl brought us piles of scrap paper and showed us how to make a collage.*

*She would talk about how to begin a drawing, how to look at things, how to think spatially, how to dream about something, how to do something, how to realize our fantasies.. I do not remember that she worked with us one on one, but rather there was contact with the entire group...*

*She changed the technique every lesson—first collage, then watercolors, then something else...We did not have any materials; she would bring everything.*

*After the lessons, she would collect the drawings and leave. The lesson ended as intensely as it had begun. I was sick with panic that it would end. I was prepared to keep going until nightfall...*

*We lived on the top floor of the children's home. We would draw from the window——the sky, mountains, nature...That is probably especially important for prisoners: to see the world on the other side, to know that it exists...*

*That probably also applied to Friedl. It was important for me to know that she existed, that she was alive....A force of freedom. In her presence, everything turned out, almost by itself.*

HELGA KINSKY IN CONVERSATION WITH E.M.

**Helga Pollaková. Landscape with Lake and Moon. 1943/44. Watercolors. Jewish Museum, Prague**

## TALENTED HANDS

*I received the first prize at the exhibit, that's true... Boards were placed on sawhorses, and the objects were displayed on them. The pictures hung on the stone walls. I had drawings there, but the main thing [I made] was an elephant and monkeys, a palm tree made out of cardboard, and underneath it were little wild animals. I had sewn them and filled them with sawdust. Friedl's husband had brought it in a little sack.*

*Friedl had books about art, but they did not interest me. She also had a fairy-tale book about Africa, printed on good quality paper. I borrowed that book from Friedl a hundred times. My elephant and monkeys at the exhibit came from that very same Africa.*

*She was not talkative, small, a bit taller than I, and she knew how to do everything, everything! But I was a hopeless blockhead. Friedl was the first one to tell me that it was not at all obligatory to study from books. She said to me, "Your hands like to learn. Intelligent hands are a gift!'*

*That drew me to her immediately. For example, we were making dolls, and Friedl had found some fibers somewhere from some corn-cobs for the hair. We dyed them, and we had both blondes and brunettes with eyes made out of little beads.*

*Once she said to me, "Now, Marta, draw a couple of lines and then turn the paper and see what it looks like..." I am turning and turning, and I do not see anything. "Turn it some ...Turn it ...Some more... And more ...Turn and look..." And suddenly I see a circle of dancers. I really do see it!*

*"Now draw it. It is as easy as two times two." And I draw and indeed a circle of dancers does appear.*

*Or I am trying to get the head of a princess to come out right, and she walks over—a couple of lines—and it is finished. She taught us to draw quickly, a couple of lines and it is done. If there was paper and something to draw was found, you'd just begin and she would look and say what it could be, what it could become.*

**MARTA MIKULOVÁ IN CONVERSATION WITH E.M.**

## JUST DRAW

*I love to talk about Friedl because I love Friedl. She was certain that everybody could draw, and, therefore, her primary goal was to find the means that would bring the children into a state of mind where they would draw.*

*My mother Rosa was head of the children's home. She was great friends with Friedl and talked with her a lot. We were half-starved, sick, and we were drawing even in that condition. ...[She would tell us], "Do not think about anything— just draw. You are happy now."*

*And at that moment we truly felt ourselves to be happy.*

**RAJA ZADNIKOVÁ IN CONVERSATION WITH E.M.**

*Friedl never criticized me, and even in the most poorly executed drawing she could find something good. She would explain something so intelligently: For example, how to look at a picture—and see it.*

*She had several books on art in her room. I was amazed by Van Gogh's "Sunflowers." She drew my attention to how the colors with which they are painted do not correspond to the real colors. It turns out that the artist sees everything differently—and that this is permitted!*

**DITA KRAUS IN CONVERSATION WITH E.M.**

**Friedl Dicker/Anny Wottitz.
Cover for "African Fairy Tales."
Vegetable material, etc.
Edited by Carl Meinhof.
Eugen Diederichs Verlag: Jena 1921.
Bauhaus-Archiv, Berlin**

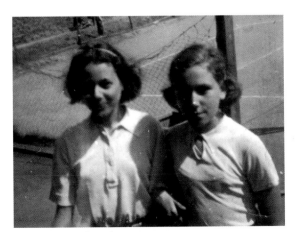

**Dita Palláchová (left) and
Raja Engländerová (right).
Photograph, 1941.
Private collection**

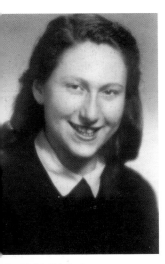

Eva Ehrlich (Adorian).
Photograph, 1946.
Private collection

## THE HEART OF THE MATTER

*I didn't have any talent, but the drawing lessons thrilled me. We were quite grownup girls, aged 14–18. Friedl would tell us about the Bauhaus. For example, she gave us an exercise from the Bauhaus—to make a spatial object out of a white sheet of paper. We had scissors and glue. We tried so hard, but the work that won was made without scissors or glue, just by hand. It turned out that the simplicity of the solution was the main thing.*

*She would use the technique of exercises. The rhythm and line that made a house a house, a brush a brush. The essence of the thing—that is what has remained in my memory.*

*She spoke softly: "Draw strong–weak, pleasant–unpleasant..." Or a subject: a woman in a hat, alone, walking down the street, nobody around, where is she going, who is she, what is she doing. You needed to think, to use your imagination. Not one finished subject, only hints: everyone decided for herself the woman's nature, whether she was happy or sad.*

*I remember the theme "Storm–Wind–Evening." One could have connected it with the feeling of fear, but I am only able to formulate it this way now. We simply drew and did not analyze anything. I believe that what she wanted from us was not directly linked to drawing, but rather to the expression of different feelings, to the liberation from our fears. She did this with an unusual level of energy and passion, which only she possessed.*

*These were not normal lessons, but lessons in emancipated meditation. Everything must be alive: line, color, rhythm.*

**EVA ADORIAN IN CONVERSATION WITH E.M.**

## THE ART OF THE CHIAROSCURO

*Because I was already a teenager, I had to work. So I worked in agriculture and in the evenings I would volunteer to help old people. Our room was next to Friedl's. I remember how one time she came to us and asked if any of us wanted to draw. I told her I would like to. Friedl brought me a pencil and paper, and I started to draw.*

*I wanted to achieve a sense of volume so that the people in the drawing would come unstuck from the paper, and Friedl started to teach me the art of chiaroscuro. She brought a book on Rembrandt and explained to me with examples that here the light was powerful, directed, and here it is also strong, as if it did not fit the rule. This light was used for expressiveness, and not to be afraid of sharp shadows as they pull the figures off the paper.*

Ružena Zentnerová
(3/26/1933-10/4/1944).
Composition with Lightning. 1943/44.
Watercolors on paper.
Jewish Museum, Prague

*Friedl praised my drawings, the figures and how I felt them. One day she brought me clay. I had never molded clay before. Friedl said: "Make what you want with it; do not be afraid." I modeled people who were sitting around a dead body. I saw so many people who were dying alone in Terezin—that's why I modeled a man dying among his family. Friedl took the work to an exhibit. She was distressed that there was no place to fire it, and, of course, my sculpture crumbled apart.*

**ESTHER BIRNSTEIN IN CONVERSATION WITH E.M.**

**Esther Birnstein (Šwarzbartová).
Photograph, 1999.
Private collection**

## STUDENTS BECOME TEACHERS

*I worked with the children from Germany. Their parents had been shot right in front of their eyes; the children were in a terrible state. Once, these children came running toward me. "There's this wonderful lady," they said. "She lets us draw with paints—anything you want, and we were drawing. We love her."*

*I wanted to find out who this lady was and went to L 140. I met Friedl for ten minutes—we were both in a hurry. Her eyes told the whole story. They radiated light. I asked her how to help my children, just to ask something since I had come. Friedl answered, "Just let them come visit me."*

*For them it was a huge thing—they got pleasure from drawing. Pleasure awakens the thirst for life. Yes, the simple pleasure of drawing.*

**ZUZANA PODEMELOVÁ IN CONVERSATION WITH E.M.**

## A NEW WORLD OPENED UP

*I came to Terezin from Prague in October 1942 and left in May 1945, from age 16 to almost 19 years, and worked the entire time as Betreuerin (tutor) in the children's home, L 318. Friedl was my teacher for about two years during this period, and I am not sure how she came to "my" children's home, but she did on her own initiative and asked me and several of my colleagues who were interested in drawing to join her classes.*

*At first we went to her "studio"; later she gave weekly sessions in the room where my group of children and I lived. Although, for the most part, it was the "grown-ups" who participated, often enough the children joined in as well. In any case, I soon passed on what I was learning to my children's group as part of our daily "school", using the same or nearly the same methods.*

*I had always loved to draw, was always less interested in painting, and had, for some obscure reason, brought along a few soft drawing / sketching pencils in the pack I had carried into the camp with me. Paper, of course, was hard to come by, but I had also brought along my sketch pad (food would have been more*

**Erna Furman. Photograph, 1970.
Private collection**

**Erna Furman. Barracks, Interior View.
1943/44. Pencil on paper.
Private collection**

sensible!). Somehow, we always managed to hunt up some paper, using both sides, of course.

We did a lot of "liberating" exercises—drawing circles and squiggles, letting our hands go and using scissors freely. But what I enjoyed most was drawing special things: portraits (I still have a number of portraits of "my" children), self portraits, some life drawing, lots of still-life sketches (I shall never forget the corner with the stove, chair and shelf where Friedl helped me figure out the underlying pattern) and there was a little yard with a few trees of which I made a watercolor which I still have. Friedl, of course, pointed out that my tree trunks were not sturdy enough.

For me , Friedl had opened a new world. What she taught has always remained with me. For years I sketched, just for myself, and later, when I had my own children, I sketched with them. Both girls enjoyed it. My older daughter is quite gifted and, although now a pediatrician, wife and mother, she still carries her sketchbook everywhere—carrying on Friedl's tradition.

Friedl's teaching, the times spent drawing with her, are among the fondest memories of my life. The fact that it was Terezin made it more poignant, but it would have been the same anywhere in the world. At the time, she conveyed peace, contentment and a special way of looking at the world. She was always kind and supportive, always judged my efforts much better than I did, always made our drawing times a great experience. I shall always be grateful to her.

Terezin had many world famous specialists in every field and most of them were glad to give lessons or seminars for bread—I was glad to give my bread for this better nourishment!— and I learned philosophy, economics, Rorschach testing, etc. But I think Friedl was the only one who taught without ever asking for anything in return. She just gave of herself."

**LETTER FROM PROFESSOR ERNA FURMAN TO E.M.**

Friedl asked me to help her teach the children drawing and painting and to explain to them in an entertaining way the things they didn't understand well enough: for example, the difference between "big and little", between "many", "few" and "none"; to help them to express depth and distance, nearness and light, the nature of coarse material on the flat surface of a piece of paper, or how to draw a smooth surface or a rough one, a flowing one or a dark one. When you simply explain, they get bored. I would begin by telling the

**Josef Bauml**
**(9/22/1931-9/6/1943).**
**Exercise on the Essence of Objects:**
**Spirals and Snails. 1943.**
**Pencil on paper.**
**Jewish Museum, Prague**

*children some fantastic tale... Here, listen to a short sample:*

*A little girl went for a walk in a park which was filled with graceful, pink magnolia blossoms and blue-green larches as translucent as a nymph's cloak. In the park an old man was taking a stroll and selling balloons. Each balloon was on a string, and all these colored wonders were raised over the old man's head and looked like a colorful bouquet.*

*The little girl bought two balloons from the old man and started to run with them through the park. And all of a sudden, from out of nowhere, a fierce wind came up, so fierce that it bent all the tree branches to the ground and seized the girl and whisked her away on its wings. The red and gold balloons swelled up even bigger and now they and the girl were flying farther and farther away in trembling space...*

*Then I would abruptly stop my story and tell them to draw the scene they liked the best as colorful and in as much detail as possible. And the girls would rush to begin drawing so courageously and passionately— I was amazed at their enthusiasm...*

**SONJA WALDSTEINOVÁ: "A DRAWING LESSON," IN "BONACO," GIRLS' JOURNAL IN HOUSE L 414**

*My dear Friedl,*

*I would like to wish you something especially beautiful...something only I could wish for you...and it would be this—when you see something in a dream that you have wanted for a long time, then let it come true! Good night, Sonja.*

**SONJA WALDSTEINOVÁ, 1943**

### Every good friend will give you Good advice when you are in need— But very few will give you A good sack of flour, indeed.

—WRITTEN BY BERTA KOHNOVÁ
IN EVA RIESSOVA'S [HÁVA SELCER] NOTEBOOK ON MARCH 31, 1943

**Erna Furman. Portrait of a Man. 1943/44. Pencil on paper. Private collection**

### The snowy white paper calls out so alluringly as do the inviolable, tantalizing paints, brushes and pencils, eraser, ruler, India ink and glass of water and the round little box whose contents are a mystery. Does it not seem to you that this is from somewhere... in heaven or in paradise or simply from the outside?

—SONJA WALDSTEINOVÁ:
"A DRAWING LESSON,"
IN "BONACO," GIRLS'
JOURNAL IN HOUSE L 414

## From the Sketchbook of Milan Marvan

Someone sent me to Friedl and told her I was talented. I went to see her in the girls' home.

*Right:* Milan Eisler.
Photograph, before 1942.
Private collection

*Above:* Milan and Irena Marvan
(Eisler). Photograph by Rita
Ostrovskaya, 1998. Private collection

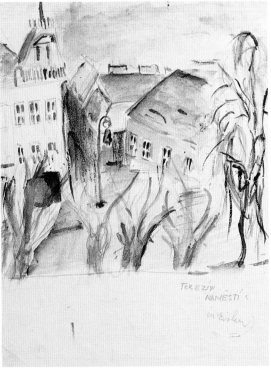

I drew this from the window.

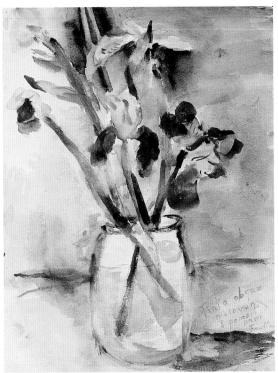

This is painted from nature. And
down below I wrote very honestly:
"Painted with the help of Mrs. Friedl."

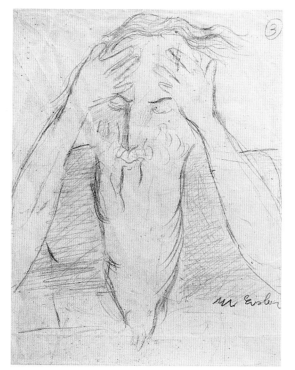

*Far left:* This is Moses. I don't know how he ended up here.

*Left:* Here the men have bowls belted to their backs: they are hiding, smoking secretly. They are afraid they will be informed on.

*Far left:* This is my best friend. He was sent away on the transport. I missed him very much, and I painted this a year later out of anguish.

*Left:* We drew life models. She brought someone with her. I painted this by myself, without her help.

**Háva Selcer (Eva Riessová).
Photograph, 1999.
Private collection**

Sept.. 14, '44: [Before the war] it was forbidden to attend an ordinary school, and we studied at Kohn the Butcher's house. There I made friends with Berta Kohnová. Now I simply cannot understand how I could have spent time with such a foolish, uncultured, uneducated and poorly brought up girl. It does not matter now, since it is already been half a year that she left for Poland.

Berta and I played with toys and the kittens. We could sit for hours upstairs in the cowshed and chatter endlessly about anything, about the most important things and problems, which we did not understand anything about but which we tried to solve...And we would also eavesdrop on what the grown-up smart people were talking about.

**FROM HANA PLATOVSKÁ'S DIARY**

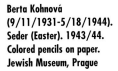

**Berta Kohnová
(9/11/1931-5/18/1944).
Seder (Easter). 1943/44.
Colored pencils on paper.
Jewish Museum, Prague**

**Berta Kohnová. Page from
Eva Riessová's personal register
[Stammbuch]. 1943.
Ink on paper. Private collection**

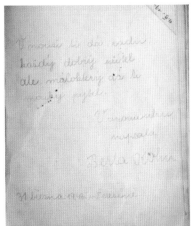

Sonja Spitzová
(2/17/1931-10/6/1944).
Theater. 1943/44. Collage.
Jewish Museum, Prague

*Sonja had firm principles and a strong will. For example, she decided not to learn German, since German was sure to be a dead language after the war—something like Latin—and she never did learn it. She swore she would keep bread for someone's birthday—and she kept her promise. Although I was three years older than she was, I broke off a piece of mine, but hers stayed intact. And both of us were starving.*

MARIE VÍTOVCOVÁ (SPITZOVÁ) ON HER SISTER SONJA SPITZOVÁ

**Marie and Sonja Špitzová.
Photograph, 1938.
Private collection**

Helena Mandlová
(5/21/1930-12/18/1943).
Prague Castle (Hradany). 1943.
Collage on red paper.
Jewish Museum, Prague

Lea Pollaková
(3/21/1930-5/18/1944).
Two Portraits of Girls. 1943/44.
Pencil on Paper.
Simon Wiesenthal Center, Los Angeles

*Helena Mandlová had red hair, a pretty face, but a sharp gaze, eyes like needles. She knew exactly how to hit a sore spot, to offend somebody intentionally and unexpectedly.*

**HANDA DRORI IN CONVERSATION WITH E.M.**

*Helena Mandlová [...] simply could not live with other people. [...] When I saw her pictures after the war and I remembered everything again, I could not hold back the tears."*

**HELGA KINSKY IN CONVERSATION WITH E.M.**

*Lea (Lenka) Pollaková—she lived in Room 25. A very intelligent girl, very serious. Her father, a doctor, died at home in Pardubice. Lenka was in Theresienstadt with her mother and her little brother. We belonged to the same 'kvuzah,' a Hechalutz-Group [Zionist youth movement]."*

**FROM THE MEMOIRS OF MICHAL (MAUD) BEER**

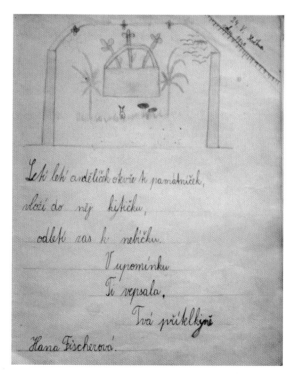

*Left:* Hana Fischerová. Page from Eva Riessová's personal register [Stammbuch]. 1943/44.
Ink on paper. Private collection

**Fly, fly, my little angel. Open the little notebook, put a sweet flower in it, and go back to heaven.**

*Left:* Written by Hana Fischerová, who was sent on the same transport as Friedl, in the personal register [Stammbuch] of Háva Selcer.

# GEORG EISLER on Friedl Dicker-Brandeis

Georg Eisler. Photograph by
Henri Cartier-Bresson.
Private collection

Georg Eisler was born on April 20, 1928 in Vienna to the composer Hanns Eisler and the singer Charlotte Eisler, née Demant. He attended the Montessori Kindergarten in Vienna. In 1936, he emigrated with his mother to Moscow and then to Prague in 1938 where he took part in Friedl Dicker-Brandeis' art lessons for children. In 1939, he and his mother emigrated to London.

Georg Eisler studied art in Manchester, England and with Oskar Kokoschka. He returned to Vienna, Austria in 1946 where he worked as an artist and a journalist.

His one-man exhibitions include: Albertina Vienna (1976), Nationalgalerie Berlin (1985), Österreichische Galerie im Belvedere, Vienna (1997). He was president of the Vienna Secession 1968-1972, and participated in the Venice Biennale in 1982.

His works are in the collection of the British Museum and National Portrait Gallery, London; Uffizien, Florence; Musée d'Art Moderne, Paris; Kunsthalle Hamburg.

*At an early age, Georg Eisler fell under the influence of Friedl Dicker-Brandeis. His memories of her classes are a testament to her work with children. The following excerpts are from an interview in 1994:*

## THE MONTESSORI KINDERGARTEN

THE KINDERGARTEN was in Goethehof, a municipal housing development on the other side of the Danube. It was the showpiece of the socialist Vienna of the 20s and early 30s. I remember this time very well, because there was a perceptible camaraderie amongst the children. Our interests were awakened and developed in many ways, as is usual in kindergarten, but perhaps a little bit more with us.

Friedl Dicker designed all the furnishings, and her partner, Franz Singer, came up with the concept for the entire kindergarten. Each piece of furniture was made in such a way that it required two children to move it—every child had to rely on someone else for help.

Everything was built to the scale of small children. I went there until 1934.

## FLIGHT TO PRAGUE

Friedl was friends with my parents—a circle of left-wing intellectuals. They then joined the underground Communist Party. My mother and her friends did not really belong to the working class, but were closer to the middle class. They were prepared to take substantial risks, and they did. These, people, strangely enough, proved capable of uniting within themselves the political and cultural avant-garde.

Friedl moved to Prague. My mother and I eventually moved there as well and resumed contact with Friedl. My memories of our times together there are much sharper than of those in Vienna.

Friedl had turned one of her large rooms into a kind of studio for children. There was no lesson plan, just a definite time frame within which one could come and go as one pleased. Friedl Dicker-Brandeis knew how to encourage children to take part in a very intensive and yet open way of working. I developed my first ideas regarding the use of paints and brushes during this time.

It was a freeing experience. We were busy—and in good hands. That meant that we could have whatever material we wanted. We didn't have to bring anything. No one told us to use a little more red here or a little more blue there. For me, it was a completely new experience—to work in a large format instead of in a small writing-box or on a sketch pad. I painted every day. The only disadvantage of these large sheets of paper was that we could not keep them.

Friedl Dicker-Brandeis let us work and encouraged us in a very unobtrusive way. She would certainly never have restricted anyone with rules. I remember her warm-heartedness. There was even something maternal about her appearance. Discipline did not play a role. I remember that Friedl Dicker-Brandeis was very present. She was a personality.

She never showed us her work because she didn't want to "infect" us with her style. She never asked us to look at

**The Montessori method meant precisely this: singing, dancing painting...and washing dishes. I washed dishes! That is something I have never done since.**

Georg Eisler. Photograph, 1932/33.
Private collection

Montessori Kindergarten Goethehof, Vienna XXII. Niche for cooking and eating. From the photo album of Hedy Schwarz, 1932-33. Private collection

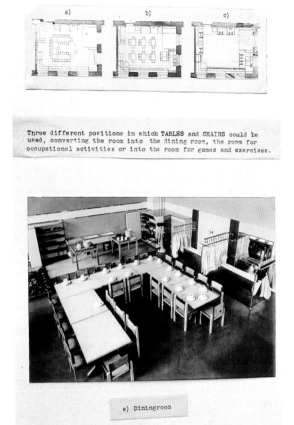

Three different positions in which TABLES and CHAIRS could be used, converting the room into the dining room, the room for occupational activities or into the room for games and exercises.

a) Diningroom

her paintings as an example and then to paint the same thing ourselves. If she had, something entirely different would have come out of those lessons.

Now, when painting has become my entire life and has brought me success, I clearly realize how much I am indebted to Friedl. She "gave me my start," gave me the sense of painting as a way of life. I owe that to her. To this day, I am grateful.

## FRIEDL DICKER THE ARTIST

When I think of Friedl Dicker, I naturally am saddened by what was lost... If only someone had used force—with or without her husband—to get her out! That not only would have saved her, it would have been important for the entire art world. Artists like her don't grow on trees!

It was only after the war that I saw her work, and I was stunned by the revelation. Here was the sort of artist who had taught me—and I was only a ten year old boy! I recalled the large sheets of paper, the freedom to create whatever you pleased and the warmth she radiated.

Her works can be classified in two completely different categories. In one are the works influenced by the early Bauhaus, constructivist-abstract, with a choice of color almost like Itten's. In the other are the works she developed in the 30s.

Her early works under the influence of Itten's color theory and the Bauhaus are typical of the period: they are of high quality and complemented by her work as a designer. They are built on the same theory. Friedl Dicker came into her own later, in Prague. There she found her own personal style, which is hard to classify.

If her life had not ended so horribly... if she had come to her exhibition at the Arcade Gallery in London—Wengraf was a very good art dealer—and if she had stayed and found other collectors, her stature would have grown even more. She is a very important woman and a very important artist, something special in a time when people speak of feminist art ...

I don't want to label her a feminist artist—she is simply a very good artist. I believe that there are very good artists who are men, and some very good artists who are women. That is all. Her work is extraordinarily sensitive; you can almost touch it. One can recognize the excellent mastery of the medium and the use of color on canvas.

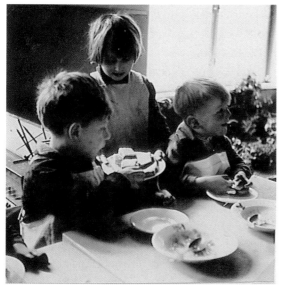

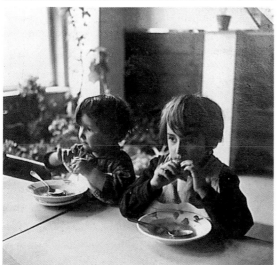

## THE CHILDREN OF THERESIENSTADT AND THEIR DRAWINGS

I know that my memories are just fragments. Those who could have told the story did not reach adolescence. Those who studied with her were sent to Auschwitz, and only a few survived.

The children's drawings are the most deeply distressing and the most moving documents and a further proof—if it requires proof at all—that life and art are deeply connected. There is no art that does not reflect life.

I do not believe that art can change the world—that is just an old romantic leftist idea. But I believe that we, when we encounter art, are deeply affected by it, and thus can change ourselves through art.

Art has a message. There is no clearer message than the one that speaks from the drawings that came into existence under the gaze of Friedl Dicker. In Vienna, her entire being encouraged us to work. She also encouraged the children of Theresienstadt to work and, through art, to overcome the horrible limitations of their existence.

**All pictures on this page: Montessori Kindergarten, designed by Atelier Singer-Dicker, Goethehof, Vienna XXII. From the photo album of Hedy Schwarz, 1932-33. Private collection**

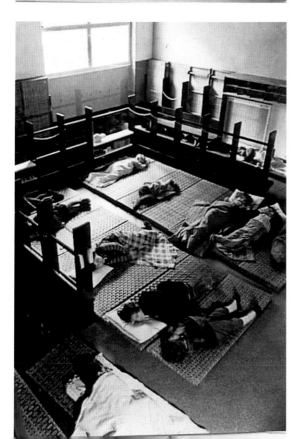

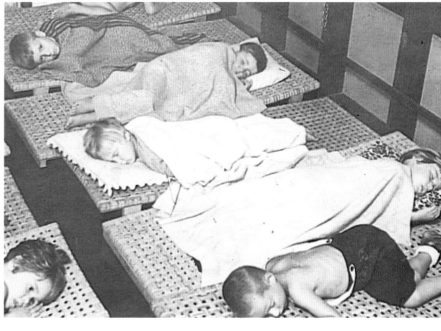

# EDITH KRAMER on Friedl Dicker-Brandeis

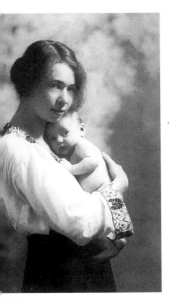

Josefina (Peppa) Kramer with her daughter Edith. Photograph, 1916. Private collection

*Edith Kramer is an internationally recognized art therapist. She was a student of Friedl Dicker-Brandeis. She has considered Friedl Dicker-Brandeis's work in both a personal and critical context. The following excerpts are from letters to the author in 1999 and from prior interviews:*

I KNEW FRIEDL DICKER-BRANDEIS the way a disciple knows the master. I knew many of the actors in the drama of Friedl's life personally. As an artist and as an art therapist, I am enormously indebted to Friedl Dicker. She was my teacher from my thirteenth to my twenty-second year. Being eighteen years her junior, my memories of Friedl are not as intimate as those of her friends and contemporaries. I never shared her generation's high hopes—for the regeneration of the Western world's cultural life through modern art, nor the illusion that Communism would bring about social justice and equality.

When we heard in New York of Friedl's transport to Auschwitz and her death, Dr. Annie Reich, the psychoanalyst whose patient she had been in Prague, stated with horror that Friedl had met a death that corresponded exactly to her worst sado-masochistic fantasies. Later, when the first exhibition of the art of the

children of Theresienstadt reached us, we also learned of the fulfilling aspects of the last two years of Friedl's life. Can her self doubt, her self-destructive inclination, her dedication to bringing the gift of art to doomed children be elucidated by psychoanalytically informed consideration?

We learn that Friedl's mother died when the child was almost five years old, an age dominated by Oedipal conflicts. We do not know what specific constellations characterized Friedl's relationship to her parents or the ambivalence and anxieties they entailed. We can be sure that they included death wishes against her mother or father and probably against both. Those wishes would have existed in a state of innocence, belonging to the inner world of a young child for whom fantasy and reality still merged—a world where wishes may have the power to influence real life and where death is irreversible.

It is a time when a little girl who has wished her mother dead nevertheless expects her to cook dinner, put her to bed and fulfill her maternal duties. The child will still fear that her mother may destroy her in retaliation for the child's wishes. It is a time when the same child may wish that her father would disappear

***Above:*** Edith Kramer. Photograph, 1988. Private collection

***Right:*** Edith Kramer. Rhythmic Study According to Dictation. 1932-34. Charcoal on paper. Private collection

Petr Ginz
(2/1/1928-9/28/1944).
Men with Children on a Bridge.
1943/44. Pencil on paper.
Jewish Museum, Prague

because he steals her mother's attention, because he interrupts play or punishes misbehavior. At the same time, the child also desires to possess the father exclusively, to be loved and protected by his might.

Ordinarily these powerful, contradictory desires will be renounced, and the child's fears will abate. The Oedipal drama will leave its mark, and eventually the emotional upheavals will contribute to maturation.

But what if these wishes come horribly true, if the mother whom one has wished away never comes back? What happens to a child's inner life when events seem to confirm that evil wishes have the power to kill? Even when such ideas are quickly repressed, a readiness to feel guilty and expect punishment may remain active.

Friedl's life as a young aspiring artist is similar to other young people of her generation. She meets her collaborator and lover Franz Singer, and the collaboration is fruitful. Friedl's love life is more troubled. Within their group, sexual fidelity is neither demanded nor valued, and Franz makes ample use of his sexual freedom. Eventually he marries and fathers a child. His love affair and creative collaboration with Friedl continues. He determines that Friedl, not being motherly, should not bear his child.

Throughout the seven years that Franz's son is alive, Friedl submits to Franz's dictum. Her behavior is contradictory. Franz has

Edith Kramer. Object Study
According to Dictation. Circa
1932-34. Charcoal on paper.
Private collection

*Right:* Edith Kramer. Rhythmic Study According to Dictation. Circa 1932-34. Charcoal on paper. Private collection
*Far right:* Edith Kramer. Exercise on Shortening. Circa 1932-34. Charcoal on paper. Private collection

required her to remain childless, but she does not protect herself by practicing birth control. Instead, she repeatedly gets pregnant. She also does not rebel by bearing a child against her lover's wishes. Instead, she submits to repeated abortions. Years later, when she is happily married, she suffers a miscarriage due to the destructive effects of her many abortions.

Friedl resented these injuries to her body. I still can hear her ranting against Franz, "How could I be motherly when I did not have a baby in my belly?"

Concerning Franz's son Bibi, Friedl must have been intensely ambivalent. She saw him often and must have developed tender feelings towards the little boy. She must also have been envious and resentful. Bibi's death must have felt like a judgement, a repetition of the trauma of her fifth year. Again a barely acknowledged fantasized death horribly comes true—the unconscious is timeless. Wish and deed are one, and guilt is eternal.

In Prague, Friedl finds a husband through her own initiative. She never defers to Pavel Brandeis as she had to Franz. In daily life she is inclined to dominate him. His presence, however,

is absolutely necessary. Her need to have him close at her side is reminiscent of the young Friedl who would not allow her new stepmother out of sight. Friedl rejects every opportunity to leave Czechoslovakia if it means leaving without her husband. She decides to share his destiny even as it leads to Theresienstadt.

If we contemplate the art of the children in Theresienstadt that was created under Friedl's guidance, we sense that they had been inspired and sustained by an accomplished artist who was a motherly person endowed with profound understanding of a child's mind and need. There exist many accounts of Friedl's ways as an art teacher and of her work in the children's theater in Theresienstadt. All of them mention her patience, kindness, calm, her inexhaustible energy, her willingness to give of herself. All of Friedl's inner turmoil seem to have been stilled in Theresienstadt. Could the suffering, the closeness of death, have been sufficient punishment so that there was no need to create additional chaos?

Had her lover Franz sensed rightly that Friedl was not meant to concentrate motherly love on a single child? Friedl gave both of her

art and herself to the many children who needed her.

## FRIEDL AS TEACHER

I was apprenticed to Friedl. She was my master, and she demanded a lot of me.

She liked to dictate pictures. For example, she would say, "Here we have a heavy, smooth rolling pin and there a pair of rough, heavy bricks. Thin blades of grass are growing between them."

She would name different things, and one had to draw very quickly. No attention was paid to the composition.

Another exercise asked for a graphic translation of the tone of her voice. She set the rhythm, and one had to follow her voice very carefully and draw the rhythm very precisely so that it could be understood from the paper. That was a very good, simple exercise because everyone has a feeling for rhythm. Even if one did not have any experience with drawing, beautiful graphic shapes appeared on the paper.

She would say, "Imagine a figure in motion. This figure is made entirely of spiral-shaped wire so that you can see through it. You would then understand how body parts come toward you or move to the back or to the side. When one draws a figure later, one draws it better and more convincingly because one understands the movement.

Friedl was passionate and temperamental. When she noticed that someone had cheated or done what she called "reportage," she would say, "I know that you can see. I know that you can draw an eye, but that is not enough."

She called it reportage when a drawing conveyed only a recognizable description and not the essence of a thing. She did not accept anything that was not done without absolute concentration. She demanded full concentration.

She would say, "Try to paint a picture starting from the top left and finish at the bottom right."

She would ask that one begin a drawing of a standing man not with the head but with the feet. "If you paint a portrait and do not know where the person's backside is sitting, it is not a good portrait."

When I had developed a good command of drawing with charcoal, she told me I should stop: "It is too easy for you." I was supposed to draw with a pencil or a brush, with India ink or with a pen, something that demanded more discipline.

She liked making collages because one can find colors and combine them instead of mixing them. With a collage, everything remains fresh—one's palette does not become messy—and that is a big help. I made collages in Friedl's class, and she made wonderful collages with the children in Theresienstadt.

I remember different things she said. For example, "If a picture is bad, it seems as small as a postage stamp. If a picture is good, it seems large. This perception is independent of its actual size." To this day, if one of my pictures seems small, I know there is something wrong with the composition.

She believed that one should observe an object from different points of view in order to understand each element individually: the rhythm, the linear composition, the spatial arrangement, the structure, the color composition.

In her courses, there was a kind of system: rhythm, structure, dictations. We did not necessarily work according to a fixed schedule.

**Anonymous. Texture Study According to Dictation. 1934-36. Charcoal on paper. Private collection**

Sometimes we would begin with a still life and then the picture would require that we go outside or add to it through a completely different activity. She let us work from models and many other things as well. It was not a strictly organized class.

I had respect for Friedl. She could be such a harsh critic. It is good that she was. When I dream of her, I dream that she is continuing to work, finishing her pictures.

I learned what art was about from Friedl. Since I have remained an artist, and art has become my life, I am endlessly grateful that she taught me the meaning of art. I was able to build on her foundation. No one else could have given me what she did.

Friedl Dicker-Brandeis or one of her students. Untitled. 1936. Charcoal on paper (lost)

## FRIEDL IN THERESIENSTADT

It was very interesting for me when the first pictures came from Theresienstadt: how strong and undamaged these children were, despite everything they had been through!

Friedl would set exercises, and pictures by old masters would be analyzed. There were color rows and the systematic mixing of colors. She did many rhythmic exercises with them so that their hands could become free for drawing and would not be used in the same way as for writing.

The pictures from Theresienstadt are full of life. One can see the personality of each child, and their enthusiasm is clearly visible. One senses how they defended themselves against their inhuman environment.

Wherever one finds good children's art, there must have been someone present who helped the children be productive, someone who inspired them. Friedl achieved something wonderful and helped the children develop and remain full of life until their deaths.

What remains of Friedl's work is beautiful…There are many forms of survival.

Edith Kramer was born on August 29, 1916, to Richard Kramer, the brother of the poet Theodor Kramer, and his wife Josephine, née Neumann, sister of the actress Elisabeth Neumann.

She studied drawing with Trude Hammerschlag and later studied art under Friedl Dicker in Prague from 1934 to 1938. In Vienna, she studied under Fritz Wotruba.

Edith Kramer emigrated to New York in 1938, and had her first art exhibition there in 1943. From 1950 to 1957 she created and directed an art therapy program for children in New York City, and in 1958 presented this program as a book entitled "Art Therapy in a Children's Community."

She taught art therapy at the New School for Social Research from 1959 to 1973. In 1963, she formed the art therapy program at the Jacobi Municipal Hospital in the Bronx, followed by art therapy programs developed for blind children at the Jewish Guild for the Blind.

In 1971, she published the work "Art in Therapy with Children" which has been translated into seven languages. She has taught at New York University and has had extensive exhibitions of her own work. In 1996, on the occasion of her 80th birthday, she was awarded the Silver Cross of Honor of the City of Vienna.

**Anonymous. Theater Stage, Spatial Study. 1934-36. Charcoal on paper (lost). Private collection**

**Edith Kramer. Rhythmic Exercise after Botticelli. Circa 1932-34. India ink on paper. Private collection**

**View from the back of Friedl Dicker's house in Praha-Nusle, Jaromirová 46.**

*I remember that we were both fascinated by the train station in Praha-Nusle. One could see it from the window. Nature and modern industry were united with each other.*

—EDITH KRAMER

**Edith Kramer. Train Tracks in Praha-Nusle. Circa 1934-36. Oil on canvas. Private collection**

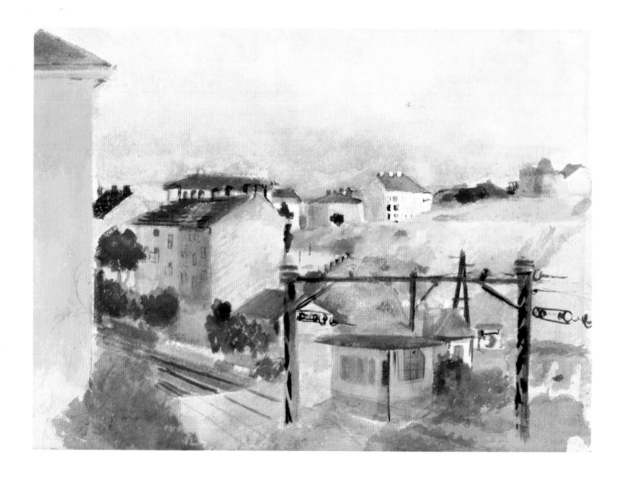

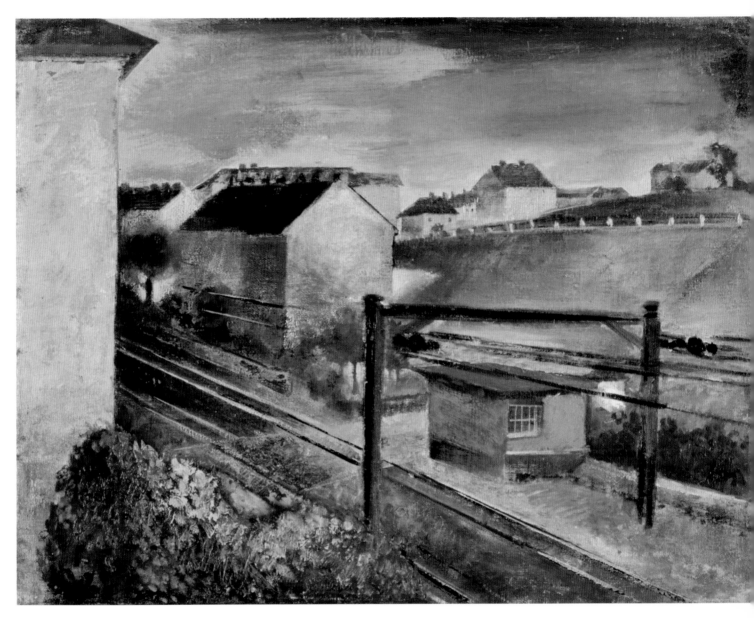

In the course of a lifetime, there are events that form an artist and which take shape in his painting...

—FRIEDL DICKER-BRANDEIS LETTER TO HILDE KOTHNY, UNDATED

Train Tracks in Praha-Nusle.
Circa 1934-36. Oil on canvas.
Private collection

# TIMELINE

### VIENNA 1898-1919

7/30/1898   Friedl Dicker born into the Jewish family of Karolina Fanta and Simon Dicker

6/26/1902   Karolina Fanta dies. Friedl remains in the care of her father, who works as a shop assistant in a stationery store. Simon Dicker marries Charlotte Schön.

Friedl Dicker attends the Bürgerschule for Girls in Vienna. She completes a course as a photographer and reproduction technician at the Graphic Teaching and Research Institute in Vienna.

Friedl Dicker attends Franz Čižek's textile class at the Artistic Trade School. At the same time she attends night classes at the Free Lyceum.

Friedl Dicker studies with Johannes Itten.

### WEIMAR BAUHAUS 1919-1923

Friedl Dicker studies at the Bauhaus School in Weimar, Germany. With Franz Singer, Friedl Dicker becomes the artistic director of Berthold Viertel's theater *Die Truppe* (The Troop) in Berlin and Dresden.

Friedl leaves the Bauhaus.

### BERLIN—VIENNA 1923-1934

Friedl Dicker and Franz Singer open the "Workshops of Fine Art" in Berlin. The atelier designs fabrics, lace, jewelry and books. After returning to Vienna, Friedl Dicker opens an atelier with Anny Moller (Wottitz), her friend from the Bauhaus.

Friedl Dicker receives an honorary diploma from the Second German Lace Trade Fair in Berlin.

Friedl Dicker opens a new atelier in Vienna with Martha Döberl. They design exclusive furniture, textiles, embroidery, wallpaper and handbags.

The "Workshops of Fine Art" are closed.

The Atelier Singer-Dicker opens in Vienna. The atelier designs luxurious houses, apartments, shops, interiors, fabrics and book bindings.

The Atelier Singer-Dicker exhibits at the "Kunstschau" (Art Show).

Friedl Dicker completes designs for a textile firm and takes part in the exhibition "Viennese Spatial Artists" at the Austrian Museum for Art and Industry

The Atelier Singer-Dicker is closed. Friedl opens her own atelier in Vienna. She joins the Communist Party and makes many anti-fascist posters.

During the February uprising, Friedl Dicker is arrested for communist activities. After her release she emigrates to Prague.

### PRAGUE 1934-1938

Friedl Dicker becomes a member of an anti-fascist group at the bookstore "The Black Rose."

Friedl Dicker turns to realistic painting. In cooperation with Franz Singer's atelier in Vienna, she takes part in designing architectural interiors in Prague and other cities. She teaches art to the children of political émigrés from Germany and Austria.

4/30/1936   Friedl Dicker marries her cousin Pavel Brandeis and obtains Czech citizenship

Friedl Dicker-Brandeis refuses a visa to Palestine.

### HRONOV 1939-1942

Friedl and Pavel Brandeis move to Hronov, a town northeast of Prague. Both of them work at the textile factory B. Spiegler and Sons. At the textile trade fair "Vystava 38 Náchod" in northeast Bohemia she receives a gold medal and a diploma for the firm Spiegler.

Pavel and Friedl Brandeis lose their jobs.

Exhibition of works by Friedl Dicker-Brandeis and Gerald Davis at the Royal Arcade Gallery in London.

12/14/1942   Friedl and Pavel Brandeis are deported to Theresienstadt (transport numbers Ch 549, Ch 548).

### THERESIENSTADT 1942-1944

12/17/1942   Friedl and Pavel Brandeis arrive at the concentration camp Theresienstadt.

Friedl Dicker-Brandeis lives in Girls' Home L 410. She teaches over a hundred children in the Girls' and Boys' Homes (L 417, L 318 and others).

May 1943   She makes costumes and sets for the children's play "The Little Fireflies."

7/17/1943   Friedl Dicker-Brandeis organizes an exhibition of children's art in the basement of home L 410. At a teachers' conference she presents her lecture "Children's Drawings."

Sept. 1943   Friedl Dicker-Brandeis makes costumes for the play "The Adventures of a Girl in the Promised Land."

9/28/1944   Pavel Brandeis is deported to Auschwitz. He survives.

10/6/1944   Friedl Dicker-Brandeis is deported to Auschwitz, Transport Number 167. On October 9, 1944 she is gassed in Birkenau.

### EXHIBITIONS

Friedl Dicker-Brandeis and Gerald Davis. Arcade Gallery, London 1940.

Friedl Dicker—Franz Singer. Darmstadt 1970.

Friedl Dicker-Brandeis 1898-1944, Prague 1988.

Friedl Dicker-Brandeis and Her Pupils. Moscow—Riga—Vilnius 1989.

2 x Bauhaus in Wien (2x Bauhaus in Vienna). Franz Singer—Friedl Dicker. Vienna 1989, Basel 1990.

From Bauhaus to Terezin. Friedl Dicker-Brandeis and Her Pupils. Yad Vashem, Jerusalem 1990.

Vom Bauhaus nach Terezin (From Bauhaus to Terezin). Frankfurt 1991.

Friedl Dicker-Brandeis: A Life Dedicated to Art and Teaching Palais Harrach, Vienna, Austria  1999

Landesmuseum Joanneum, Graz, Austria, 2000

Egon Schiele Art Centrum, Český Krumlov, Czech Republic, 2000

Friedl Dicker-Brandeis: Light Defining Darkness Musée d'Art et d'Historie du Judaisme, Paris, France, 2000

Bauhaus Museum, Berlin, Germany, 2001.

William Breman Heritage Museum, Atlanta, Georgia, USA, 2001-2002

The Drawing Center, New York, New York, USA, 2002-2003

The Museum of Tolerance, Los Angeles, California, USA, 2002-2003

# SOURCES

Correspondence of Dr. Hilde Angelini-Kothny: Private archive of Dr. Hilde Angelini-Kothny.

Anny Wottitz (married name Moller) and Judith Moller: Private archive of Judith Adler (née Moller).

Poldi Schrom: Private archive of Georg Schrom.

Martha Döberl: ibid

Hans Hildebrandt: ibid

Willy Groag: Archive Beit Theresienstadt (Givat Chaim)

Friederike Brandeis (Friedl Dicker-Brandeis): Children's Drawings. The manuscript of the lecture is in the archive of the Jewish Museum, Prague.

BONACO: The Lesson Of Drawing, In: Journal of The Girls's Home XI in L 414. Archive of the Theresienstadt Memorial.

Edith Kramer: Memories of Friedl Dicker, In: 2x Bauhaus in Wien (2x Bauhaus in Vienna), Exhibition Catalogue, Vienna 1989.

Erna Furman: Letter on Friedl, archive of Elena Makarova.

Michal Kraus: Children's journal Kamarád (November 19, 1943) and his diary from June 1945: Archive Beit Theresienstadt.

Fritz Stecklmacher: Theresienstadt, November 26 1942, Report, In: Private archive of Michal Beer [Maud Stecklmacher], Tel Aviv.

In cases of doubt, the spelling in Friedl Dicker's letters was made to match current orthography

Elena Makarova's Private Archive

The archive consists of copies of private correspondence as well as records of conversations that took place between 1988 and 1999 with the following people:

Florian and Judith Adler, Eva Adorian-Ehrlich, Edna Amit (Lilka Bobašová), Dr. Hilde Angelini-Kothny, Maud Michal Beer (Stecklmacher), Rita Münzer (Bejkovská), Esther Birnstein (Šwarzbartová), Zuzana Podmelová (Dorfler), Georg Eisler, Raja Žadniková (Engländerová), Anna Flachová-Hanušová, Jiří Franěk, Erna Furman, Lisa Gidron, Willy Groag, Helga Kinsky (Pollaková), Lisa Klein, Greta Klinsberg (Hoffmeisterová), Josef Knytl, Edith Kramer, Noemi Makovcová (Blanová), Milan and Irena Marvan (Eisler), Eva Landová-Merová, Marta Mikulová (Freulichová) Ziporah Moller, Handa Drori (Hana Pollaková), Dita Kraus (Pollachová), Margit Silberfild, Anna Sládková, Háva Selcer (Eva Riessová), Hanne Sonquist, Eva Štichová-Beldová, Zdena Turková, Jozef Vavrička, Sari Verešová, Marie Vítovcová (Špitzová).

## BIBLIOGRAPHY

50 Jahre Bauhaus. Exhibition Catalogue. Stuttgart 1968.

Adler, Bruno (ed.): Utopia. Dokumente der Wirklichkeit, Weimar 1921 (Reprint Munich 1980).

American Journal of Art Therapy, vol. 35, Norwich University, November 1996.

Bayer H./Gropius W./Gropius I. (ed.): Bauhaus 1919-1928. Stuttgart 1955.

Bothe, Rolf/Hahn, Peter/von Tavel, Hans Ch. (publisher): Das frühe Bauhaus und Johannes Itten. Exhibition Catalogue, Ostfildern-Ruit bei Stuttgart 1994.

Bauhaus Experiment. Exhibition Catalogue, Berlin–Darmstadt 1989.

2 x Bauhaus in Wien. Franz Singer—Friedl Dicker. Exhibition Catalogue, Vienna 1989.

Dekorativnoe iskusstvo Nr. 3, Moscow 1986.

Franz, R.: German Painting in the 20th Century. New York 1968.

Golomshtok, Igor: Totalitarnoe iskusstvo (Totalitarian Art). Moscow 1994.

Hildebrandt, Hans: Die Frau als Künstlerin. Berlin 1928.

Hildebrandt, Hans: Die Kunst des 19. und 20. Jahrhunderts. Potsdam 1931.

Itten. Johannes: Mein Vorkurs am Bauhaus. Gestaltungs-und Formlehre, Ravensburg 1963.

Kandinsky, Wassily: Über das Geistige in der Kunst. Munich 1911.

Karny Miroslav/Kemper, Raimund/Karna, Margita (ed.): Theresienstädter Studien and Documente. Theresienstädter Initiative 1998.

Makarova, Elena: From Bauhaus to Terezin. Friedl Dicker-Brandeis and Her Pupils. Exhibition Catalogue, Yad Vashem, Jerusalem 1990.

Makarova, Elena. Theresienstadt. Kultur och barbari. Exhibition Catalogue, Stockholm 1995.

Moskau-Berlin 1900-1950. Exhibition Catalogue, Munich 1995.

Redlich, Egon (Gonda) (1916-44). Zitra jedeme, synu pojdeme transportem. Deník Egona Redlicha z Terezina, January 1 1942-October 22 1944, Brno 1995.

Scheidig, Walther: Bauhaus Weimar 1919-1924. Werkstättenarbeiten. Leipzig 1966.

The Journal of Holocaust Education, vol. 6, no. 2, 1997.

Von Tavel, Hans Ch./Helfenstein, Josef (ed.): Johannes Itten. Künstler und Lehrer. Exhibition Catalogue, Bern 1984.

Wingler, Hans M.: Das Bauhaus 1919-1933. Weimar, Dessau, Berlin. Third edition, Cologne 1975.

Wingler, Hans M.: The Bauhaus. Weimar, Dessau, Berlin, Chicago. Chicago 1969.

Wingler, Hans M.: Friedl Dicker—Franz Singer. Exhibition Catalogue, Darmstadt 1970.

Withalm, G.: Zur Kulturpolitik des Nationalsozialismus. Exhibition Catalogue, Vienna 1985.

Zwiauer, Charlotte (ed.): Edith Kramer. Malerin und Kunsttherapeutin zwischen der Welten. Vienna, 1997.

# INDEX